A PICTURE GALLERY OF THE SOUL

A PICTURE GALLERY OF THE SOUL

———

CURATED BY

**Herman J. Milligan, Jr.
and Howard Oransky**

TEXTS BY CHERYL FINLEY, HERMAN J. MILLIGAN, JR.,
CRYSTAL AM NELSON, HOWARD ORANSKY,
SEPH RODNEY, AND DEBORAH WILLIS

KATHERINE E. NASH GALLERY
UNIVERSITY OF MINNESOTA

UNIVERSITY OF CALIFORNIA PRESS

This catalogue is published in conjunction with the exhibition *A Picture Gallery of the Soul*, organized by Herman J. Milligan, Jr., and Howard Oransky for the Katherine E. Nash Gallery at the University of Minnesota, Minneapolis, September 13–December 10, 2022.

A Picture Gallery of the Soul was made possible by The Andy Warhol Foundation for the Visual Arts, the National Endowment for the Arts, a gift of Kate and Stuart Nielsen, a gift of Blu Dot, and a gift of Metropolitan Picture Framing.

COLLEGE OF LIBERAL ARTS

UNIVERSITY OF MINNESOTA

The Andy Warhol Foundation for the Visual Arts

Published by the Katherine E. Nash Gallery at the University of Minnesota and University of California Press. www.art.umn.edu/nash www.ucpress.edu

Editorial inquiries:
Katherine E. Nash Gallery
University of Minnesota
405 21st Avenue South
Minneapolis, MN 55455

Sales Inquiries:
University of California Press
1111 Franklin Street
Oakland, CA 94607

Excerpt from "The Negro Speaks of Rivers" by Langston Hughes. Reprinted from *The Collected Poems of Langston Hughes*, by Langston Hughes, edited by Arnold Rampersad with David Roessel, Associate Editor. Published by Penguin Random House, 1994. Reprinted by permission of Harold Ober Associates. Copyright 1951 by the Langston Hughes Estate.

Cataloging-in-Publication Data is on file at the Library of Congress.

ISBN 978-0-520-38806-2 (cloth : alk. paper)

Printed in China.

30 29 28 27 26 25 24 23 22 21
10 9 8 7 6 5 4 3 2 1

My soul has grown deep like the rivers.

LANGSTON HUGHES

CONTENTS

FOREWORD

Art must be an integral part of the struggle. It can't simply mirror what's taking place. . . . It must ally itself with the forces of liberation.

CHARLES WHITE

FROM W. E. B. DU BOIS'S *The Souls of Black Folks* to Eldridge Cleaver's *Soul on Ice,* to Ellis Haizlip's *Soul!* and Don Cornelius's *Soul Train* television programs to Peggy Cooper Cafritz's *Soul Memories,* the idea of soul has been inextricably linked to the social and cultural tapestry of African Americans. But it is often perceived or understood as an abstraction, ephemeral, and conceptually romantic, undergirded by concepts of soul music and with clear delineations of past, present, and future as a linear construct. Yet, in each of the texts and programs cited above, the idea of soul is not conceptual, it is the fluid intersection between past, present, and future. It is evidentiary. *A Picture Gallery of the Soul* brings together a cross section of photographers and artists who use lens-based art to provide evidence of its agency, its beauty, its refusal, and ultimately its permanence. Their works construct new narratives about moments in history. This exhibition is ultimately about unpacking the idea of what *soul* means to the artists and the curators.

In reviewing the works in this exhibition, I began to consider and visualize the experience of each of the artists and, immediately, memory emerged as the central theme. Each work, whether created in the nineteenth or the twenty-first century, focuses on art historical references, identity, cultural traditions, and the land. The artists interrogate formal and conceptual components of image-making. The interplay between the historical and the contemporary, between self-presentation and projected representation, are all essential to their practice. Images of Civil Rights Movement protests in the twentieth century and Black Lives Matter protests of today explore the ways in which our contemporary understanding of art, history, and politics are informed and constructed through the lens. The photographers and artists wrestle with a turbulent past as they combine archival photographs, text, color, and abstraction to challenge ideas about black life, black joy, and black death. While we are confronted with news coverage of a global pandemic and police abuse, this timely exhibition offers an artistic intervention to explore the possibilities of working with archival materials and consider how these images are transforming our understanding of the social issues of our time.

Frederick Douglass believed in the implicit egalitarianism of photographs. People of any condition, economic circumstance, and demographic could be seen the way they saw themselves. In a country where the political, social/cultural, and economic imaging constructed African Americans as less than human/citizen, and the religious imaging as soulless, the decision to sit for a photograph was an oppositional act. The gaze that was then captured could be nothing other than oppositional. An oppositional gaze has profoundly determined the imaging of African Americans today. This exhibition takes a critical look at the works of activists, studio photographers, photojournalists, and artists who, working with their cameras, address topics of portraiture, identity, music, family life, fashion and style, racism, history, abstraction, black interior spaces, birth, and death.

A *Picture Gallery of the Soul* informs us that during their lifetimes, each photographer, artist, and journalist play[ed] a crucial role in advocating for change in our society. Examples from the nineteenth century include a Goodridge Brothers portrait of newborn William O. Goodridge, Jr., C.M. Battey's portrait of Frederick Douglass, and a J.P. Ball portrait of Mattie Allen. From the twentieth century we see Henry Clay Anderson's photograph of Ruby Washington standing next to a radio holding a handbag; Arthur Bedou's deportation image of Marcus Garvey; Gordon Parks's *American Gothic*; John F. Glanton's photograph of a young woman posing with her phonograph records; Charles 'Teenie" Harris's image of Howard Hawkins playing marbles; and

family pictures by Earlie Hudnall, Florestine Perrault Collins, and Chester Higgins of his Great-aunt Shugg McGowan Lampley. The twenty-first century introduces us to photographs of injustices and protests reflecting on the Civil Rights Movement in the 1960s and the Black Lives Matter movement that illuminate a long history of black people's fight against racism. Images that grapple with beauty, representation, agency, and resistance are realized in the works of Nona Faustine, Adama Delphine Fawundu, Alanna Fields, Lola Flash, Allison Janae Hamilton, Daesha Devón Harris, L. Kasimu Harris, Keisha Scarville, and Elnora and Arthur Chester Teal.

The concept of black visual culture entails the critical evaluation of images in multiple realms, and the genre of self-portraiture is vital to how photographers see themselves in front of and behind the camera. Self-portraits by Kwame Brathwaite, María Magdalena Campos-Pons, Barbara DuMetz, Rashid Johnson, Robert H. McNeill, John Pinderhughes, Addison Scurlock, Paul Mpagi Sepuya, Coreen Simpson, Hank Willis Thomas, Carrie Mae Weems, and Carla Williams provide insights and allow us to reimagine their identity as imagemakers. A few of the works that collage prints and painting can be viewed as political as they explore the complexity of narrating a past through disparate objects. The artists who view history as a place setting for their art include Radcliffe Bailey, Tameca Cole, Awol Erizku, Krista Franklin, Mildred Howard, Ayana V. Jackson, Caroline Kent, Fern Logan, Howardena Pindell, Deborah Roberts, and Lorna Simpson.

A *Picture Gallery of the Soul* impresses upon us that the impact of the photographic medium crosses time and space as it explores the possibilities of image-making and policy-making in communities across the United States. It affirms the diversity of images created over time, emphasizing a dialogue with photographers and artists who engage and address their personal experience of social justice and formalist issues in the production of their art.

<div align="right">

Deborah Willis, Ph.D.
New York University

</div>

NOTE

Epigraph: Charles White, quoted in Jeffrey Elliot, "Charles White: Portrait of an Artist," *Negro History Bulletin* 41, no. 3 (May–June 1978): 828.

HERMAN J. MILLIGAN, JR., PH.D.

PREFACE

A **PICTURE GALLERY OF THE SOUL** presents the work of
more than one hundred Black American artists, showcas-
ing their ability to reveal the uniqueness and the com-
monality of the Black American experience through their creative
use of photography. The body of work displays the individual,
societal, cultural, religious, symbolic, political, and economic per-
spectives of Black American experience over time. While many of
these artists were born and raised in the United States, a number
of them immigrated to this country, coming with dreams and
desires of forging a new and better future, pursuing their artistic
practice, and making indelible contributions to society and the
visual arts through the medium and profession of photography.

The exhibition title comes from the "Lecture on Pictures"
delivered by Frederick Douglass on December 3, 1861, in Boston
on the importance of photography, an emerging art form at the
time. Douglass theorized photography as a tool for documenting
society and contended, "Rightly viewed, the whole soul of man is

a sort of picture gallery, a grand panorama, in which all the great facts of the universe, in tracing things of time and things of eternity, are painted. The love of pictures stands first among our passional inclinations, and is among the last to forsake us in our pilgrimage here."[1]

One hundred and sixty-one years after this important speech by Douglass, the visual legacy of Black American experience is shown to be well-documented and explored by the artists in this exhibition, who have created compelling, beautifully executed, and well-composed images. Photographs from the late 1850s to the early 1900s reveal individuals who were professional, confident in their sense of self-worth and achievement, despite the obstacles they had faced due to racial discrimination, along with those who were still facing economically difficult times and who were not faring as well. Images from the late 1920s to the early 1960s continue to reveal a more fragmented socioeconomic order with some sense of optimism, despite the ongoing racially discriminatory practices against Black Americans that were still prevalent. Images depicting professional achievement along with the contentious struggles for civil rights and equality continue to reveal a more unjust society through the 1960s and well into the early 2000s. Some photographers were investigating the emergence of ethnically diverse youth cultures (Dawoud Bey), while others were focusing on LGBTQ communities and communicating to the broader society their existence and pride (Lola Flash). This "subcultural" documentary work had already begun taking form in the 1950s (Charles "Teenie" Harris) but was not generally highlighted in gallery and museum exhibitions until at least twenty years later.

In the early 2000s, I detected a major shift in the compositional styles of the younger emerging Black American artists using photography. I found that pictorial space became more floral and baroque, combining African American designs and surrounding the subjects with these decorative elements. I'm calling this the "Kehinde Wiley effect" based on his paintings of that period employing this technique (e.g., adoring young Black, Latino, and individuals of color in the tradition of classical painting masters such as Botticelli, Van Dyck, Titian, and David). Works in this exhibition by Crystal Z Campbell, Albert Chong, and Daesha Devón Harris are examples of this portraiture style. The work of Thomas E. Askew and James Van Der Zee, also included in this exhibition, demonstrates the use of this technique in a more simplified and elegant manner at a much earlier point in time.

Within the last ten to twenty years, the United States has undergone another wave of civil unrest in response to the use of deadly force by police in Atlanta, GA; Falcon Heights, Minneapolis, and St. Paul, MN; Ferguson, MO; Huntley, MT; El Paso, TX;

Omaha, NE; Cleveland, OH; and many other American cities. Just in the last year, using May 5, 2021, as an end point, the *Washington Post*'s "Democracy Dies in Darkness" reports that 985 people have died at the hands of police. The haunting image of the Philando Castile Memorial Site (Kris Graves) is a powerful reminder of the danger of a routine traffic stop for Black people, and the portrait of a hooded figure (John Edmonds) recalls the tragic death of Trayvon Martin, who was wearing that simple item of clothing. Photography can also inform us how new symbols of defiance and protest dramatize the current conditions under which we are living in the United States. Slogans such as #Black Lives Matter have become normalized (yet remain important) within the sociocultural and political landscape, as depicted in the work of Devin Allen.

Throughout these seismic shifts in society, Black American photographers are still documenting and revealing to us the ever-present examples of humane values that Black Americans share and hold dear, as do other Americans and people around the world: *family* (Gerald Cyrus, Goodridge Brothers Studio, Allison Janae Hamilton); *pride* (Adger Cowans, Bill Gaskins); *aspirations* (Thomas E. Askew, Louis Draper); *sense of accomplishment* (Florestine Perrault Collins, Barbara DuMetz); *determination* (John L. Banks, C.M. Battey, Walter Griffin); and *remembrance* (Anthony Barboza, Ronald Barboza, Bill Cottman, Mara Duvra, Nona Faustine) are just a few examples that this exhibition presents.

We, the co-curators, sincerely offer you the opportunity to explore this exhibition of a select group of Black American artists, living and deceased, who have shared their vision with us through their exceptional and wonderful work.

NOTE

1. John Stauffer, Zoe Trodd, and Celeste-Marie Bernier, *Picturing Frederick Douglass: An Illustrated Biography of the Nineteenth Century's Most Photographed American* (New York: Liveright Publishing Corporation, 2015), 131.

HOWARD ORANSKY

PREFACE

THE HISTORY OF AMERICAN PHOTOGRAPHY and the history of Black American culture and politics are two interconnected histories. From the daguerreotypes made by Jules Lion in New Orleans in 1840 to the Instagram post of the Baltimore Uprising made by Devin Allen in 2015, photography has chronicled Black American life, and Black Americans have defined the possibilities of photography. Frederick Douglass, a former enslaved person and prominent abolitionist, anticipated the quick, easy, and inexpensive reproducibility of photography. He presciently developed a theoretical framework for understanding the implications of photography on public discourse in a series of four lectures he delivered during the Civil War. Douglass was the subject of photographic portraits 160 times, becoming the most photographed American of the nineteenth century.[1]

The history of American photography and the history of Black American culture and politics are two disconnected histories. From its inception, photography has been used as a tool to

rationalize slavery, celebrate the terror of lynching, and popularize racist tropes through advertising and the media. Simultaneously and separately, photography has been used to create a vast "picture gallery, a grand panorama" of the compassion, respect, and love in Black lives.[2] In 1850, Professor Louis Agassiz of Harvard University commissioned Joseph Zealy to produce a series of daguerreotypes of seven enslaved persons in South Carolina. With the sitters partially or completely stripped of their clothing, the images are the quintessential photographic expression of racist objectification. Nine years later, Agassiz would go on to become the founding director of Harvard's Museum of Comparative Zoology. At the same time, Augustus Washington produced a daguerreotype of John Hanson, a formerly enslaved person elected to the Senate of the Republic of Liberia. In this image, Hanson is portrayed compassionately and respectfully as fully human, dignified (Pl. 106). In the next century, a photographic postcard souvenir depicting the 1910 lynching of Allen Brooks in Dallas, Texas, surrounded by an enormous crowd, was mailed to Dr. J.W.F. Williams, of LaFayette, Kentucky, with the inscription, "Well John, this is a little token of a great day we had in Dallas."[3] At the same time, Lucius W. Harper produced a photographic souvenir of his son Lucius Harper, Jr. (Pl. 60). The boy is holding his hat in one hand and his schoolbooks in the other. The proud father inscribed the card, "Off for School, Lucius Harper, Galveston, Texas," with his love reflected in the photograph's precise lighting.

The Katherine E. Nash Gallery, operated by the Department of Art at the University of Minnesota, presents *A Picture Gallery of the Soul*, a group exhibition of Black American artists whose work incorporates the photographic medium. Sampling a range of photographic expressions from traditional photography to mixed media and conceptual art, and spanning a timeframe that includes the nineteenth, twentieth, and twenty-first centuries, the exhibition honors, celebrates, investigates, and interprets Black history, culture, and politics.

This project began with an email I received in 2014 from Jim Gubernick, the facilities coordinator in the Department of Art: "Hi Howard, I know you must get a ton of ideas for exhibitions in the Nash Gallery, but I'm sending this one anyway. I met Lou Draper at a small college I went to in New Jersey back in the '80s. His work is just amazing. I have seen it on and off for the past 30 years and it's as fresh as ever." I had never heard of Louis Draper, but I thought a group exhibition of Black American artists who have used photography at different times and in different ways would be perfect for our gallery. At the time I was busy working on an exhibition of Ana Mendieta's films, and on one of my visits to New York for that project I had the opportunity to see

Draper's work. It was amazing, and his name became the first on a list of artists I hoped to include in a future exhibition. My thanks to Jim Gubernick for his great idea.

In 2016 I invited my colleague Herman J. Milligan, Jr., to join the project as co-curator, and we began our work together in earnest. I first met Herman in the mid-1990s as a staff member at Walker Art Center, when we served together on the Community Advisory Committee. After I became director of the Katherine E. Nash Gallery, I invited Herman to collaborate on our 2012 exhibition *Minnesota Funk*. It is such a pleasure to work with Herman. His dedication, knowledge, and passion are immense, and I am grateful for his commitment and work on this project. In addition to co-curating the exhibition, Herman has curated a program of jazz for the installation. I am also grateful to Deborah Ultan, the arts and design librarian at the University of Minnesota, who has organized a display of historical materials within the exhibition.

A Picture Gallery of the Soul is co-sponsored by the Department of African American and African Studies; Department of Art; Department of Art History; Department of History; Race, Indigeneity, Gender, and Sexuality Studies Initiative; Office for Public Engagement; Imagine Fund; the Dean's First-Year Research and Creative Scholars Program; University Libraries, including the Archie Givens, Sr. Collection of African American Literature and The Givens Foundation for African American Literature. The exhibition and catalogue have been made possible by the generosity of The Andy Warhol Foundation for the Visual Arts, the National Endowment for the Arts, and an early, critical gift from Kate and Stuart Nielsen. My thanks to our donors Jane Bassuk, Harriet and Bruce Bart, and Mary Baumgartner and to our corporate sponsors, Blu Dot and Metropolitan Picture Framing, for their valuable in-kind support.

I am grateful to all the artists and the many dedicated staff at the museums, galleries, libraries, and archives who facilitated the loans of work to the exhibition and the necessary permissions for their inclusion in this publication. Three of the artists have been especially helpful. In 2016 I sent an email to Professor Deborah Willis, inviting her to participate in the exhibition. She responded as if we were old friends: "Dear Howard, I look forward to speaking with you about my work and the exhibition. Excited to hear about Lou Draper, my dear photo mentor. Best, Deb." I didn't know that Deb, in addition to her career as an artist, had been engaged in years of research on the history of Black American photography and had published numerous books on the subject. As her books began to fill my shelves and I explored the palace of her scholarship, it felt like Deb had become my photo mentor. Herman introduced me to Anthony Barboza by email in 2019 and let him know I would be in New York the next day. Anthony wrote back, "Love to meet him." Three days later I was sitting in the

living room of Shawn Walker's home, discussing with Anthony and Shawn how they would like to participate in the exhibition. In the next room preparations were under way for the transfer of Shawn's massive photographic archive to the Library of Congress. I was a bit tongue-tied; what should I say to these giants of American photography? Anthony and Shawn were open, friendly, and helpful, giving me names and phone numbers of other artists I should contact.

At the Katherine E. Nash Gallery, I am fortunate to work with Assistant Curator Teréz Iacovino, who has supported virtually every component of this project in her usual tireless, helpful, and enthusiastic way. The undergraduate and graduate student assistants in the Gallery have also been extremely helpful: Nick Bauch, Destiny Bilges, Taylor Johnson, Julia Maiuri, Nicole Ocansey, Prerna, Eleanore McKenzie Stevenson, and Emma Tierney. Our operation of the Gallery is supported by the administrative and technical staff in the Department of Art, the College of Liberal Arts, and the University of Minnesota. My thanks to Nicolas Allyn, Christine Baeumler, Mindy Breva, Alexandra Brown, Gregory Brown, John Coleman, Colleen Donahue, Rochelle Emmel, Joshua Gates, Jim Gubernick, Tarisa Halek, Karen Haselmann, Regina Hopingardner, Kathy Kipp-Huspeni, Shannon Birge Laudon, Paul Linden, Kevin McKoskey, Michael Oakes, Seva Ormanidhi, Lynda Pavek, Sonja Peterson, Kimberlee Roth, Robin Schwartzman, Caroline Houdek Solomon, Patricia Straub, Victoria Troxler, and Pamela Windingstad.

This catalogue exists because of the advocacy and effort of Archna Patel, associate editor of art history at University of California Press. When Archna found out about our exhibition, she contacted me and asked if I would be interested in publishing the catalogue with UC Press. Archna enlisted the support of the Press and ensured the success of this project, while keeping her eye on the countless details along the way. Thank you, Archna. I would also like to thank and acknowledge the staff at UC Press who have helped make this publication a reality: Alexandra Dahne, Summer Farah, Teresa Iafolla, Katryce Kay Lassle, Jessica Moll, and Claudia Smelser.

We have presented the artists' work alphabetically by last name, regardless of chronology, as this catalogue documents an exhibition and is not intended to be a history of photography. Just as photography continues to change, so does language. Some of the artists and writers in this volume prefer the lower case "black" or "white" and some prefer the upper case "Black" or "White." All styles are respected in this book. My thanks to our authors for their beautiful essays: Cheryl Finley, Herman Milligan, crystal am nelson, Seph Rodney, and Deborah Willis.

I appreciate that while I was growing up in Los Angeles in the 1960s my mother, Hannah Theile, gave me the same books she taught to her students at San Fernando

High School: *Manchild in the Promised Land, The Learning Tree, The Autobiography of Malcolm X,* and others. Perhaps my favorite was a book of poetry, *I am the Darker Brother,* those words by Langston Hughes and other poets illustrated with line drawings by Benny Andrews.

My wonderful life partner, Anna R. Igra, has been her usual generous self, offering intellectual and emotional support every step of the way. She helped me think through historical issues, gave me articles to read, referred artists for me to consider, and thoughtfully answered my oft-repeated question: "which picture do you like better—this one? or this one?"

The hardest part of this project for me has been to draw the line and call it finished. I wish I could continue to curate this exhibition for the rest of my life, and every few years present a new iteration of the "grand panorama."

NOTES

1. John Stauffer, Zoe Trodd, and Celeste-Marie Bernier, *Picturing Frederick Douglass: An Illustrated Biography of the Nineteenth Century's Most Photographed American* (New York: Liveright Publishing Corporation, 2015), ix.

2. Frederick Douglass, quoted in Stauffer, Trodd, and Bernier, *Picturing Frederick Douglass,* 131.

3. James Allen, *Without Sanctuary: Lynching Photography in America* (Sante Fe, NM: Twin Palms Publishers), 2000, plates 10, 11.

CHERYL FINLEY, PH.D.

MINING THE ARCHIVE OF BLACK LIFE AND CULTURE

Rightly viewed, the whole soul of man is a sort of picture gallery, a grand panorama, in which all the great facts of the universe, in tracing things of time and things of eternity, are painted.

FREDERICK DOUGLASS

———

THE GREAT NINETEENTH-CENTURY ABOLITIONIST and orator Frederick Douglass understood the power of photography and the archive better than most. In his oratory and advocacy, he used both as tools for social change and liberation, shifting perspectives, and transforming lives. The passage that begins my essay is revelatory of a period at the start of the Civil War in 1861 when the very *soul of the nation* was under siege. Yet Douglass takes up the photograph and its archival uses in his "Lecture on Pictures" as a metaphor to signal concurrent battles over established and emerging media (forms of visual representation and presentation)—the picture gallery vs. the panorama, the painting vs. the photograph—and how this unprecedented time of national crisis would be remembered, documented, and archived. His specific reference to the picture gallery and the grand panorama demonstrates his deep knowledge of and personal experience with technological innovation and visual representation, notably photography, and the presentation and circulation of

images and ideas. It also serves as a rallying call for image-makers and activists alike to harness these emergent tools of communication for the dawn of a new era.

With his series of essays on photography, Douglass set the stage for Black nineteenth-century photographers to document generations of survivors of slavery, chart the progress of the race, and, indeed, guarantee the future. Photographers like C.M. Battey, whose 1893 seated portrait of Douglass captures the stalwart statesman in his sunset years (Pl. 12), went on to make lasting portraits of Black leaders and intellectuals, including Booker T. Washington, W.E.B. Du Bois, and Paul Lawrence Dunbar. Battey's portraits of Black leaders frequently appeared on the covers of influential early twentieth-century Black publications, such as *The Crisis, The Messenger,* and *Opportunity,* while his status as official photographer at Tuskegee Institute, following his predecessor Arthur P. Bedou, promised future generations of Black photographers through his pedagogy and example.

Works by the Twin Cities photographers J.P. Ball (Minneapolis) and Harry Shepherd (St. Paul) offer a local perspective on the responsibility and legacy of nineteenth-century Black photographers. Ball, who was among the first generation of photographers in America, had studios in Cincinnati, Minneapolis, and Helena, Washington, boasting all forms of the medium from daguerreotypes to cabinet cards. In addition to his celebrated national reputation, which attracted sitters like Douglass and other abolitionists, Ball was famously known to have created a large-scale, painted canvas panorama in Cincinnati: *Mammoth Pictorial Tour of the United States Comprising Views of the African Slave Trade; of the Northern and Southern Cities; of Cotton and Sugar Plantations; of the Mississippi, Ohio, and Susquehanna Rivers; Niagara Falls &C* (1855). A staunch abolitionist and supporter of the Union Army during the Civil War, Ball later became the official photographer of the twenty-fifth anniversary of the Emancipation Proclamation, held in Minneapolis in 1887. He is represented in the exhibition by an exquisite carte de visite of Mattie Allen (1874–77), her three-quarter pose revealing Ball's innate talents in studio portraiture (Pl. 7).

Both Ball and Shepherd originally hailed from Virginia. Shepherd was active from 1880 to 1905 in St. Paul, where he operated the first Black-owned studio, the People's Photography Gallery, and several other studios, infusing his practice with the portraits of men of prominent political stature, such as Frederick L. McGhee, the first Black lawyer in Minnesota and an organizer of the Niagara Movement with Du Bois (Pl. 94). Shepherd's most notable commission came from Thomas Calloway of the Library of Congress in Washington, DC, to make portraits akin to the formal three-quarter bust shown in the exhibition of McGhee for the critically acclaimed *American Negro* exhibit

at the 1900 Paris Exposition Universelle. Thomas E. Askew provided similar portraits of African Americans from his native Georgia for albums commissioned by Du Bois for the same show, uplifting Black progress despite the failures of Reconstruction and the landmark Plessy v. Ferguson Supreme Court decision of 1896 codifying Jim Crow laws that would endure for the next half century (Pl. 5). Together, their art and activism served as fodder for Black artists and photographers of the twentieth and twenty-first centuries to develop powerful mnemonic aesthetic practices foregrounding archival images in their contemporary works as catalysts of memory, activism, and determination.

TRACING THINGS OF TIME

At the dawn of the twentieth century, Black photographers continued to document Black life and culture in cities and rural communities around the country. Addison Scurlock moved from Fayetteville, North Carolina, to Washington, DC, in 1900 and opened a photography studio on popular U Street in 1911. His family firm served ordinary folks, politicians, and celebrities, and enjoyed a coveted role as staff photographers for Howard University. Scurlock's pride in his practice can be seen in a telling self-portrait, which demonstrates his technical expertise with large-format studio cameras and his attention to the details of lighting Black subjects (Pl. 91). From New Orleans, Arthur P. Bedou enjoyed a long career, focusing on individuals of note in the South and the activities of prominent historically Black colleges and universities, including Tuskegee Institute and Xavier University. For seven years, from 1908 until 1915, Bedou, taking over from Battey, was the personal photographer to Tuskegee's Booker T. Washington, creating the most memorable and dynamic images of this captivating leader. Bedou was highly attuned to an evolving Black political sphere, and his photographs of Washington and Marcus Garvey show how he used his camera for the purposes of social change (Pl. 15).

The Black Press was an important outlet for disseminating news and information to segregated Black communities around the country in the twentieth century. Photographs that accompanied news stories or stood on their own enabled generations of Black people to take pride in their self-images. Following his service in World War II, John F. Glanton returned to Minneapolis and opened a photography studio catering to families and the community. His untitled portrait of a young woman and her record albums gives a sense of the stylish vernacular images he made, showing the popularity of Black music in households (Pl. 54). Glanton's photographs were published widely in the Twin Cities Black Press, including the *Minneapolis Spokesman* and the *St. Paul Recorder*. Charles "Teenie" Harris enjoyed a more than thirty-year career with the

popular *Pittsburgh Courier,* known for its documentary photographs and sophisticated marketing finesse around the country. Harris regularly photographed in and around the Hill District of Pittsburgh, capturing the work lives and leisure time of the City of Steel's workers and performers (Pl. 61).

MINING THE ARCHIVE

Several of the artists in the exhibition working in the late twentieth century and today employ what I have called a mnemonic aesthetic practice, mining the archive of historical photographs to create works that relate the past to the present. In many cases, their works are realized as collages that involve multiple photographic images and multiple media. Krista Franklin's *In Hea'bin* (2008) combines loving family portraits (a father and son reading, a young girl, a mother carrying a tray of drinks) with a portrait of Frederick Douglass and images of clouds in a mixed-media collage that serves as a memorial (Pl. 48). Conceptual artist Hank Willis Thomas digitally collaged reporter James "Spider" Martin's documentary photographs of the Selma to Montgomery marches onto mirrored surfaces in *Bury Me Standing* (2016), which invite and demand that viewers see themselves in history and the passing of time (Pl. 102). In other works, Kesha Bruce's *Begotten* (2008), from the series *(Re)calling & (Re)telling*, was inspired by a historical image of enslaved children. In this sepia-toned archival pigment print, the artist reframes the inspirational photograph in the simple shape of a house, which she places on a background with the words from the biblical Book of Matthew, tracing the genealogy of Jesus (Pl. 23).

The works of Thomas and Bruce show how the narrative practice of mnemonic aesthetics frequently uses documentary images precisely to reveal historical truths that impact if not drive social justice movements. In other examples, artists like Nona Faustine and Rashid Johnson use their own bodies, their own portraits, to uncover little known histories or to reify influential historical figures. In Faustine's *Ye Are My Witness, Van Brunt Slave Cemetery Site, Brooklyn* (2018), her body covered only by a white sheath blowing in the wind, she marks this controversial site hidden from history for far too long (Pl. 43). In Johnson's *Self-Portrait with My Hair Parted Like Frederick Douglass* (2003) and others, he reaches back in time to personify great African American leaders from history (Pl. 73).

In other works in the exhibition, historic familial images are centered in works of memorialization honoring ritual practice and generational legacy. For example, Albert Chong's *Miss Peggy* (2015) honors her legacy by decorating her formal studio portrait from the 1950s with purple and white flowers, illuminating family photographs and his

roots in Jamaica with talismanic objects found in nature (Pl. 29). Atlanta-based artist Radcliffe Bailey often incorporates historic family photographs and those that he's collected, notably tintypes and other nineteenth-century processes, in his mixed-media works. In *4*, the upper half of this large-scale mixed-media work reveals the portrait of a woman from a nineteenth-century tintype (Pl. 6). Another work by Bailey titled *Tricky* bears the ghostly figure of a man wearing a top hat looking straight at the viewer through a spiritual haze, projecting the sense of a long-ago memory. Both Chong and Bailey frequently employ ritual practices in their works of photography, installation, and sculpture, whether through the manipulation of the photographic process, use of historic images, or incorporation of other meaningful symbols to create the overall work.

PORTRAITIST = ACTIVIST

A Picture Gallery of the Soul offers a dramatic and joyful survey of African American photography with a special focus on the portrait and its role in identity formation, social change, and community activism. Timely in its mounting, this historical survey shows the lasting impact of some of the nineteenth century's seminal Black photographers and images on its counterparts of the next two centuries, foregrounding the portrait's pivotal role in documenting moments of national reckoning, including the turbulent times in which we live today. For example, Vanessa Charlot's *Love in Struggle* (2020) takes the setting of one of the many Black Lives Matter sit-ins of the last year to zero in on a masked couple taking solace in each other, a handmade "No Justice, No Peace" sign giving way to their sense of purpose (Pl. 28). The work of Mark Clennon in *Untitled* (2020) highlights the intergenerational nature of the ongoing political struggle, documenting the moment for his three-year-old daughter and posterity (Pl. 30).

As Douglass demonstrated in his writings and by his example, to have one's portrait made is a form of self-determination and self-preservation. Armed with cameras in their hands, the Black photographers exhibited here not only document the historical record, they also imbed themselves within it through radical and intentional acts of self-portraiture, as in works by María Magdalena Campos-Pons (Pl. 25), John Pinderhughes (Pl. 84), Coreen Simpson (Pl. 95), and Kwame Braithwaite (Pl. 19). Thus, if a photographic portrait is evidence of humanity's perseverance despite the odds, a testament to having been there, then documentation of Black life and culture—of beauty, triumph, failure, art, music, place, and education—proposes a mode of photographic practice that uses memory as an aesthetic tool, uniting communities, sharing stories, creating possibility, and forging pathways to sustainable Black futures.

NOTE

Epigraph: Frederick Douglass, quoted in John Stauffer, Zoe Trodd, and Celeste-Marie Bernier, *Picturing Frederick Douglass: An Illustrated Biography of the Nineteenth Century's Most Photographed American* (New York: Liveright Publishing Corporation, 2015), 131.

It is with gratitude that I acknowledge the research assistance of Jade Flint, M.A. student in art history, Tulane University, in writing this essay.

CRYSTAL AM NELSON, PH.D.

A VISUAL POLITICS OF BLACK PLEASURE

THE SOVEREIGNTY OF PAIN

Pleasure and joy have rarely figured into the calculus of black life. In America, black life is typically framed by struggle and strife. Indelibly marked by nearly two hundred and fifty years of enslavement, black people, despite being legally emancipated, spent the subsequent decades trying to get free from the confines of white supremacy. Specifically, the time from the end of the Civil War until the civil rights era of the mid-twentieth century is often viewed through the prism of black resistance to subjugation. To be certain, this historical period is defined, in part, by concerted efforts to exclude black Americans from the body politic and restore white dominance. For nearly a century, Jim Crow laws, at both the state and local levels, not only codified U.S. apartheid but also denied black people the right to vote, prohibited them from holding certain jobs, prevented them from accessing public accommodations, and deprived them from attaining an education and taking advantage of opportunities.

Subjected as they were to poor economic conditions, racial oppression, and racial terrorism, Southern blacks began migrating to Northern, Midwestern, and Western metropolises in search of better prospects and better, unfettered lives. In other words, freedom or some semblance of what they believed freedom to be. The first wave of migrants left the South between 1915 and the 1930s, but migration slowed with the onset of the Great Depression. The second wave of migration started in 1940 with larger numbers of migrants pursuing opportunities in the defense industry as the country ramped up for World War II.[1] While in each wave migrants did, indeed, find work, they also encountered de facto segregation and racial terrorism. Housing covenants, major riots against black mobility, racial violence, and the spread of the Ku Klux Klan across the country (1915–40) punctuated black life for the first half of the twentieth century.[2] It may be difficult to imagine the potential for pleasure and joy under these conditions; however, it is important to think of them as critical to black survival.

Throughout this fraught period, a substantial visual discourse coalesced around black pain and black suffering, as well as around black people as caricatures and objects of derision. Though the birth of the visual archive of black suffering predates the invention of photography, the advent of the medium brought a certain scientific absolutism that drawing and painting could not approximate. The epistemological realism of photography was attractive to both practitioners and viewers, and so grew the popularity of the medium as a weapon against the black subject. From J.T. Zealy's daguerreotypes of enslaved Africans to lynching photographs, photography was part of a larger drive to fix the racial status quo in place. Historically, photography was used to subordinate black subjectivity to the black body and, ultimately, the white gaze. However, black people, historically, have produced a photographic counterdiscourse that not only challenged stereotypes but also laid the terrain for new modes of looking at blackness—modes of looking that privileged black subjectivity and resisted subjugation of the black subject. This was particularly evident between the 1940s and 1950s, a period marked by significant changes in photography and visual culture.[3] For black photographers during this time, photography enabled them to craft an image of blackness and black lives willfully unseen at the time. Among the more prominent of these artists are Charles "Teenie" Harris and John Glanton.

"THE NORMALCY OF BLACK LIFE": CHARLES "TEENIE" HARRIS

Charles Harris (1908–1998), affectionately known as "Teenie," was active in Pittsburgh's Hill District, the cultural center of black life in the city.[4] The forties was one of

the most prosperous decades in the Hill's history. Harris captured this thriving community life in his work as the first and only full-time staff photographer for the *Pittsburgh Courier*.[5] Although he worked tirelessly for the newspaper, Harris maintained rigorous studio and freelance practices. Between the paper, the studio, and private work, Harris amassed an archive of nearly eighty thousand images taken in Pittsburgh. He photographed everything in the community from social club meetings to music performances, from church services to nightclubs. Harris was gifted at recording what mattered to black Pittsburghers: the joys and pleasures they found in their everyday lives. He was particularly adept at capturing the bliss of black children at play and just being children. His portrait *1948 City of Pittsburgh Marbles Champion, Howard Hawkins* (1948) exemplifies Harris's primary interest in capturing the easy delight with which children engage the world (Pl. 61). The boy crouching over the marbles is certainly pleased to be the champion, but he is no doubt also happy to be the center of attention and have his picture taken. The other children's wide-toothed smiles and fixated stares, some at Howard and others at the camera, demonstrate the sense of awe that tends to permeate childhood experiences. The children's deportment is important to note. Some lean on one another, others have their hands in their pockets. These are signs that they are relaxed and likely feel safe enough to occupy this public space, congregating for recreation and leisure. The photographer's images of black children engaged in these everyday pleasures render them intelligible as children and worthy of fun. Harris's photographs of children at play are an immensely important form of representation, given that black childhood is "among the most invisible, the most underrepresented and misrepresented, of all."[6]

One can look to more contemporary practitioners to find an ongoing engagement with more sympathetic views of black childhood. Mark Blackshear's *Mirror Reflection and Antics at Our Chinese Take-Out Captured with iPhone SE* (2017) is a whimsical portrait of a young boy wondering at his reflection in a restaurant mirror (Pl. 18). With his eyes wide open and his mouth agape, it is as if he has seen himself for the first time. Where Blackshear's portrait depicts a young boy amid self-surprise, Earlie Hudnall's *The Guardian* (1991) is a deeply touching image of a young girl being kept warm by her father (Pl. 69). The girl's smile expresses a sense of profound pleasure that comes from knowing she is well loved and safe. Taken at the little girl's eye level, the double portrait emphasizes her vulnerability and at the same her father's tenderness as only a child would experience it. Hudnall's photograph challenges prevailing images of the delinquent black child and the absentee black father.

EVERYDAY BLACK LIFE: JOHN GLANTON

John Floyd Glanton (1923–2004) was active in the Twin Cities of Minneapolis and St. Paul, Minnesota, from the late 1940s to about the early 1950s. The Twin Cities contained the largest black populations in the state, where many migrants had fled from the South during the Great Migration. Minnesota has always had a significant but small black presence since the turn of the twentieth century. Between 1940 and 1950, the population jumped from less than 9,000 to 14,022.[7] Black Minnesotan life was heavily inflected by discriminatory practices in housing, labor, entertainment, education, and recreation. Despite the active hostility from the white community and its successful efforts to restrict black residents to specific neighborhoods, black Minnesotans established communities that flourished. Glanton was a first-generation Minnesotan, born in Minneapolis to parents who migrated from Georgia in the early 1900s. He fell in love with photography in high school, where he was a member of the photography club. Unfortunately, upon entering the military, his camera was taken away from him for reasons that are not entirely clear.[8] Nonetheless, upon his return from World War II in the late 1940s, he resumed his practice and opened a professional studio. Like Harris in Pittsburgh, Glanton captured everyday black life in the Twin Cities. More specifically, he documented the quotidian pleasures black inhabitants of Minneapolis and St. Paul were able to create in spite of the social exclusion they suffered. Though Glanton showcased pleasure as part of the visible landscape of Minnesotan black social life, he was particularly gifted at capturing the difficult-to-represent interiority of individual subjects: their joys, desires, pleasures, longings. *Untitled* (1940s) is a captivating portrait of a seated young woman (Pl. 54). Glanton has created a well-considered scene that highlights the woman's class, sophistication, and taste. Sitting in front of what appears to be a 1940s Zenith floor model radio phonograph, surrounded by records, she is having a personal listening party. This image is remarkable for its staging of a simple, private enjoyment of worldly pleasures. At the time, juke joint and jazz club photography was extremely popular. Viewers are accustomed to dramatic photographs of black people enjoying music and swing dancing. These images are rather conventional in their representation of black people but lend themselves to an understanding of blackness as something that is always public, always subject to display. With *Untitled,* Glanton invites viewers to consider the possibilities of what Kevin Quashie calls "wild selffullness, a kind of self-indulgence" in black life.[9]

Much like his forebear, Gerald Cyrus documents the poetics of black mundanity. He particularly highlights the stillness and quiet that moves through and in black life and limns its human dimensions. Most known for his reportage, Cyrus is masterful at cap-

turing the "decisive moment," that rare instance when the black interior is illuminated. *Keith Hoisting Seth, New Orleans* (1992) is a candid image but nuanced in its representation of that private moment a father has with his infant son when he thinks nobody is looking (Pl. 35). Love, happiness, joy, awe, adoration, and respect fill the space between them. Mara Duvra's *Remembering* (2019) shows what quiet can look like in everyday black life when blackness is not limited by the demands for it to resist racism (Pl. 38). The woman's doll face wears a gentle half-smile, drawing viewers into an encounter with the face of the other, prompting a recognition of her subjectivity. This is a meditation on what the poet and essayist Elizabeth Alexander calls "the black interior," that "inner space in which black artists have found selves that go far, far beyond the limited expectations and definitions of what black is, isn't, or should be."[10]

WHAT IT MEANS TO BE ALIVE

Harris and Glanton were prolific photographers, committed to documenting black humanity in its complexity. Each of their oeuvres illuminate the importance of the everyday and the ordinary to black subjectivity. They also bring into full relief the role of pleasure in structuring black social life. If, as Quashie argues, living through pleasure is a human right, then Harris and Glanton provide the evidence of black freedom.[11] When we view their images through this lens, we not only know there is something to live for, we know what it means to be alive.

NOTES

1. William J. Collins, "The Great Migration of Black Americans from the US South: A Guide and Interpretation," *Explorations in Economic History* 80 (April 2021): 101382, n.p. https://doi.org/10.1016/j.eeh.2020.101382; and Marvin E. Goodwin, *Black Migration in America from 1915 to 1960: An Uneasy Exodus* (Lewiston, NY: The Edwin Mellen Press, 1990).

2. John Kneebone, *Mapping the Second Ku Klux Klan, 1915 1940*, from Virginia Commonwealth University Libraries, https://labs.library.vcu.edu/klan/; and Goodwin, *Black Migration in America*.

3. Technological developments in photography included smaller, handheld cameras, flash bulbs, and faster films, which not only offered more flexibility to seasoned photographers but also made the medium more widely accessible. Additionally, a new type of magazine helped define the period through a reliance on photographs more than text to tell the world's news stories. While *Look* and *Life* dominated the mainstream market, black Americans created their own illustrated magazines that responded to and affirmed their concerns and interests. During this period, *Ebony, Our World,* and *Sepia* were founded in close succession to satisfy a growing readership.

4. The phrase "normalcy of black life" comes from Deborah Willis in *One Shot: The Life and Work of Teenie Harris,* directed by Kenneth Love (San Francisco: California Newsreel, 2001), DVD, cited in

Nicole R. Fleetwood, *Troubling Vision: Performance, Visuality, and Blackness* (Chicago: The University of Chicago Press, 2011), 47.

5. The *Pittsburgh Courier* was the largest-circulation weekly black newspaper in the 1940s, with fourteen city editions, including ones for Chicago, Detroit, Philadelphia, New York, and St. Louis.

6. Michael J. Dumas and Joseph Derrick Nelson, "(Re)Imagining Black Boyhood: Toward a Critical Framework for Educational Research," *Harvard Educational Review* 86, no. 1 (Spring 2016): 33.

7. Jennifer Delton, "Labor, Politics, and African American Identity in Minneapolis, 1930–1950," *Minnesota History* (Winter 2001 2): 420.

8. According to Glanton's brother Wayne, black soldiers were prohibited from having cameras, so Glanton's was confiscated upon entering boot camp. However, according to Deborah Willis, most black photographers active during the 1940s learned photography in the military. See *Double Exposure: Images of Black Minnesota; The Photography of John Glanton* (St. Paul: Minnesota Historical Society Press, 2018), xiv, and *Reflections in Black: A History of Black Photographers 1840 to the Present* (New York: W. W. Norton & Company, 2000), 85.

9. Kevin Quashie, *The Sovereignty of Quiet: Beyond Resistance in Black Culture* (New Brunswick, NJ: Rutgers University Press, 2012), 21.

10. Elizabeth Alexander, *The Black Interior: Essays* (St. Paul, MN: Graywolf Press, 2004), 5.

11. Quashie, *Sovereignty of Quiet,* 66.

SEPH RODNEY, PH.D.

WHY WE WEAR A SUIT TO DO THE WORK

MANY YEARS AGO, when I was a student working toward my master of fine arts degree at the University of California, Irvine, a professor said to our class, "Your work has to wear a suit." What he meant, I think, in essence, was that the art we were producing should be finely finished; we were making objects and images for public engagement and, in some way, each piece would stand in for the maker. At the time, this sounded right to me, especially because an aesthetic of elegant execution, clean lines, and well-mitered joints was where I felt most at home.

But favoring this aesthetic is not simply a feature of my character that I share with others; it has something to do with my history, upbringing, and sociopolitical place in the world. I also generally prefer cleaned-up, upmarket attire. What undergirds a feeling that wearing such clothing is the safest way I, as a Black man, can navigate my world can be found in a critical examination of the images featured in *A Picture Gallery of the Soul*. This exhibition includes several photographic images of Black men, which,

taken together, suggest that something important informs their public presentation of themselves in suits. Here, civil rights warriors, working-class men, the photographers themselves, and even children are dressed this way, or in the adjacent ensemble of jackets and ties, to reveal an unspoken precept: to accomplish certain work, or to be seen as capable of this work, a Black man in the United States of America often "has to wear a suit."

There are several images in the exhibition of Black men wearing what we term "business attire." There is C. M. Battey's photograph of Frederick Douglass, who, being the most photographed American of the nineteenth century, would of course be included. Douglass, a former enslaved person and an unwavering crusader for the abolitionist cause, strenuously advocated for using the photographic image as a tool for affirming the humanity and inherent dignity of Black people. In all the images I have ever seen of Douglass, including Battey's own, he is wearing a collared shirt, a tie, and a coat (Pl. 12). In *Marcus Garvey Giving Farewell Address Minutes Before Deportation from the United States* (1927), the photographer Arthur P. Bedou presents another famous freedom fighter in the formal, tailored, business regalia of the time. Garvey is leaning on a railing as he addresses a crowd, clothed in a suit, shirt, and tie, topped with what looks like a bowler hat, and a quarter inch of white sleeve cuff peeking out from his jacket (Pl. 15).

In Walter Griffin's *Civil Rights March* (1990), one can see the Reverend Jessie Jackson at the center of a phalanx of civil rights activists preparing to start the demonstration. Most of the men who are leading the protest (and thus serve as the most visible representations of the movement for social justice) wear suits with collared shirts and ties. Jackson's jacket is even buttoned at the front (Pl. 58). Rashid Johnson replicates this visual trope in his *Self-Portrait with My Hair Parted Like Frederick Douglass* (2003) (Pl. 73). Ozier Muhammad's image of the back of the then Chicago senator, and later U.S. President, Barack Obama, and Harry Shepherd's portrait of lawyer and civil rights advocate Frederick (or Fredrick) L. McGhee, show the men also in these trappings (Pls. 79, 94). The male photographers Kwame Brathwaite, Robert H. McNeill, and Addison N. Scurlock—when they come out from behind the camera—also wear these costumes (Pls. 19, 78, 91). The male children follow suit. (In contrast, the female photographers Barbara DuMetz and Coreen Simpson do not wear business clothing [Pls. 37, 95].) Lucius Harper's *Lucius Harper Jr., Off for School* (ca. 1910) and Al Fennar's *Straight Street* (1965) show boys mimicking the styles of high-end dress that their fathers or other role models have represented (Pls. 60, 45). Even in the portraits where the men are not central, such as Florestine Perrault Collins's undated *Family Portrait,*

in which the mother is the principal figure, the men are dressed up in well-tailored jackets and carefully styled ties (Pl. 32).

This recurring motif can't be due to happenstance. Rather, the curators of *A Picture Gallery of the Soul* recognize that these images have everything to do with the current social reality in which Black men find themselves: we are confronted by others, particularly White men and women, who are consciously and unconsciously impelled by fear, loathing, desire, and awe of our bodies, along with the urge to touch, explore, dominate, and be dominated by us. There are complex, intertwined, and overlapping reasons that Black men—when the occasion does not strictly require it—choose to wear suits. The wearing of the suit indicates our social status; it tells others we have the means to purchase this clothing, and that we have some measure of personal success.

For several years, beginning in 2002, I worked as a salesperson in upscale clothing retail, much of this time spent selling suits for Hugo Boss and, later, Emporio Armani. The thing about a suit of clothing (the term derives from the French *suite,* which means following, because the constituent garments follow each other) is that it can be transformative. I often dealt with men who came into the store wearing casual clothing. The difference between how they looked when they had tried on a suit and how they looked previously was consistently striking. A properly tailored suit confers competence and sophistication on the wearer—partly because it is, itself, a garment that requires competence and sophistication to be properly made. A well-made suit costs a good deal of money because it requires time, attention, energy, and specialty knowledge. Seeing a man so outfitted encourages us to think that he also has high value. Because of this homology, even though I was earning a salary that barely placed me in the middle class by U.S. standards and I held no real authority, I felt pride in wearing my suits.

Wearing a suit also indicates that we are willing to play the roles that men in suits play. We are not only less physically threatening—it's more difficult to have a full range of upper body motion while wearing a jacket—but we are also signifying that we are prepared to act in prescribed ways. If we are to accomplish any work, it will be intellectual labor, or the labor of pedagogy, knowledge organization, public speech, or other so called white-collar activity. We dress in suits to indicate our ability and preparedness to carry out sophisticated cognitive tasks.

Nevertheless, for the Black men depicted in this exhibition, as well as for the image makers (whether seen or not), there is a certain kind of labor in which both are engaged. It is essentially the same labor that Frederick Douglass was engaged in more

than a century ago: contending that Black men are as valid as any other members of American society and that we deserve to share in all the opportunities, consideration, and privileges that devolve to other members. The labor here is the work of representation. What's revealed in this exhibition that is surprising is that within this ongoing and seemingly endless struggle for equity, one front of which is synecdochical representation, the terms have shifted since the Civil Rights Movement. Now, Black male bodies have a crucial weight without the suit.

Look at the images in which Black men are naked from the waist up: Mark Clennon's *Untitled* (2020), Cyndi Elledge's *Facing Change: Davonte* (2016), and Nancy Musinguzi's *Son of Sons* (2020) (Pls. 30, 41, 80). Two of the men featured are engaged in organized protest work, and their bodies look to me as no less crucial than the besuited bodies of the movement to end the systemic injustice and inequity meted out to Black people, other people of color, and women. In the post–Civil Rights Movement era, the consistent push by photojournalists and visual artists to represent Black working-class people and those at the margins of society not as martyrs, aberrations, or failures, but as full human beings, has made it possible to see these bodies both as vulnerable and as rightful heirs to the concessions won through the brutal and protracted contests of the movement.

And in a complex turn, within the past generation hip-hop has saturated popular culture with its proclamation of the stories of poor and working-class people who have inherited a set of circumstances that they refuse to blithely accept. While hip-hop has erred in also valorizing misogynist and violent behavior, along with a certain idealized notion of success that is too weighted toward ostentatious displays of wealth, it has helped to make a more casual appearance one that is typically associated with distinguished and renowned Black men. Images of Black male celebrities, artists, patrons, and benefactors in informal clothing has served to uncouple business attire from previous notions of masculine validity and propriety.

The collection of images here gives me even more hope than these sociohistorical changes. In images such as Dudley Edmondson's *African American Mountaineers in Alaska* (2012), the clothing is neither ordinary nor business attire, but specific to their profession as mountaineers (Pl. 40). These men are not as concerned with representation as they are with doing what they do competently and safely. They are not dressing to impress the viewer or argue for their competence; they simply proceed from that place of competence. And then there is the image by Gerald Cyrus, *Keith Hoisting Seth, New Orleans* (1992), which shows a man in casual clothing, signifying neither a professional affiliation nor a concern with the classifying gaze of the viewer (Pl. 35). He is

simply playing with a small child, his own gaze on the toddler, his hands holding the boy in intimate care. This is what a post–white supremacist promised land might look like: laying down the burden of having to constantly work to demonstrate that we are able and responsible, and that we legitimately belong in this culture at every rung and echelon. This promised land looks like leisure. Black men don't fully escape the classifying gaze; it's just no longer able to tell us who we are.

Salimah Ali

I am the photographer, the artist, and the vehicle that captures moments in life and time exactly as they are and as they will remain in that image. —Salimah Ali

———————————

Born in Harlem, New York, Salimah Ali has always possessed the spirit of creativity. Her father was an oil painter for as long as she can remember. Her work has been included in numerous gallery and museum exhibitions, including at The Studio Museum in Harlem, Brooklyn Museum, Tweed Gallery, Soho Photo Gallery, Jamaica Center for Arts and Learning, Michael Schimmel Center for the Arts, Schomburg Center for Research in Black Culture, Aperture Gallery, and Kenkeleba House in New York. She is the winner of the first Shahin Shahablou Photography Award in London. Since 2005 Ali has been a member of Kamoinge, Inc., the historic collective of African American photographers established in 1963. Ali's work has been widely published, including in *Black Enterprise, Essence, Los Angeles Times, Ms., New York Times, Newsday, New York Magazine, USA Today,* and *Washington Post.* Works by Ali are included in numerous books, including *Viewfinders: Black Women Photographers, The Encyclopedia of Black Women in America, Committed to The Image: Contemporary Black Photographers, Reflections in Black: A History of Black Photographers 1840 to the Present, The Face of Our Past: Images of Black Women from Colonial America to the Present, Timeless: Photographs by Kamoinge,* and *MFON: Women Photographers of the African Diaspora.*

PLATE 1

Salimah Ali (born 1954). *Dare (Portrait of Ugochi Egonu),* 2019. Pigmented inkjet print, image 20 × 13⅜ in. (50.8 × 34 cm), sheet 22 × 15⅜ in. (55.9 × 39.1 cm). Courtesy of the artist.

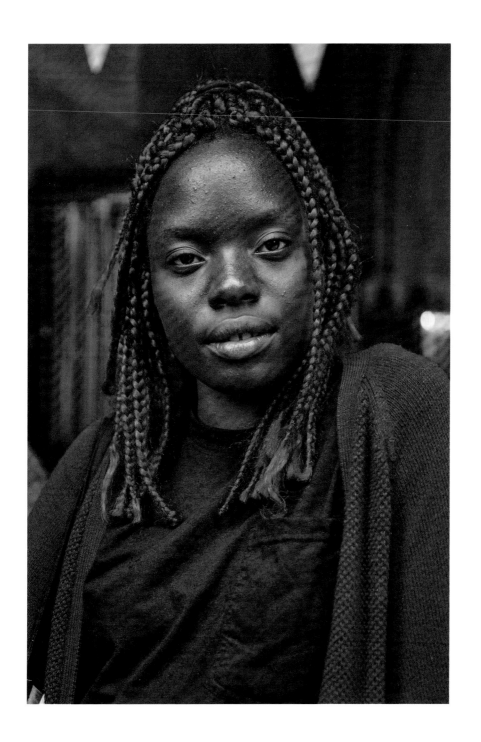

Devin Allen

My legacy is love where you're from and if you want to make change and make Baltimore a better place for our kids, we have to do the leg work. I'm proud to be from Baltimore. I want everyone else to feel proud. It's a place that's still thriving and we don't lay down. —*Devin Allen*

———————————————

Devin Allen is a self-taught artist, born and raised in West Baltimore. He gained national attention when his photograph of the Baltimore Uprising was published on the cover of *Time* in May 2015, only the third time the work of an amateur photographer had been so featured. Five years later, in June 2020, his photograph of a Black Trans Lives Matter march was also featured on *Time*'s cover. His photographs have also appeared in *New York Magazine,* the *New York Times,* the *Washington Post,* and *Aperture,* and are in the permanent collections of the National Museum of African American History and Culture; Reginald F. Lewis Museum, Baltimore; and The Studio Museum in Harlem. Now known as a professional photographer, he is the founder of Through Their Eyes, a youth photography educational program. Allen was the first winner of the Gordon Parks Foundation Fellowship in 2017.

PLATE 2

Devin Allen (born 1988). *Untitled,* 2015. From the series *A Beautiful Ghetto.* Pigmented inkjet print, image 24 × 36 in. (61 × 91.4 cm), sheet 26 × 38 in. (66 × 96.5 cm). Courtesy of the artist.

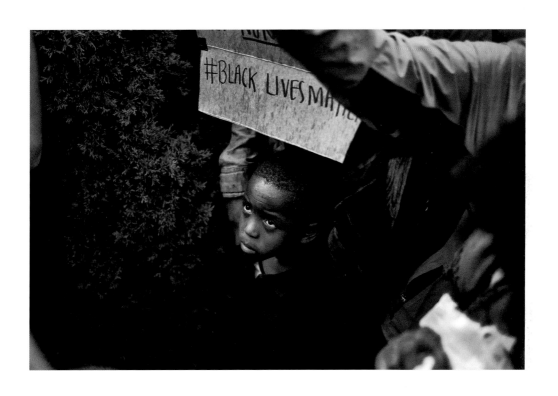

The Rev. Henry Clay Anderson

Making pictures is like telling a story, and you've got to tell the whole story.
—The Rev. Henry Clay Anderson

———————————

Beginning in the late 1940s, the photographer H.C. Anderson recorded an insider's picture of black life in the city of Greenville, Mississippi, during the era of segregation. Seen through Anderson's lens, Greenville is a place of spirit and resolve—a community where the black middle class refused to be defined and held captive by the systemic injustice and racial stereotypes of the time. Anderson's Photo Service photographed individuals, families, and groups at schools, events, and businesses. His portrayal makes possible a deeper and more nuanced understanding of African American life in the Deep South.

Henry Clay Anderson was born in 1911 in Nitta Yuma, Mississippi. He died in Greenville in 1998. Apart from service in World War II and two years of study in Baton Rouge, Louisiana, he spent his life in the Mississippi Delta. A teacher, minister, and Mason, he brought to his work a deep spirituality, a commitment to social service, and a quiet but fervent political activism. With his wife, Sadie Lee, and daughter helping to run the business, Anderson captured the dignity, integrity, and depth of black Greenville for three decades. In his hands, the camera was a tool to advance a strategy for racial pride.

The H.C. Anderson Collection at the Smithsonian National Museum of African American History and Culture contains more than four thousand images of Greenville and wider Mississippi. Black photography studios like Anderson's played an integral role in shaping how African Americans pictured themselves and their communities in the nineteenth and twentieth centuries.

PLATE 3

The Rev. Henry Clay Anderson (1911–1998). *Indoor Portrait of a Child Leaning against a Radio, Ruby Washington,* 1948–70s. Digital copy of silver and photographic gelatin on acetate film, 5 × 4 in. (12.7 × 10.2 cm). Collection of the Smithsonian National Museum of African American History and Culture. Copyright Smithsonian National Museum of African American History and Culture. 2007.1.69.6.8.D.

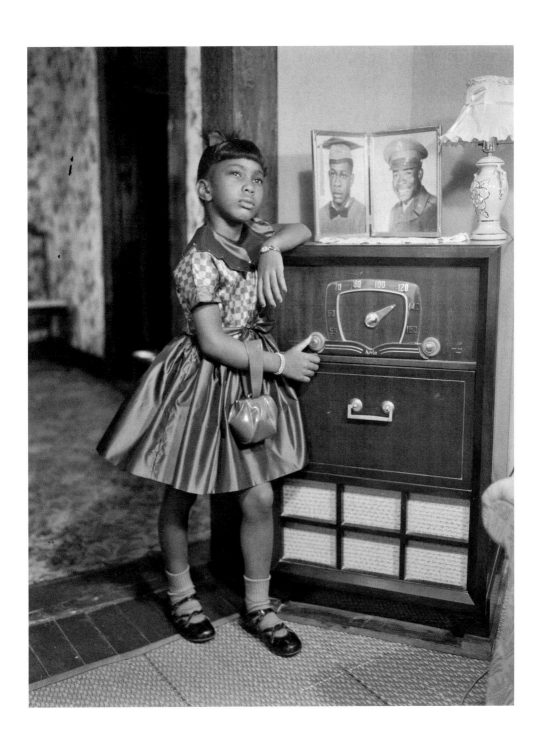

Jean Andre Antoine

My style of photography bridges concepts that are seemingly at odds with one another: classic cameras and contemporary subjects, both street vendor and fine artist, and access to today's "unlimited content" with a finite supply of discontinued film. Eight years ago, under the mentorship of Louis Mendes, I devoted myself to the bygone art of analog instant film photography. Each day since, I've reported to the same location in Soho where I sell portraits to passersby while also expanding my collection of street photography—recording the intrinsic character of New York City shot by shot. Due to the increasing scarcity of the discontinued film, I need to make every shot worthwhile. My analog style is a subtle rebellion against the unceasing wave of new technology. While society is in the crux of a digital revolution, I try achieving a sense of timelessness by framing contemporary subjects in the gaze of my classic camera.—*Jean Andre Antoine*

Harlem-born Jean Andre Antoine is an analog street photographer in New York City. He works daily from his "office" on the corner of Prince and Broadway capturing portraits of passersby on instant film. Antoine also produces editorial and commercial work in both instant and 35mm film format, and exhibits his original instant photographs, fine prints, and installations. Each of his photographs are one-of-a-kind and carry a story from the moment they enter materiality. The faded film, erosion, and marks on the photographs may point to the expiration of the vintage film or the moments Antoine traveled around the city with them, sometimes taping them to the wall of his "office" on the street corner.

PLATE 4

Jean Andre Antoine (born 1983). *Drummer,* 2017. Polaroid film 667, expired 2003/discontinued, 3⅜ × 4¼ in. (8.5 × 10.8 cm). Courtesy of the artist.

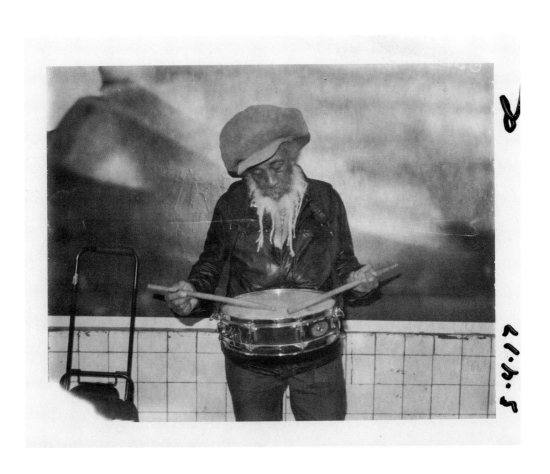

Thomas E. Askew

Thomas E. Askew's early life is not well-documented. It is believed he was born into slavery. In the 1880s he was employed at the C.W. Motes photographic studio as a printer at a time when the studio produced a portrait of the Atlanta lawyer and future President Woodrow Wilson. In 1896 he and his family moved to a home and studio at 114 Summit Avenue in that city, where he made the beautifully composed photograph *Summit Avenue Ensemble*. Askew produced a number of photographs that were included in *Types of American Negroes, Georgia, U.S.A.* and *Negro Life in Georgia, U.S.A.*, compiled by Thomas Calloway, W.E.B. Du Bois, and Daniel Murray for the Paris Exposition Universelle in 1900. Askew's contribution was more widely recognized through the research and publication in 2003 of *A Small Nation of People: W.E.B. Du Bois and African American Portraits of Progress* by David Levering Lewis and Deborah Willis.

PLATE 5

Thomas E. Askew (ca. 1850s–1914). *Daughter of Thomas E. Askew,* 1899 or 1900. Digital copy of gelatin silver print, image 9 × 13 in. (22.9 × 33 cm), sheet 12 × 16½ in. (30.5 × 41.9 cm). W.E.B. Du Bois albums of photographs of African Americans in Georgia exhibited at the Paris Exposition Universelle in 1900. Daniel Murray Collection, Library of Congress Prints and Photographs Division. LC-USZ6–2232.

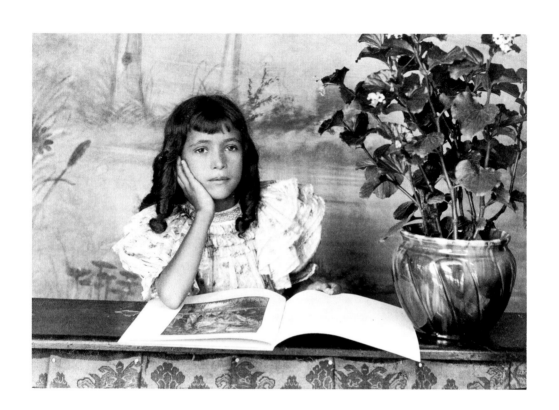

Radcliffe Bailey

One Christmas when all my family members were together my grandmother gave me a photo album of family members. It was photographs and tintypes. That was one of my biggest influences.
—Radcliffe Bailey

Work by Radcliffe Bailey has been shown in numerous one-person exhibitions, including *Vessel III*, at The Aldrich Contemporary Art Museum, Ridgefield, CT (2019); *Pensive*, Gibbes Museum of Art, Charleston, SC (2018); and *Radcliffe Bailey: Memory as Medicine*, High Museum of Art, Atlanta (2011). Bailey has been included in many group exhibitions, including *Emerge Selections*, Museum of Contemporary Art Chicago (2020); *Afrocosmologies: American Reflections*, Wadsworth Atheneum Museum of Art, Hartford, CT (2019); and the *16th Istanbul Biennial* (2019). His work is included in numerous collections, including the High Museum of Art, Atlanta; Metropolitan Museum of Art; Montreal Museum of Fine Arts; The Studio Museum in Harlem; and the Virginia Museum of Fine Arts. Bailey was born in New Jersey. He lives and works in Atlanta, where he received a B.F.A. from the Atlanta College of Art.

PLATE 6

Radcliffe Bailey (born 1968). *4*, 2012. Archival pigment print, lithograph, collage, 51 × 36 in. (129.5 × 91.4 cm). Edition of 8. Courtesy of Island Press, Sam Fox School of Design & Visual Arts, Washington University in St. Louis.

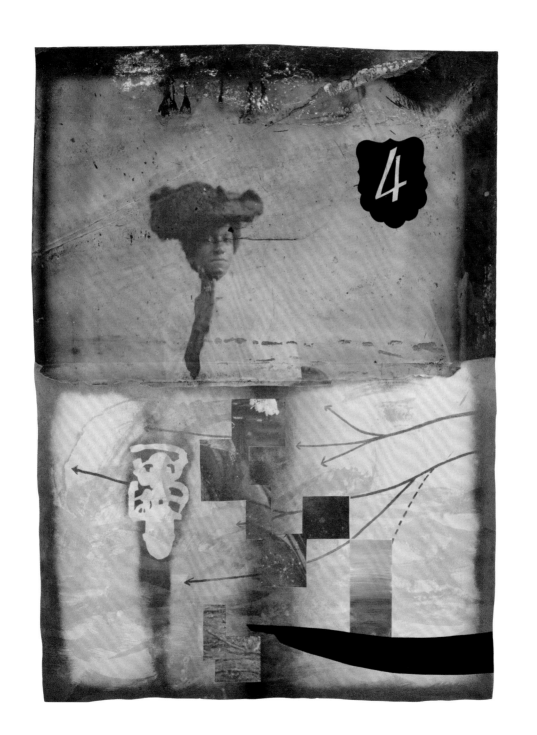

James Presley Ball

James Presley Ball was born in Virginia in 1825 to Susan and William Ball, free persons of color. It is believed that he learned daguerreotype from John B. Bailey, a Black photographer active in Boston in the 1840s. Over the course of his long career, Ball traveled throughout the United States, operated numerous photography studios, and made hundreds of daguerreotypes and photographs. His earliest success was in Cincinnati in the 1850s, where he founded "Ball's Great Daguerrian Gallery of the West," employed a sizable staff, and prospered. In the late 1860s Ball experienced financial difficulties, and in 1871 he left Cincinnati. For the next several years he lived and worked in Mississippi, Louisiana, and Missouri. In 1887 Ball moved to Minneapolis and opened a studio at 221 Nicollet Avenue. While briefly working there he was chosen as the official photographer for the 25th anniversary celebration of the Emancipation Proclamation. Later that year Ball moved to Helena, Montana Territory, where he ran a successful studio. In 1900 Ball followed his son J. P. Ball, Jr., to Seattle in the Western Territory of Washington, where they operated two studios. Finally, Ball moved to Honolulu where he opened a studio in his home. J.P. Ball died on May 4, 1904, at the age of seventy-nine, in Honolulu.

PLATE 7

Ball & Thomas, Photographers (1874–77). *Mattie Allen,* 1874–77. Digital copy of carte de visite, 4¼ × 2¼ in. (10.8 × 5.7 cm). Cincinnati Museum Center History Library and Archives. Ball and Thomas Photograph Collection (SC#17–005).

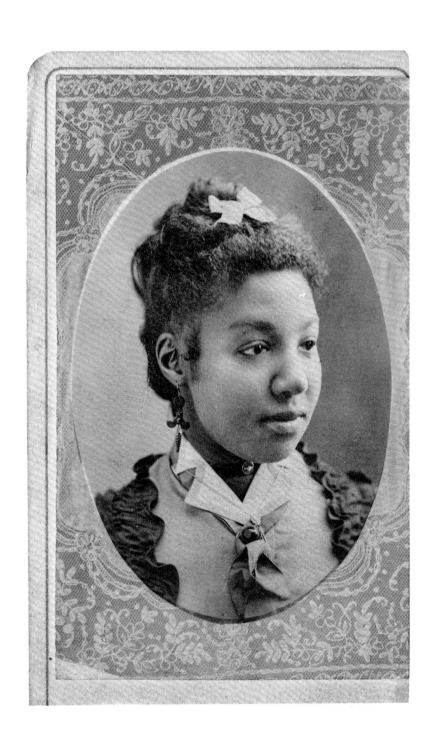

John L. Banks

Now the reason I try to get involved in these things was that Blacks out there were not accepted when I went out there. And I just wanted to show them, by golly, that we could do these things the same as they did.—John L. Banks

——————————————

John L. Banks was born in Dyersburg, Tennessee. In 1923 he moved to Northfield, Minnesota, and in 1926 he settled in St. Paul. He pursued his interest in photography while employed at the Ford Motor Company. He was president of the Camera Club organized by employees at the Ford plant and organized an exhibition of the club members' work. Banks was active in the Black community of St. Paul; he served on the boards of a local credit union and the Crispus Attucks Home, and volunteered with the N.A.A.C.P. Banks continued his practice of photography in retirement, experimenting with color into his late sixties. The John L. Banks Photograph Collection at the Minnesota Historical Society spans 1927–65 and includes views of friends, dances, parties, picnics, fishing, hunting, boating, swimming, golf, tennis, skiing, the Credjafawn Social Club, and the Credjafawn Co-op Store.

PLATE 8

John L. Banks (1907–?). *Corabelle Banks,* ca. 1955. Digital copy of photograph, 7 × 5 in. (17.8 × 12.7 cm). Minnesota Historical Society. por 13975 r2.

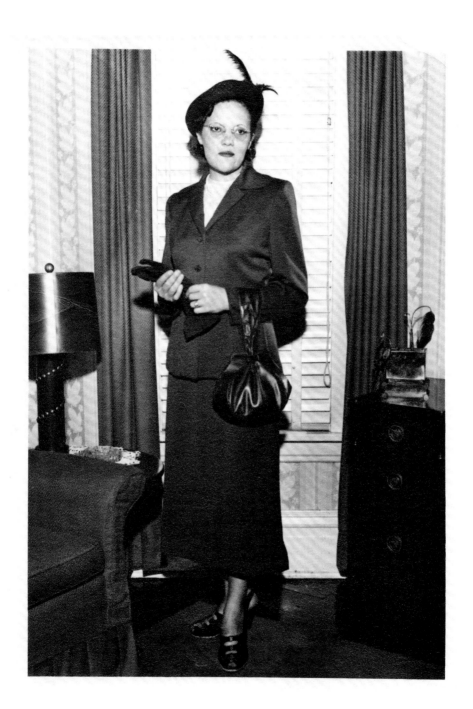

Anthony Barboza

Images embody what we endure throughout our lives with the spiritual pulse of our ancestors' collective past. —Anthony Barboza

Anthony Barboza's sixty-year career began with the Kamoinge Workshop in 1963. His portrait photography reads like a Who's Who of Black American culture: James Baldwin, Romare Bearden, Aretha Franklin, and other notable subjects. Barboza's work is included in numerous museum collections, including the Boston Museum of Fine Arts, Museum of Modern Art, and Smithsonian National Portrait Gallery.

PLATE 9

Anthony Barboza (born 1944). *Requiem of Rain,* 2014. Pigmented digital prints, each image 16 ¼ × 23 in. (41.3 × 58.4 cm), each sheet 20 × 24 in. (50.8 × 61 cm). Courtesy of the artist.

Captions corresponding to photographs in plate 9:

1 Rain Pravato, 12/11/65. My mother named me "Tinker"—I was always tinkering around, getting into mischief.

2 I saw into the future two years ahead that I would have a daughter.

3 Italian, French, Black. I stand for what is the future of mankind divided only by those who believe that to be different from others is to be weak of mind and body. Every generation has a Joan of Arc.

4 Bosco and I loved to hear Mommy read, but our favorite was Ms. Mary Mac all dressed in black with silver buttons all down her back.

5 Rain Pravato #35364439. Cancer discovered August 3, 2012. Today November 12, 2013, 4 months remission. Age before cancer 46. Women that inspire me—Eartha Kitt, 1st Lady Michelle Obama, Rosa Parks.

6 "My mission in life is not merely to survive, but to thrive; and to do so with some passion, some compassion, some humor, and some style." Maya Angelou

7 My fantasy is to surround myself in Baby Blue Silver Light, to protect me, and dance with my enemy "Cancer." The Big Bad "Monster" and live a long, beautiful, colorful, and fruitful life, to have tears of joy, not sorrow. And grow old happily and healthy with my daughter.

Rain Pravato Critz lost her battle with cancer, June 4, 2014.

Rain Passed on June 4, 2014

Ronald Barboza

The body and soul of my work focuses on bringing to life the story of Cabo Verde and Cape Verdeans. I have dedicated nearly fifty years to the pursuit of documenting my Cape Verdean roots and capturing our story for the world to see. Photography, like love and laughter, is a language of the world and I am proud to use it to share the beauty of Cabo Verde.—Ron Barboza

Ron Barboza has photographed and documented not only the islands of Cabo Verde, but also prominent Cape Verdean communities throughout the world. Between 1976 and 2018, he photographed Cabo Verde, visiting all of its islands on seventeen occasions. His work has been shown in numerous expositions and exhibitions, including *Expo-92 World's Fair*, Seville (1992); *Mamae-Terra, Artistes due Cap Verte*, Paris (1993); *Mostra De Arte Cabo Verdeana*, Lisbon (1994); *Culturfest Caixa Geral de Depositos*, Lisbon (1994); Smithsonian American Folk Life Festival, Washington, DC (1995); *Committed to the Image: Contemporary Black Photographers*, Brooklyn Museum (2001); *A Man and His Journey: Recent Tributes to President Aristides Pereira*, Embassy of Cape Verde, Washington, DC (2012); *With The Wind At Our Backs*, Palácio da Cultura Ildo Lobo, Praia, Cape Verde (2013); and *Visual Music*, Câmara Municipal da Praia, Cape Verde (2014), as well as the Peabody Museum of Archaeology and Ethnology, Cambridge, MA; Schomburg Center for Research in Black Culture; Rhode Island College; and Rhode Island Black Heritage Society.

PLATE 10

Ronald Barboza (born 1946). *A Youth Remembered (Damaio da Silva Gonsalves, Holding a Portrait of Himself)*, 1986. Pigmented inkjet print, image 15 × 22 in. (38.1 × 55.9 cm), sheet 20 × 24 in. (50.8 × 61 cm). Courtesy of the artist.

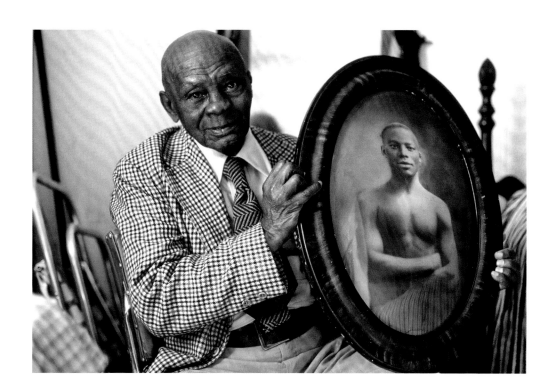

Miranda Barnes

I've been thinking of the rural and suburban black communities and how often redlining gets pushed aside during the conversations we are currently having. While Nassau County is no way near as isolating as other regions, systemic racism through zoning is a calculated form of oppression in Long Island, and I wanted to try and capture that isolation. —*Miranda Barnes*

Miranda Rae Barnes is a Caribbean American photographer. She was born in Brooklyn in 1994 and raised in Long Island, New York. She received her bachelor of arts in humanities and justice from John Jay College of Criminal Justice in New York City. She is a Scorpio and a N.Y. Mets fan. She currently lives and works in Brooklyn and Central Texas.

PLATE **11**

Miranda Barnes (born 1994). *Self-Portrait,* 2020. Fiber print, image 18 × 18 in. (45.7 × 45.7 cm), sheet 24 × 20 in. (61 × 50.8 cm). Courtesy of the artist.

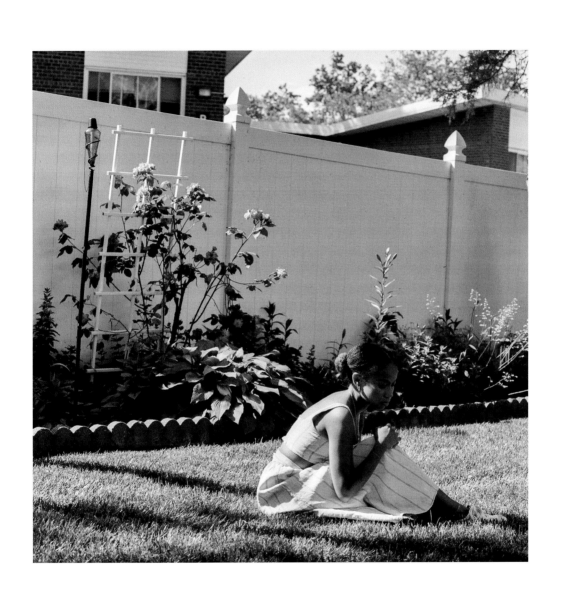

C.M. (Cornelius Marion) Battey

C.M. Battey was born in Augusta, Georgia. He moved to Cleveland and then New York, worked in several photographic studios, and established the partnership Battey and Warren. Battey's portraits were widely published, including cover images for *The Crisis*, the magazine published by the National Association for the Advancement of Colored People; *The Messenger*, a magazine associated with the Harlem Renaissance; and *Opportunity: A Journal of Negro Life* published by the National Urban League. Battey's portrait of W.E.B. Du Bois, made in 1918, is an iconic image. Battey replaced Arthur P. Bedou as the official photographer at the Tuskegee Institute and in 1916 he became head of its new Photography Division, which he led for the rest of his life. One of his students, P.H. Polk, joined the faculty in 1928 and later became head of the program.

PLATE 12

C.M. (Cornelius Marion) Battey (1873–1927). *Frederick Douglass* (1818–1895), 1893. Digital copy of silver and photographic gelatin on photographic paper, 9 × 7⅛ in. (22.9 × 18.1 cm). Collection of the Smithsonian National Museum of African American History and Culture. 2009.37.1.

Frederick Douglass was portrayed by four African American photographers: J.P. Ball (1867, Cincinnati, OH), James Hiram Easton (1869, Rochester, MN), C.M. Battey (1893, New York, NY), and James Reed (1894, New Bedford, MA). Battey was just twenty when this portrait was made; Douglass was seventy-five.

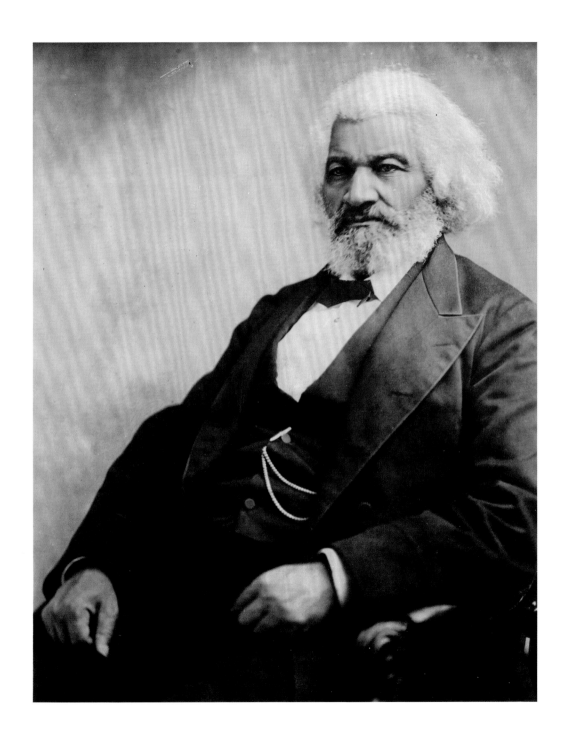

James "Jimmy" Baynes

Jimmy Baynes's beautiful 4x5 portraits of ladies out for a night on the town in early 1960s Cleveland were deceivingly modest.—*Andrew Garn*

James Hamilton Baynes, Jr., was born in Cleveland. He worked as a railway postal clerk and operated the Baynes Foto Service at 2220 East 87th Street. For years Baynes documented Black life and culture of Cleveland's east side. His work was widely published in the African American press, including the *Call and Post*. Baynes photographed many musicians who performed in Cleveland from the 1940s into the 2000s, including Louis Armstrong, Aretha Franklin, Mahalia Jackson, and Memphis Slim. The Rock and Roll Hall of Fame Library and Archives at Cuyahoga Community College in Cleveland is home to the Jimmy Baynes Collection, spanning works from 1953 to 1983. In the summer of 2010, just prior to his death in September of that year, works by Baynes were included in the exhibition *Polaroid: Instant Joy* at the A.M. Richard Fine Art Gallery in New York, alongside photographs by Chuck Close, Sally Mann, and William Wegman. In 2018 the Oberlin College Libraries presented an exhibition of photographs by Baynes, drawn from the James and Susan Neumann Jazz Collection.

PLATE **13**

James "Jimmy" Baynes (1922–2010). *Well-Dressed Trio,* ca. 1950s. Gelatin silver print, 10 × 8 in. (25.4 × 20.3 cm). Collection of Anna R. Igra and Howard Oransky.

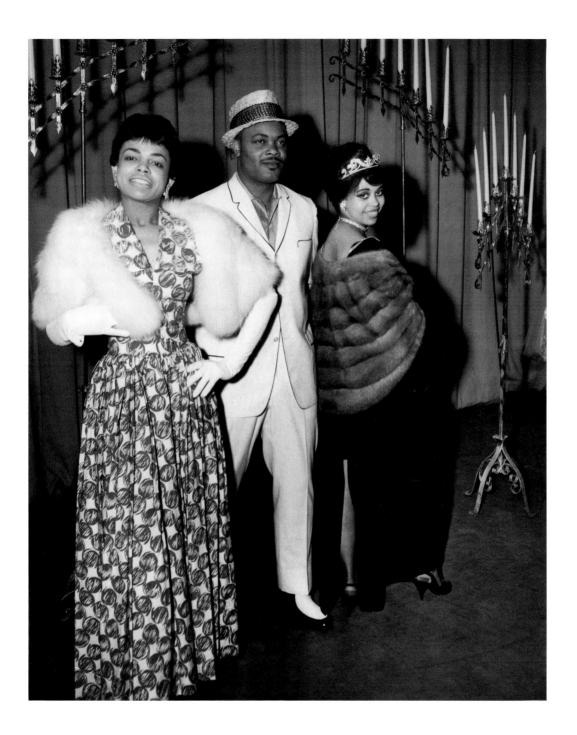

Endia Beal

Endia Beal is a North Carolina–based artist, curator, and author. Beal's work merges fine art and social justice. She uses photography and video to reveal the often overlooked and unappreciated experiences unique to people of color. Beal's first monograph, *Performance Review,* brought together work over a ten-year period that highlighted the realities and challenges for women of color in the corporate workplace. Beal's work has been exhibited at the Nasher Museum of Art, Durham, NC; Charles H. Wright Museum of African American History in Detroit; and Aperture Foundation in New York City. Beal's photographs are included in private and public collections, such as The Studio Museum in Harlem; Museum of Contemporary Photography at Columbia College Chicago; and Portland State University, OR. Endia Beal holds a dual B.F.A.-A.H. in art history and studio art from the University of North Carolina at Chapel Hill and an M.F.A. from Yale University.

PLATE 14

Endia Beal (born 1985). *Rev. Dr. William J. Barber II,* 2020. Archival pigment print, 63 × 42 in. (160 × 106.7 cm). Courtesy of the artist.

This portrait was made at Pullen Memorial Baptist Church in Raleigh, North Carolina, on January 27, 2020, before a backdrop showing the North Carolina House of Representatives chamber, where the Rev. Dr. William J. Barber II was arrested in 2011. The photograph was included in the March 2 issue of *Time* ("The Equalizers") and *Time*'s Best Portraits of 2020.

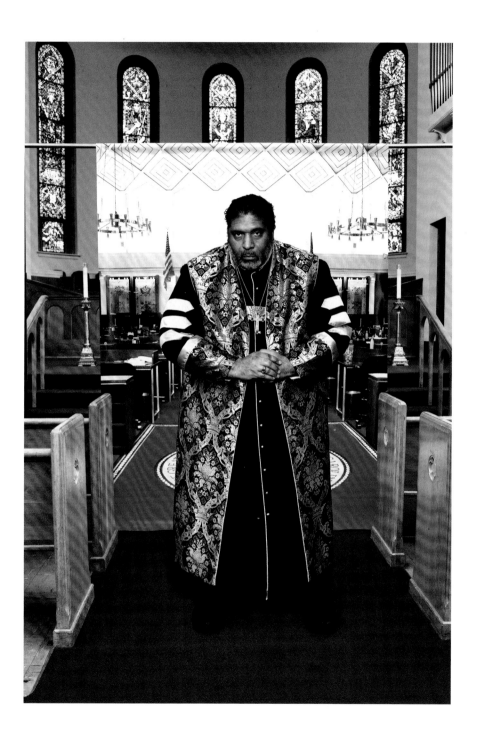

Arthur P. Bedou

Arthur P. Bedou was for a time the personal photographer of Booker T. Washington and extensively documented the last decade of Washington's life. Most of Bedou's photographs of Washington were taken between 1908 and 1915, the year of Washington's death. His position brought him further commissions to photograph other notable figures, including George Washington Carver, Theodore Roosevelt, Andrew Carnegie, and Julius Rosenwald. In the 1920s, Bedou opened his own studio in New Orleans, where he photographed everything from Black families and their children to the laying of the cornerstone at Corpus Christi Church, to the visits of jazz bands and celebrity speakers. His photographs appeared often in both the *Louisiana Weekly* (a newspaper with a primarily Black circulation) and the general-circulation newspaper *Louisiana Times-Picayune*. He was also very much in demand by Black colleges, such as Xavier University of Louisiana, Fisk University, Wiley College, and the Tuskegee Institute to document life on their campuses, and by professional organizations such as the National Negro Business League, the National Medical Association, and the National Baptist Convention. He won several awards, including the Gold Medal at the 1907 Jamestown Tercentennial Exposition.

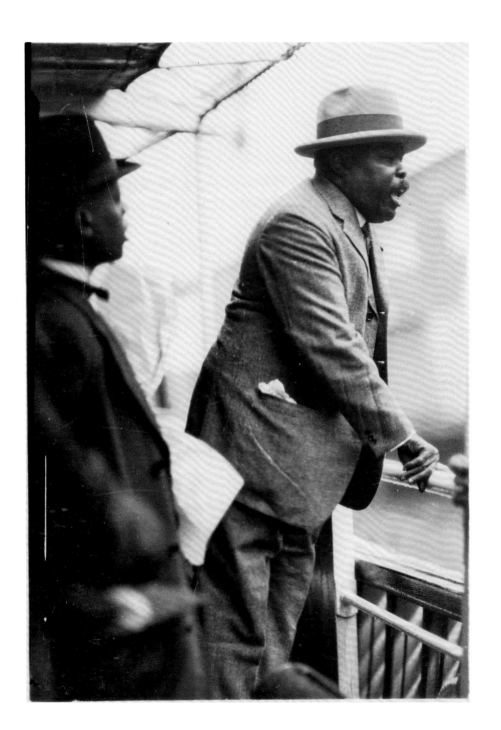

Hugh Bell

I'd like to show what race consciousness means through pictures.—Hugh Bell

————————————

Hugh Cecil Bell was born in Harlem to parents from the Caribbean island of St. Lucia. As a young man he first attended City College, later graduating with a degree in journalism and cinematic art from New York University in 1952. That same year Bell shot his first of many legendary photographs of jazz greats, *Hot Jazz*. In 1955, Edward Steichen selected *Hot Jazz* for the groundbreaking exhibition *The Family of Man* at the Museum of Modern Art. More than two million photographs were submitted, but only 503 were selected. The exhibition showcased work from 273 photographers, including Dorothea Lange, Irving Penn, and Edward Weston. During the 1950s, Hugh Bell frequented all the top jazz clubs in New York City, such as the Village Gate, Open Door Café, and Circle in the Square. He encountered and photographed many legendary musicians, including Louis Armstrong, Billie Holiday, Thelonious Monk, Charlie Parker, and Sarah Vaughan. These photographs were known collectively as the *Jazz Giants* series. In 2016, nine of these photographs were loaned to Harvard University for the exhibition *Art of Jazz: Form/Performance/Notes*. Also that year, the U.S. Postal Service issued the Sarah Vaughan stamp as part of its *Music Icons* series. The stamp, designed by Ethel Kessler, features an oil painting by Bart Forbes based on this 1955 photograph. In 2020, the Smithsonian National Museum of African American History and Culture acquired a gelatin silver print of *Sarah Vaughan* for its permanent collection.

PLATE 16

Hugh Bell (1927–2012). *Sarah Vaughan,* 1955. Lifetime gelatin silver print, 24 × 20 in. (61 × 50.8 cm). Copyright The Estate of Hugh Bell. Courtesy of Gartenberg Media Enterprises.

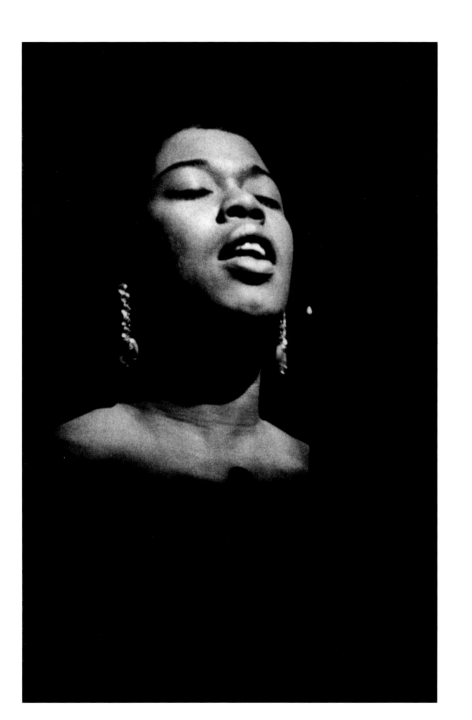

Dawoud Bey

The gaze of the subjects toward the lens signified, to me, a gaze of reciprocation: an awareness of the attention being directed at them and an attendant decision to acknowledge that by returning the gaze of the camera—and therefore the viewer.—*Dawoud Bey*

───────────

Dawoud Bey was born in New York City. His family encouraged his interest in photography: he received a Kodak Instamatic camera at the age of eleven; at the age of fifteen he received an Argus camera that belonged to his late godfather; and he received a single-lens reflex camera as a high school graduation gift. Bey's work has been exhibited extensively. In 2021 the Whitney Museum of American Art and San Francisco Museum of Modern Art presented *Dawoud Bey: An American Project.* Works by Bey are included in numerous collections, including the Solomon R. Guggenheim Museum, Metropolitan Museum of Art, Museum of Modern Art, The Studio Museum in Harlem, and Whitney Museum of American Art. He has received a MacArthur Fellowship, Guggenheim grant, and N.E.A grant. He is professor of art at Columbia College Chicago. Bey has a B.A. from Empire State College, S.U.N.Y., and an M.F.A. from Yale University.

PLATE 17

Dawoud Bey (born 1953). *Brian and Paul,* 1993. Polaroid, 29½ × 43½ in. (74.9 × 110.5 cm), overall installed. Collection Walker Art Center, Minneapolis. Justin Smith Purchase Fund, 1994.

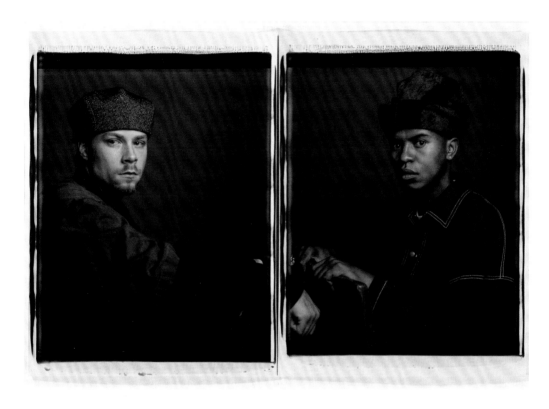

Mark Blackshear

As a photographic artist, my creative pursuit is to escape categorization, characterization, and any kind of compartmentalization that attempts to explain or limit my photographic expression. I take pleasure in how observers of my work respond with delight to my visualizations. My quest is to pursue my life as a photographer unbridled, and always with a constant yearning to be better.
—*Mark Blackshear*

Photographs by Mark Blackshear have appeared in several books, such as Danny Simmons's *Three Days as the Crow Flies* and Wayne Enstice and Janis Stockhouse's *Jazzwomen: Conversations with Twenty-one Musicians.* He has also had many images published in magazines and newspapers, such as *ARTnews, The International Review of African American Art, Russell Simmons' One World, NRG The Pulse of Brooklyn, Vibe, New York Daily News, New York Amsterdam News, Minority Business News USA,* and *Our Time Press.* Blackshear has had exhibitions and presentations of his works at many prestigious institutions, including the Brooklyn Academy of Music; Leica Gallery, New York; BRIC Rotunda Gallery, Brooklyn; African American Museum in Philadelphia; 40 Acres Art Gallery, Sacramento, CA; Chastain Arts Center Gallery in Atlanta; and Nordstrom Department stores. Blackshear's artistic philosophy is founded on his ability to capture a fleeting moment, a solitary instant in which he is almost transparent.

PLATE 18

Mark Blackshear (born 1953). *Mirror Reflection and Antics at Our Chinese Take-Out Captured with iPhone SE,* August 29, 2017. Archival digital print, 19 × 13 in. (48.3 × 33 cm). Courtesy of the artist.

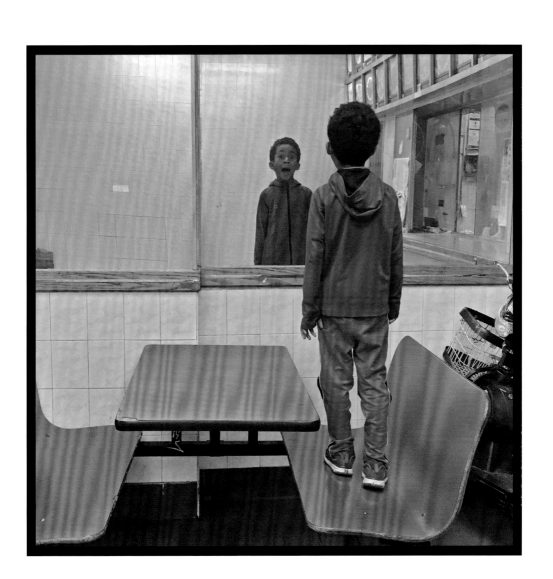

Kwame Brathwaite

I have been called the "Keeper of the Images." My task has been to document creative powers throughout the diaspora—not only in our Black artists, musicians, athletes, dancers, models, and designers, but in all of us. It was my job to capture each moment of this creativity in its truest form ... From the act of photography to the process of developing the film myself, spending hours in the darkroom, just me and my work, it was always about getting to the truth of each moment. There's so much history that must be made known, so much to share. As the Keeper of the Images, my goal has always been to pass that legacy on and make sure that for generations to come, everyone who sees my work knows the greatness of our people.—*Kwame Brathwaite*

Kwame Brathwaite was born in Brooklyn, New York, on January 1, 1938. Inspired in part by the writings of Marcus Garvey and the teachings of Carlos Cooks, Kwame Brathwaite's photography created the visual overture for the Black Is Beautiful movement in the late 1950s and early 1960s. Brathwaite spread this idea through his writings and photographs, as well as the activities of the two organizations he helped co-found with his older brother Elombe Brath (1936–2014): the African Jazz Arts Society and Studios (AJASS) (1956) and the Grandassa Models (1962). Brathwaite worked to disrupt media and produce positive images of African Americans. Working as an artist and a theorist, Brathwaite produced photographs that were specifically intended to shape the course of American visual discourse. Brathwaite's photographs foreground the idea that artistic and political vision can effect change in popular culture—and that popular culture can effect change in the culture at large.

PLATE 19

Kwame Brathwaite (born 1938). *Untitled* (*Kwame Brathwaite Self-Portrait at AJASS Studios*), ca. 1964 (printed 2016). Archival pigment print, mounted and framed, 30 × 30 in. (76.2 × 76.2 cm). Courtesy of the artist and Philip Martin Gallery, Los Angeles.

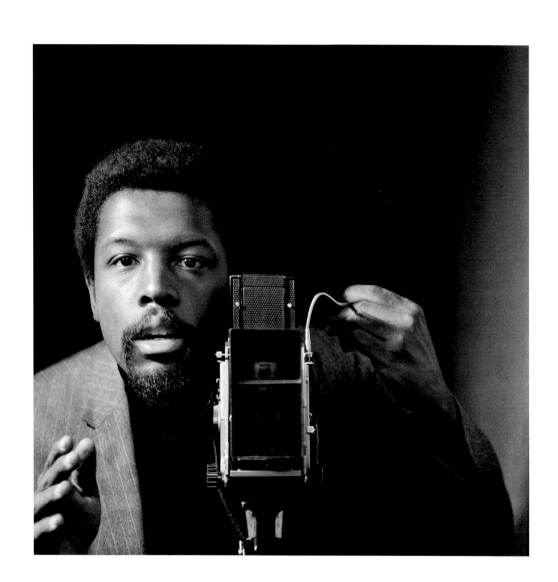

Sheila Pree Bright

As a fine art photographer, I am interested in the life of those individuals and communities that are often unseen in the world. My objective is to capture images that allow us to experience those who are unheard as they contemplate or voice their reaction to ideas and issues that are shaping their world. I create contemporary stories about social, political, and historical contexts not often seen in the traditional media and fine art platforms. My work captures and presents aspects of our culture, and sometimes counterculture, that challenge the typical narratives of Western thought and power structures.—*Sheila Pree Bright*

Sheila Pree Bright is an internationally acclaimed fine art photographer known for her series *#1960Now*, *Young Americans*, *Plastic Bodies*, and *Suburbia*. Bright is the author of *#1960Now: Photographs of Civil Rights Activists and Black Lives Matter Protest* (Chronicle Books). She appeared in the documentary films *Through a Lens Darkly: Black Photographers and the Emergence of a People* and *Election Day: Lens Across America*. Her work has been exhibited at the High Museum of Art, Atlanta; Smithsonian National Museum of African American History and Culture; Halsey Institute of Contemporary Art, Charleston, SC; The Museum of Contemporary Art, Cleveland; Art Gallery of Hamilton, Ontario, Canada; Turner Contemporary, Margate, England; and Leica Gallery in New York. She was awarded the commission for "Picturing the South" by the High Museum of Art and the Boston University Mugar Memorial Library commission for a multimedia installation titled *Re-birth*.

PLATE 20

Sheila Pree Bright (born 1967). *Suburbia Untitled 13*, 2006. Pigmented inkjet print, 24 × 30 in. (61 × 76.2 cm). Courtesy of the artist.

George O. Brown

George O. Brown was born in Orange County, Virginia. After the Civil War, his family moved to Richmond. During his twenties, Brown learned photography and worked in the photographic gallery of George W. Davis. After operating the Jefferson Fine Art Gallery as a partnership, Brown opened his own photography studio, the Old Dominion Gallery. In 1907 he was awarded a silver medal at the Jamestown Tercentennial Exposition, which included a display of inventions and innovations by African Americans. His two adult children, Bessie Gwendola Brown and George Willis Brown, joined his studio, and photographs by "The Browns" remained highly regarded and widely published for another generation.

PLATE 21

George O. Brown (1852–1910). *Josephine D. Chambers, Right Worthy Grand Council of Virginia Chief,* ca. 1903. Photographic emulsion on paper, 6 × 3¾ in. (15.2 × 9.5 cm). Courtesy of The Valentine Museum; Richmond, VA. Independent Order of St. Luke Collection, V.88.20.36.

The Right Worthy Grand Council Independent Order of St. Luke was established in 1867 to "promote the general welfare of society by uniting fraternally Negro persons of good moral character who are physically, morally, and socially acceptable, to educate and assist its members in thrift, to create and maintain funds out of which members . . . may receive benefits for themselves or their beneficiaries, [and] to provide death benefit protection to members."

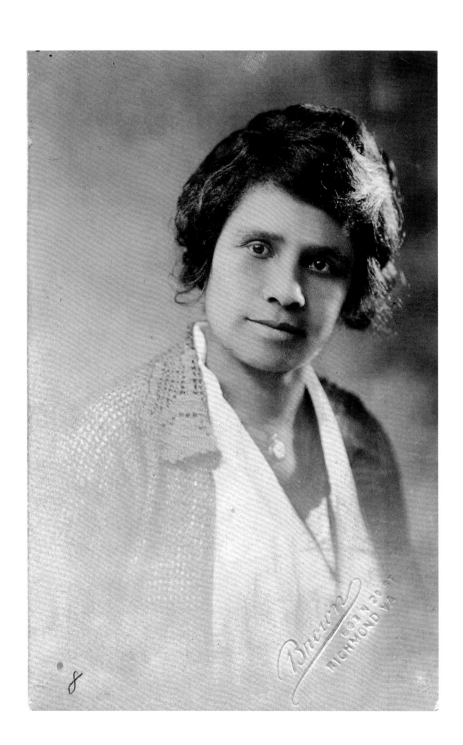

Nakeya Brown

"If Nostalgia Were Colored Brown" mediates Black beauty rituals and culture through the staging of feminine objects. Time-specific materials that have racialized, commodified, and cultural relevance in relationship to Black women's bodies are metonyms for nostalgia—a type of memory. Each vignette is a "Black feminine space" that is as intergenerational as it is a formative place for identity. The shower cap, the hot comb, grease, rollers, vinyl records depicting images of iconic African American songstresses, and hair dryers are just a few of the articles photographed to entwine the materiality of the world with the intimacies of womanhood.—*Nakeya Brown*

Nakeya Brown was born in Santa Maria, California. She received her B.A. from Rutgers University and her M.F.A. from The George Washington University. Her work has been featured nationally in solo exhibitions at the Catherine Eldman Gallery, Chicago; Urban Institute for Contemporary Art, Grand Rapids; and Hamiltonian Artists, Washington, DC; and in group exhibitions at the Eubie Blake Cultural Center, Baltimore; the Prince George's African American Museum and Cultural Center, North Brentwood, MD; and the Woman Made Gallery, Chicago. She has presented her work internationally at the Museum der bildenden Künste, Leipzig, and NOW Gallery, London. Brown's work has been featured in the *New York Times, Time, Vogue,* and *The New Yorker,* and in the photography books *MFON: Women Photographers of the African Diaspora, Babe,* and *Girl on Girl: Art and Photography in the Age of the Female Gaze.*

PLATE 22

Nakeya Brown (born 1988). *Don't You Know Love When You See It?,* 2018. From the series *If Nostalgia Were Colored Brown.* Archival inkjet print, 24 × 16 in. (61 × 40.6 cm). Courtesy of the artist.

Kesha Bruce

While religion has never been the subject of my work, my religious upbringing has definitely had a significant influence on my work. The idea for this image came from an archival photo of enslaved children on a plantation. This particular photograph of the children brought to mind a biblical verse that had always fascinated me. The first chapter of the Book of Matthew traces the genealogy of Christ. The chapter begins: "Abraham begot Isaac, and Isaac begot Jacob, and Jacob begot Judah and his brothers … " and continues until we reach the birth of Jesus. I used a simplified shape of a house and the words from the passage as a foreground to reframe the original image.
—*Kesha Bruce*

———————————————

Born and raised in Iowa, Kesha Bruce completed a B.F.A. from the University of Iowa before earning an M.F.A. in painting from Hunter College in New York. She has been awarded fellowships from the New York Foundation for the Arts, Vermont Studio Center, and CAMAC Foundation, and received a Puffin Foundation grant for her artist's books. Her work is included in the collections of the Smithsonian National Museum of African American History and Culture, Amistad Center for Art and Culture, University of Iowa Women's Center, En Foco Photography Collection, and the Museum of Modern Art's Franklin Furnace Artist Book Collection. In addition to her studio work, Kesha Bruce is an independent curator and founding director of Baang + Burne Contemporary in New York City.

PLATE 23

Kesha Bruce (born 1975). *Begotten,* 2008. From the series *(Re)calling & (Re)telling.* Archival pigment print, 12 × 9 in. (30.5 × 22.9 cm). Edition of 15. Courtesy of the artist and Morton Fine Art, Washington, DC.

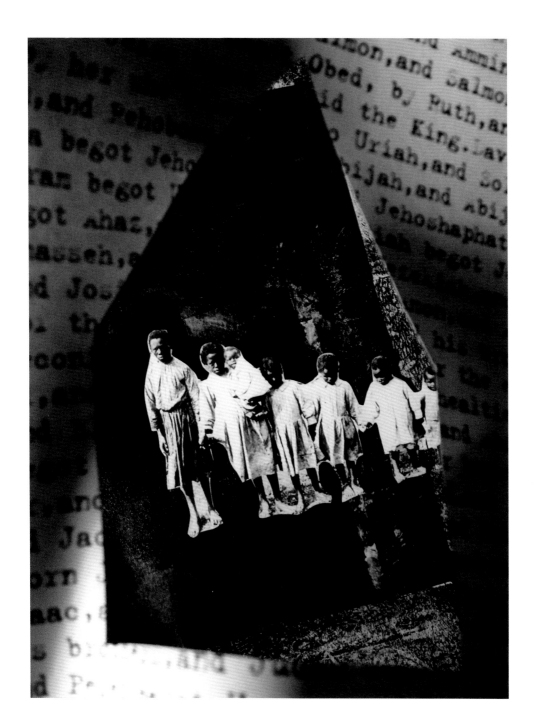

Crystal Z Campbell

The Notes from Black Wall Street series invites a meditation on the future of our complicit fictions, suppressed memories, and united histories. Culled from institutional archives, these ruptured photographic histories feature Black residents of Greenwood after the 1921 Tulsa Race Massacre. Each photograph is translated via cuts, collage, ceramic shards, and recoloring with paint applied as thick as scars. These paintings foreground self-fashioning and self-determination precisely one hundred years after the 1921 Tulsa Race Massacre. Yet, the narrative is always at stake. Will justice enter the frame upon a century?—*Crystal Z Campbell*

Crystal Z Campbell is a multidisciplinary artist, experimental filmmaker, and writer of African American, Filipino, and Chinese descents. Campbell finds complexity in public secrets—fragments of information known by many but untold or unspoken. They are the recipient of numerous honors and awards, including a Pollock-Krasner Foundation grant, MAP Fund grant, MacDowell Fellowship, Franklin Furnace grant, and Tulsa Artist Fellowship, as well as residencies at Skowhegan, Rijksakademie, Whitney Independent Study Program, and Black Spatial Relics. They have exhibited artwork at the Drawing Center, New York; ICA Philadelphia; REDCAT, Los Angeles; Artissima, Turin; The Studio Museum of Harlem; SculptureCenter, Long Island City; and San Francisco Museum of Modern Art. Campbell's writing has been published in *World Literature Today, Monday Journal, GARAGE,* and *Hyperallergic.* Founder of archiveacts.com, Campbell was a 2020-21 Harvard Radcliffe Film Study Center & David and Roberta Logie Fellow. Named a 2021 Guggenheim Foundation Fellow in Fine Arts, Campbell is a Distinguished Scholar at the University of Buffalo who lives and works in New York and Oklahoma.

PLATE 24

Crystal Z Campbell (born 1980). *Notes from Black Wall Street (Soft, Receptive, and Absolute),* 2019. Mixed media on wood panel, 20 × 30 in. (50.8 × 76.2 cm). Copyright Crystal Z Campbell. Courtesy of the artist.

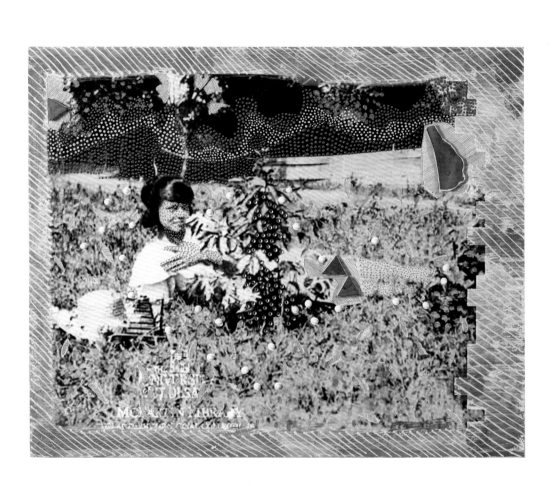

María Magdalena Campos-Pons

I collect and tell stories of forgotten people to foster a dialogue to better understand and propose a poetic, compassionate reading of our time. —María Magdalena Campos-Pons

———————————

María Magdalena Campos-Pons combines and crosses diverse artistic practices, including photography, painting, sculpture, film, video, and performance. Her work addresses issues of history, memory, gender, and religion, and investigates how each of these themes informs identity formation. Born in La Vega, a town in the province of Matanzas, Cuba, Campos-Pons is a descendant of Nigerians who had been enslaved and brought to the island in the nineteenth century. Directly informed by the traditions, rituals, and practices of her ancestors, her work is deeply autobiographical.

Campos-Pons has had solo exhibitions at the Museum of Modern Art, Indianapolis Museum of Art, Peabody Essex Museum, and National Gallery of Canada, among other distinguished institutions. She has participated in the Venice Biennale (twice), Dakar Biennale, Johannesburg Biennial, Documenta 14, Guangzhou Triennial, three editions of the Havana Biennial, Pacific Standard Time: LA/LA, and Prospect.4. Campos-Pons's works are in more than thirty museum collections, including the Smithsonian National Portrait Gallery; Whitney Museum of American Art; Art Institute of Chicago; National Gallery of Canada; Victoria and Albert Museum; Museum of Modern Art; Museum of Fine Arts, Boston; Pérez Art Museum Miami; and Fogg Museum.

PLATE 25

María Magdalena Campos-Pons (born 1959). *Freedom Trap,* ca. 2013. Polaroid Polacolor Pro, 24 × 20 in. (61 × 50.8 cm). Courtesy of the artist and Gallery Wendi Norris, San Francisco.

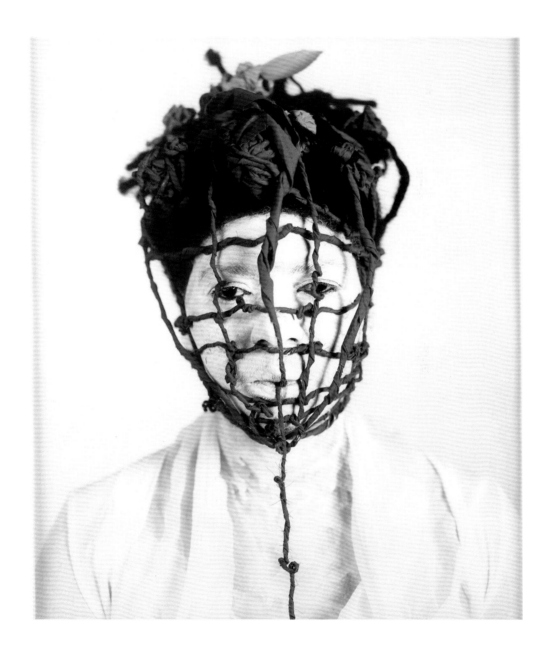

Micaiah Carter

I really want my photography to be a quality platform for the representation of people of color that hasn't been seen before.—*Micaiah Carter*

Micaiah Carter's work is a singular alchemy of contemporary youth culture, fine art, street style, and the certainty that the simple act of representation can be a force for change. His vision is all his own, but within his photographs are echoes of the Black Power movement, the art of Carrie Mae Weems and Viviane Sassen, the seminal street photography of Jamel Shabazz, and the work of British fashion shooter Alasdair McLellan. His images are preternaturally sophisticated. His lighting is intentional but not attention-seeking. And his subjects always seem fully themselves, whether he's photographing a celebrity or a musician, of for a fashion story or an ad campaign. His client list includes Thom Browne, *Vanity Fair, Vogue,* Nike, Puma, Adidas, Showtime, A24 Films, Pepsi, Converse, Apple, Vice, Afropunk, i-D, the *New York Times,* Urban Outfitters, *Time,* Warner Bros. Records, Epic Records, *Document Journal, Teen Vogue, Elle,* Tumblr, Nylon, Recens Paper, Men in This Town, and *V Magazine.* Carter is currently working on his first monograph, *95 48,* the title of which refers to his and his father's birthdates, and which takes as its inspiration photographs of his dad and his friends during the 1970s. He is based in Brooklyn.

PLATE 26

Micaiah Carter (born 1995). *Alvin Ailey and May 2019,* 2019. Digital C-print, 25 × 20 in. (63.5 × 50.8 cm). Courtesy of the artist and Sarah Hasted Art Advisory, New York.

Charles Chamblis

There's only one game in town and that is reality.—*Charles Chamblis*

Charles Chamblis was born in Pittsburgh and attended art school while growing up there. Following military service and marriage, he moved to Minneapolis in 1958. He began his photography career in the 1960s after receiving a Polaroid camera as a gift from his wife. Affectionately known as "The Pictureman," Chamblis was seen everywhere in the African American communities, and everywhere he went his camera went with him. In the 1970s and 1980s, Chamblis photographed community events, family gatherings, weddings, fashion shows, landscapes, music venues, and musicians. His photographic legacy includes hundreds of images of such venues as the Taste Show Lounge and the musicians associated with the Minneapolis Sound. Chamblis worked as a freelance photographer and shared his photographs with the community. In 2001, his daughter Reva Chamblis generously donated 2,130 of her father's photographs from 1975 to 1988 to the Minnesota Historical Society. In 2014 the Minnesota Historical Society presented an exhibition of sixty photographs, and in 2017 it published *Sights, Sounds, Soul: The Twin Cities Through the Lens of Charles Chamblis,* with two hundred photographs and text by Davu Seru.

PLATE 27

Charles Chamblis (1927–1991). *Taste Show Lounge,* 1975–85. David Ellis (far left, plaid shirt); Kevin Jenkins (3rd from left, with beard). Digital copy of color photograph, 10 × 8 in. (25.4 × 20.3 cm). Minnesota Historical Society. I.368.479.

Vanessa Charlot

Vanessa Charlot is a documentary photographer living and working between St. Louis, Missouri, and Miami, Florida. She shoots primarily in black and white to explore the immutability of the collective human experience and to disrupt compositional hierarchy. Her work focuses on the intersectionality of spirituality, socioeconomic issues, and sexual/gender expression. The purpose of her work is to produce visual representations of varied human existences that are free of an oppressive gaze.

Charlot has worked as a freelance photographer and lecturer throughout the United States, the Caribbean, and Southeast Asia. Her photographs have been commissioned by *Vogue, The New Yorker, Oprah Magazine, The Atlantic, New York Magazine, Buzzfeed, Artnet News,* and other national and international publications of note.

PLATE 28

Vanessa Charlot (born 1985). *Love in Struggle,* 2020. Pigmented inkjet print, 20 × 30 in. (50.8 × 76.2 cm). Courtesy of the artist.

Albert Chong

One of my earliest memories is spending time with the family photo album. I was completely fascinated by the images of these people who were my family but many of whom I did not yet know as I was the youngest child of a large family of eight children. The photographs were my portal to a mysterious past. These were mnemonic objects that acted as triggers or supports to memories. The color still life photographs that I created were made from the old family photographs. Some of these became tributes to the lives and memory of these individuals. The use of colorful flowers is a standard motif in the construction of these images. —*Albert Chong*

Albert Chong, born in Kingston, Jamaica, is a contemporary artist working in the mediums of photography, installation, and sculpture. His works have dealt directly with personal mysticism, spirituality, race and identity, and numerous other topics, as well as celebrating the beauty of images and objects. Chong has a B.F.A. from the School of Visual Arts in New York and an M.F.A. from the University of California, San Diego. He is professor of art at the University of Colorado in Boulder. Chong has received fellowships from the N.E.A., the John Simon Guggenheim Foundation, and the Pollock-Krasner Foundation. He has represented his home country Jamaica in many national and international exhibitions, including the 1998 Sao Paulo Biennale, 2000 Havana Biennial, and 2001 Venice Biennale.

Mark Clennon

The energy was different to other protests, and I had to go out. I spotted a man. I never saw the front of this man's face. I never spoke to him. I kind of waited for him to raise his fist. I had a feeling he would. I went out that day to make sure a Black voice got to tell our story. I wanted to give the protests the nuance they deserved. In a way, my audience was my daughter. I wanted her to see what the world was like in the first few months of her life. —*Mark Clennon*

———————————

Mark Clennon is a New York-based photographer with a particular focus on editorial, commercial, and documentary projects. Adeptly moving between these forms of photography, which he has been practicing since leaving his tech job in 2017, Mark aims to capture the Black experience in its totality. His images are therefore nuanced and multifaceted, capturing joy, pain, triumph, and everything in between.

PLATE 30

Mark Clennon (born 1988). *Untitled,* 2020. Pigmented digital print. 60 × 40 in. (152.4 × 101.6 cm). Courtesy of the artist.

On May 30, 2020, five days after George Floyd was killed in Minneapolis, Mark Clennon went out to photograph a peaceful protest winding through Manhattan.

Tameca Cole

My pain and struggles are just one of the inspirations I draw upon to create. My goal is to express the human condition in a way that enables the audience to see that we are all simply human.
—*Tameca Cole*

Tameca Cole was born in Birmingham, Alabama. She rediscovered her youthful interest in art and created the remarkable self-portrait *Locked in Dark Calm* while incarcerated at the Julia Tutwiler Prison for Women in Wetumpka, Alabama. The artwork was included in the ground-breaking 2020 exhibition *Marking Time: Art in the Age of Mass Incarceration,* curated by Nicole R. Fleetwood for MoMA PS1 in New York, and was featured in *Art in America, Artforum, ARTnews, Momus, The Nation,* and the *New York Times.* Cole served as the inaugural participant in PS1's (Non) Residency for Artists Impacted by the Social Justice System. Also in 2020, Cole was commissioned by the *New York Times* to create three photo collages to illustrate the short story *The Seventh Crown Players* by Ayana Mathis, published in *T Magazine.* Cole has been active as a visual artist and writer with the production company Die Jim Crow since 2014.

PLATE 31

Tameca Cole (born 1971). *Locked in Dark Calm,* 2016. Digital copy of collage and graphite on paper, 8½ × 11 in. (21.6 × 27.9 cm). Copyright Tameca Cole and Die Jim Crow. Image courtesy of MoMA PS1. Photo by Kris Graves.

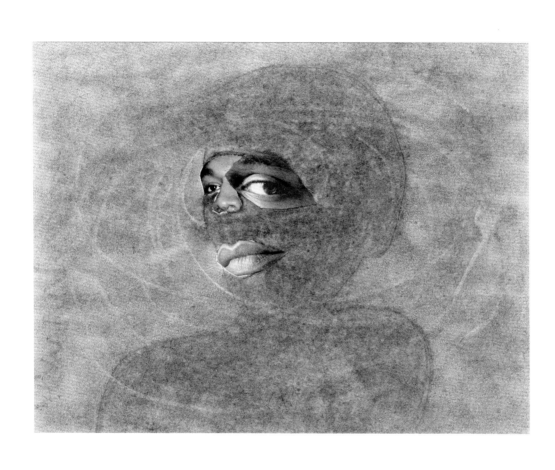

Florestine Perrault Collins

They got dressed in their best clothing when they went to her studio. These people were invisible to much of New Orleans, but Florestine portrayed them as they saw themselves: with dignity and worth.—Arthé A. Anthony

Florestine Perrault (Bertrand) Collins was born in New Orleans to free people of color. During the Jim Crow era she learned photography at a young age by assisting white photographers who believed that she was white. After her first marriage she opened a photography studio in her home in 1917 and publicized herself as an African American female photographer. She subsequently relocated her business, the Bertrand Studio, to downtown New Orleans in 1923, specializing in portraits, family events, and weddings. Her business prospered for thirty years. Collins mentored her younger brother Arthur, who later opened Perrault's Studio, first in Atlanta and later in New Orleans. In 1949 she retired to Los Angeles with her second husband, Herbert W. Collins. In 2009 The New Orleans Museum of Art and The Historic New Orleans Collection included work by Collins in *Women Artists in Louisiana, 1825–1965: A Place of Their Own.*

PLATE 32

Florestine Perrault Collins (1895–1988). *Family Portrait,* n.d. Gelatin silver print, 3½ × 5 in. (8.9 × 12.7 cm). University of Minnesota Libraries, Department of Archives and Special Collections.

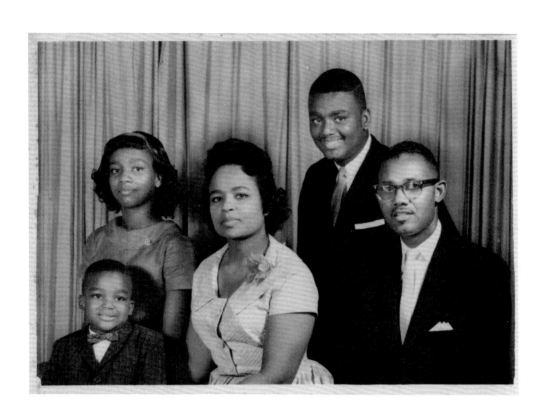

Bill Cottman

I have been making photographs since 1969. In high school I wanted to be a commercial artist, but my school did not offer guidance in this area, so I became an engineer and photography became my tool for self-expression. Early on, I tried to make photographs that looked like paintings in the hope of being accepted as an artist. I learned the rules of composition and looked at work by the masters: Weston, Strand, and Adams. Later, I discovered Winogrand, Cartier-Bresson, and Frank, photographers of ordinary people and places. Much later, I discovered Van Der Zee, Parks, and DeCarava, Black photographers consistently documenting the lives of Black people. My work is motivated by identifying and investigating the universalities contained in the personal stories of four women: my mother, my wife, my mother-in-law, and my daughter. My method of presentation has expanded to include projection design for theater.—*Bill Cottman*

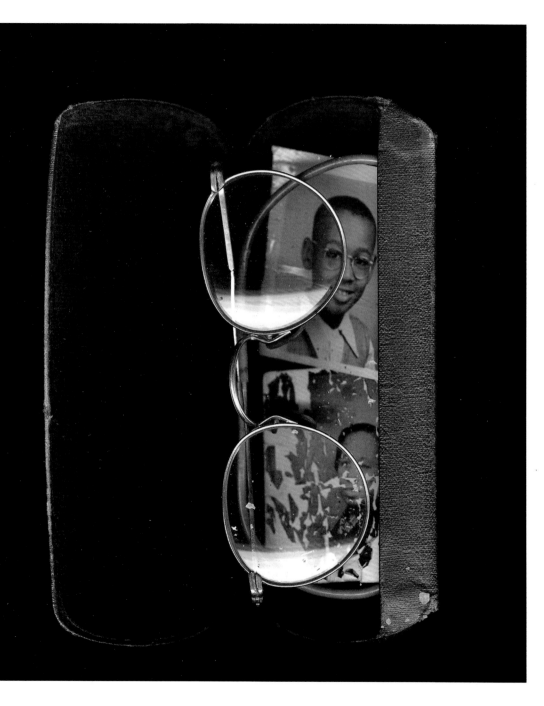

Adger Cowans

For me, the artist's responsibility is to keep the temple (body, mind, and spirit) clear, clean, and open by being aware and by keeping watch over what enters it mentally and physically. When it is so tuned, the creative impulses can be fully received and reflected to the highest degree, where line, form, and color define a space that the viewer can feel with the heart, explore with the eyes, and contemplate with the mind. —*Adger Cowans*

Adger Cowans is a fine art photographer and abstract expressionist painter. He has experimented with many mediums over his artistic career. Renowned in the world of photography and fine art, his works have been shown at the George Eastman House, Metropolitan Museum of Art, International Museum of Photography, Museum of Modern Art, Whitney Museum of American Art, J. Paul Getty Museum, Cleveland Museum of Art, Harvard Fine Art Museum, Detroit Institute of Arts, James E. Lewis Museum, and numerous other art institutions. After leaving Ohio University with a B.F.A. in photography, Cowans worked with *Life* magazine photographer Gordon Parks before entering the U.S. Navy in 1958. Throughout his impressive career, Cowans has received many awards. Among the most prestigious was the Lorenzo il Magnifico alla Carriera in recognition of a Distinguished Career at the 2001 Florence Biennale of Contemporary Art. He also received The Lifetime Achievement Award from Howard University. In 1961 Cowans had his first one-person show at The Heliography Gallery; Jacob Deschin of the *New York Times* described his work as "Boldly inventive and experimental . . . and the artist is a craftsman to his fingertips."

PLATE 34

Adger Cowans (born 1936). *Gordon Parks,* 1958. Gelatin silver print, 16 × 20 in. (40.6 × 50.8 cm). Copyright Adger Cowans. Courtesy of the artist and Bruce Silverstein Gallery, New York.

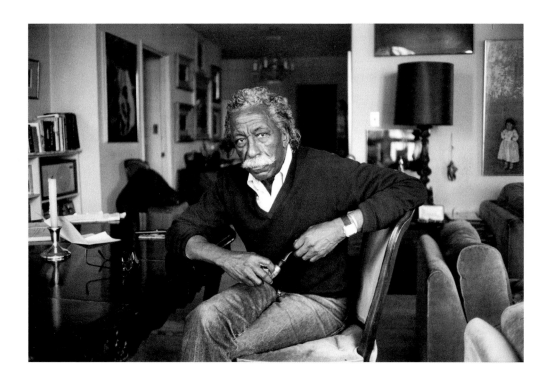

Gerald Cyrus

These photographs from the 1990s are about family, friends, and the spirit of kinship that is present when people that are close to each other interact. The project documents my relatives and friends in their homes as well as other families that I met as I proceeded along. The scenes depicted include the mundane everyday activities that generally pass by unnoticed, as well as special events. I was focusing on the middle class, a segment of the African American population that was receiving scant attention in the genre of documentary photography. My goal was to portray these moments through a visual style that infused them with animation, drama, and wry humor.
—*Gerald Cyrus*

Gerald Cyrus was born in Los Angeles, where he began photographing in 1984. In 1990 he moved to New York City to pursue an M.F.A. at the School of Visual Arts, which he obtained in 1992. While at S.V.A., Cyrus interned at the Schomburg Center for Research in Black Culture and began work on *Kinship*, a project focusing on African American family life. In 1994, he frequented the nightclubs and bars in Harlem and photographed the vibrant music scene. The resulting body of work, *Stormy Monday: New York's Uptown Jazz Scene,* was published as a book in 2008. His photographs are in the collections of the Philadelphia Museum of Art, New Orleans Museum of Art, Schomburg Center for Research in Black Culture, Amistad Center for Art and Culture, and Museum of the City of New York.

PLATE 35

Gerald Cyrus (born 1957). *Keith Hoisting Seth, New Orleans,* 1992. Gelatin silver print, image 12 × 18 in. (30.5 × 45.7 cm), sheet 16 × 20 in. (40.6 × 50.8 cm). Courtesy of the artist.

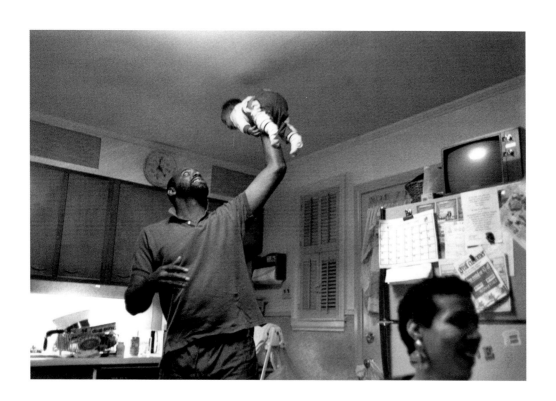

Louis Draper

I want to show the strength, the wisdom, the dignity of the Negro people. —Louis Draper

Louis Draper was born in Richmond, Virginia, and in 1957 moved to Harlem, New York, where he enrolled at the New York Institute of Photography, studying under W. Eugene Smith. Draper worked between Harlem and New Jersey, where he taught at Mercer County Community College from 1982 to 2002. In 1963 Draper founded the Kamoinge Workshop with Albert Fennar, James Ray Francis, Herman Howard, Earl James, James Mannas, Calvin Mercer, Herbert Randall, Shawn Walker, and Calvin Wilson. Later that year they were joined by Anthony Barboza, David Carter, Adger Cowans, and Herb Robinson. Beuford Smith joined two years later, and C. Daniel Dawson and Ming Smith were added in 1972. Draper's work was included in *Working Together: The Photographers of the Kamoinge Workshop*, a landmark traveling exhibition organized by Sarah Eckhardt for the Virginia Museum of Fine Arts. Draper's work is held in several public collections, including the Museum of Modern Art; George Eastman House; Ebony Museum of Negro History and Art, Chicago; and the Schomburg Center for Research in Black Culture. During his lifetime Draper had solo exhibitions at Image Gallery, New York, and The Photo Workshop Center for Photography, New Jersey.

PLATE 36

Louis Draper (1935–2002). *Girl and Cuba (Philadelphia)*, 1968 (printed ca. 1968). Gelatin silver print mounted to board, 13 × 10 in. (33 × 25.4 cm). Copyright Louis H. Draper Preservation Trust. Courtesy of Bruce Silverstein Gallery, New York.

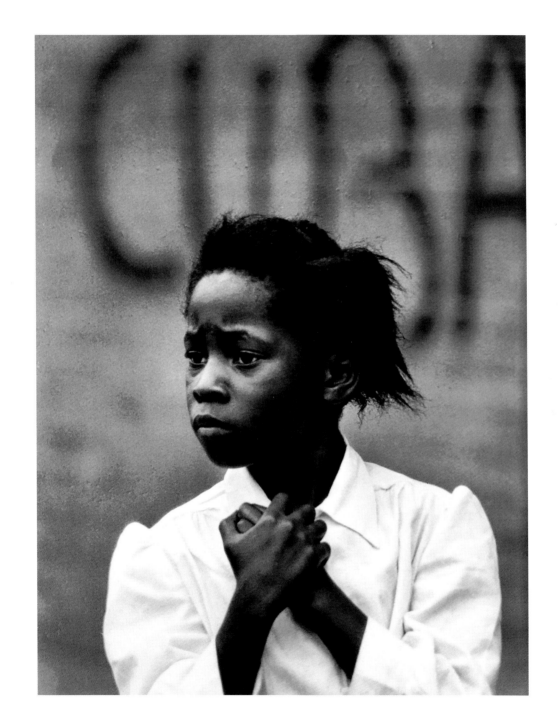

Barbara DuMetz

With my personal work, the images that I create are born out of my need to manifest visual interpretations of human experiences centered around emotions such as love, happiness, joy, friendship, and laughter, as well as feelings of beauty, sensuality, and serenity. I am inspired by listening to good music (jazz, most often), my vivid imagination, and an insatiable curiosity and inquisitiveness about life and spirituality.—*Barbara DuMetz*

———————————————

Barbara DuMetz was born in Charleston, West Virginia, and raised in Detroit. Her grandfather was a professional photographer. After graduating from Fisk University, DuMetz became a buyer trainee for a New York department store. While on an advertising shoot she fell in love with photography, which she subsequently studied at Art Center College of Design in Pasadena, California, graduating in 1973. Her career in commercial photography included assignments for the magazines *Essence* and *Black Enterprise*; the labels A&M Records, MCA Records, and Capitol Records; and for the promotion divisions of numerous agencies and production companies. She also photographed fashion advertisements for the Broadway department stores. She currently splits her time between Los Angeles and Atlanta.

PLATE 37

Barbara DuMetz (born 1947). *Self-Portrait, Los Angeles Studio,* 1981. Hasselblad 2¼ camera, Tri-X 400 film. Pigmented digital print, 16 × 20 in. (40.6 × 50.8 cm). For *Black Enterprise* magazine, "The World of Commercial Photographers," February 1982.

Mara Duvra

This work is about the quiet and quotidian, the still and meditative, and considers possibilities for Black subjectivity that center tenderness. —*Mara Duvra*

———————————

Mara Duvra is a visual artist, writer, and curator. Her research-based practice combines photography, poetry, and video to create installations that explore stillness and interiority as critical modes of self-study. Duvra's current body of work, *Tending: Meditations on Interiority and Blackness,* uses poetic and ephemeral imagery to understand Blackness beyond resistance or public identity. Photographing landscapes, interiors, and the body, Duvra explores shifts in proximity through moments laid bare/unfolding the vulnerability of being present/uncovering a shared intimacy.

Mara Duvra is from Silver Spring, Maryland. She received a B.A. in studio art and psychology from the University of Maryland, College Park, and an M.F.A. in studio art from the University of Minnesota, Twin Cities. Her work has been featured in Minneapolis galleries such as Soo Visual Arts Center, Public Functionary, and Yeah Maybe, and she has held artist residencies at the Soap Factory and White Page Gallery. Duvra is the instructor of painting, drawing, and printmaking at Saint Paul Academy and Summit School.

PLATE 38

Mara Duvra (born 1989). *Remembering,* 2019. Pigmented inkjet print, 17 × 22 in. (43.2 × 55.9 cm). Courtesy of the artist.

John Edmonds

John Edmonds is an American artist and photographer who first came to public recognition with his intimate portraits of lovers, close friends, and strangers. He received his M.F.A. from Yale University and his B.F.A. from the Corcoran School of the Arts and Design. His practice draws upon art historical representations of portraiture and figuration while expanding its roster to include individuals of his own creative community in New York and beyond. Incorporating everyday items of adornment and preservation while also juxtaposing these objects with sacred and spiritual sculptures from Central and West Africa, the artist has developed a distinct approach to photography as a critical tool for engaging with personal and collective history, commemorating the past, and continually reshaping the present and future. In 2019, he was included in the 79th Whitney Biennial.

Recent exhibitions include those at the Brooklyn Museum; Atlanta Contemporary; Henry Art Gallery at the University of Washington, Seattle; Milwaukee Art Museum; John and Geraldine Lilley Museum of Art, Reno; Columbus Museum of Art, OH; and California African American Museum, Los Angeles. His work is in numerous public and private collections, including the National Gallery of Art; Whitney Museum of American Art; Solomon R. Guggenheim Museum; Art Gallery of Ontario; Columbus Museum of Art, OH; Philadelphia Museum of Art; the Museum of Fine Arts, Houston; San Francisco Museum of Modern Art; and Brooklyn Museum.

PLATE 39

John Edmonds (born 1989). *Untitled (Hood 1)*, 2016. Archival pigment photograph, image 50 × 33 in. (127 × 83.82 cm), framed 50.56 × 33.62 in. (128.42 × 85.39 cm). Courtesy of the artist and Company Gallery, New York.

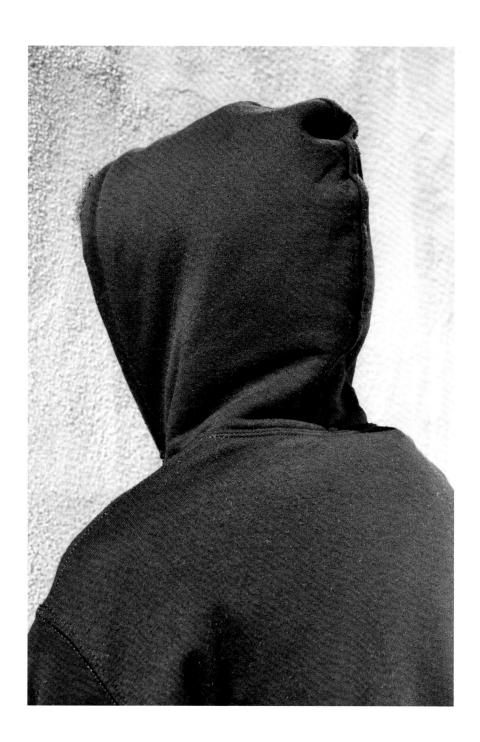

Dudley Edmondson

Whenever I go to public lands or national parks, I don't see many people who look like me, African Americans with a deep, unwavering connection to nature. I want to create outdoor role models for young African Americans. Influencing our young people this way may be the greatest thing we can do for our future. —*Dudley Edmondson*

Dudley Edmondson's career in photography spans nearly three decades. His exhibition *Northern Waters,* photographs of Lake Superior's North Shore and surrounding waters, was presented at the Minnesota Marine Art Museum in 2021. His work has been featured in galleries around the world and nearly one hundred publications, ranging from state-specific flora and fauna field guides by Stan Tekiela to Audubon's *Bird: The Definitive Visual Guide.* Edmondson is the author of the landmark book *Black & Brown Faces in America's Wild Places,* which profiles African Americans in nontraditional vocations and avocations in the outdoors. He speaks regularly on his books and his career as a wildlife photographer. His clients are educational institutions, such as the University of Minnesota and Oregon State University; state and federal agencies, including the Bureau of Land Management and the National Park Service; and environmental non-profits, including The Conservation Fund and The Nature Conservancy.

PLATE 40

Dudley Edmondson (born 1962). *African American Mountaineers in Alaska,* 2012. Pigmented inkjet print, 12½ × 18¾ in. (31.8 × 47.6 cm). Courtesy of the artist.

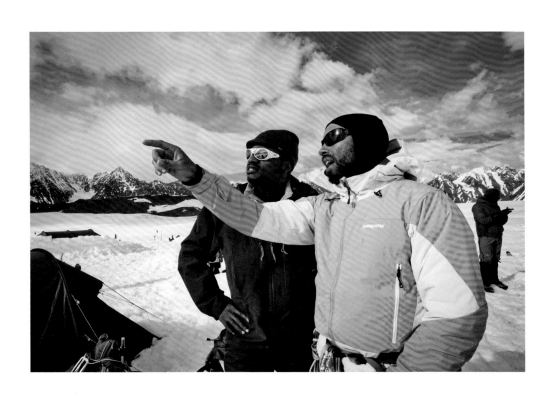

Cyndi Elledge

Visual media has an undeniable power over perception. Throughout American history, the media has worked tirelessly to tarnish the image of Black people by creating false narratives riddled with negativity cultivating a world that is conditioned to see us as less than. These inaccurate depictions and portrayals have created a society in which others do not see Black people for the beauty, power, strength, and value that we truly hold. Rather, they see us in the light, or lack thereof, that the media has shown us. Without intention to deny or diminish the importance and the mistreatment of Black women and girls, my artistic focus and effort to combat this gravitated to the young Black man. History shows a very specific demonization of Black men in America with no end in sight. My work is showcasing them through an unconditioned eye. Through my lens, I set out to create photographs that show the truth and beauty of young Black men. These images are my way of beginning to dismantle these stereotypes. —*Cyndi Elledge*

Cyndi Elledge is a photographer from Detroit whose love for art and natural talent transformed a hobby into a profession. Her work has been published in many publications, including the *New York Times, Vogue Arabia, Man Repeller,* and *MFON: Women Photographers of the African Diaspora.* Elledge is a 2016 Documenting Detroit Fellow. Her photographs were featured in Grand on River in Detroit and at Photoville in Brooklyn. Elledge holds a B.F.A. in photography from the College for Creative Studies. Her commitment to the community and love for her hometown speaks through her work as it captures the essence of Detroit and focuses on the unfiltered everyday lives of its residents.

PLATE 41

Cyndi Elledge (born 1991). *Facing Change: Davonte,* 2016. Pigmented inkjet print, image 21³⁄₁₆ × 14½ in. (53.8 × 36.8 cm), sheet 26¼ × 18⅛ in. (66.7 × 46 cm). Courtesy of the artist.

Awol Erizku

There's a quote from Manthia Diawara that says, "In the 21st century, the saxophone and the African mask are the two symbols of blackness, those are the icons." In my work, sometimes they're a stand-in for the black figure, where they become an opportunity to reimagine the body and the spirit. Also, it's not like, "Yo, I went to Africa and I got these masks." I like the fact that these are commodifiable objects, a part of global trade. *—Awol Erizku*

––––––––––––––––

Awol Erizku, a conceptual artist living and working in Los Angeles, was born in Gondar, Ethiopia. Erizku received his B.A. from Cooper Union in 2010 and his M.F.A. from Yale University in 2014. He has exhibited at institutions across the country, including the Museum of Modern Art and The Studio Museum in Harlem. Among his recent solo exhibitions are *New Visions For Iris,* with the Public Art Fund, New York and Chicago; *Mystic Parallax* and *New Flower | Images of the Reclining Venus* at The FLAG Art Foundation, New York; *Slow Burn* at Ben Brown Fine Arts, Hong Kong; *Menace II Society* at Night Gallery, Los Angeles, *Make America Great Again* at Ben Brown Fine Arts, London; and *Bad II the Bone* presented at the nomadic exhibition venue Duchamp Detox Clinic, by Night Gallery.

PLATE 42

Awol Erizku (born 1988). *Head Hunters,* 2018–20. Digital chromatic print, 26¾ × 20 in. (67.8 × 50.8 cm). Edition of 3 + 2 AP. Courtesy of the artist and Ben Brown Fine Arts, London.

Nona Faustine

The land holds the memory of man. These images function as memorials that I make myself, one at a time with my body. The naked truth of its blackness braced against a cold city, reconstructing a narrative where the enslaved have dignity and are not afraid.—*Nona Faustine*

Nona Faustine was born and raised in Brooklyn, where she currently lives and works. Recent exhibitions of her work include *Half the Picture: A Feminist Look at The Collection* at the Brooklyn Museum (2018); *Historos afro-Atlanticas* at Instituto Tomie Ohtake, São Paulo (2018); *Ye Are My Witness*, Higher Pictures (2018); and *Regarding the Figure* at The Studio Museum in Harlem (2017). Her work has been published in *Artforum, Huffington Post, Hyperallergic, The Guardian, The New Yorker, Los Angeles Times,* and *New York Times.* Her work is in the collections of the David C. Driskell Center for the Study of the Visual Arts and Culture of African Americans and the African Diaspora at the University of Maryland, College Park; The Studio Museum in Harlem; Brooklyn Museum; and Carnegie Museum of Art. Faustine was awarded a New York State Council on the Arts Fellowship and an Anonymous Was a Woman grant. In 2020 she participated in the inaugural class of Kehinde Wiley's Black Rock Senegal Residency. Faustine received her M.F.A. from the International Center of Photography at Bard College and her B.F.A. from the School of Visual Arts.

PLATE 43

Nona Faustine (born 1977). *Ye Are My Witness, Van Brunt Slave Cemetery Site, Brooklyn,* 2018. Pigmented inkjet print, 27 × 40 in. (68.58 × 101.60 cm). Courtesy of the artist.

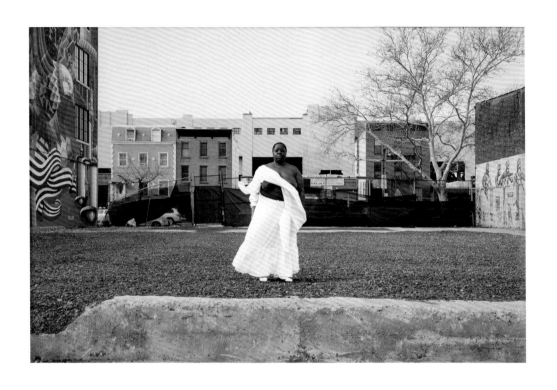

Adama Delphine Fawundu

Adama Delphine Fawundu is a photo-based visual artist born in Brooklyn to parents from Sierra Leone and Equatorial Guinea, West Africa. She received her M.F.A. from Columbia University. Fawundu is a co-author/editor of the critically acclaimed book *MFON: Women Photographers of the African Diaspora*, which features work by more than one hundred female photographers of African descent from around the globe. Her most recent work investigates Indigenous ontologies while imagining new ways of *being* in the world. Her interests include decolonization, memory, and interrogating histories. Using photography, video, sculpture, and printmaking, she creates new transnational identities as she explores Afrofuturist ideas.

Her most recent group exhibitions were on view at the Kunstverein Braunschweig, Germany; Moody Center for Arts, Rice University, Houston; and Wadsworth Atheneum Museum of Art, Hartford, CT. She was commissioned by the Park Avenue Armory and New York University to participate in *100 Years| 100 Women*, an exhibition commemorating one century since the ratification of the Nineteenth Amendment. Solo presentations of her work were recently on view at the Miller Theater at Columbia University; Hesse Flatow, Chelsea; Granary Arts, Ephraim, Utah; Museum of the African Diaspora, San Francisco; and The African American Museum, Philadelphia. Her work is included in the permanent collections of the Brooklyn Museum; Brooklyn Historical Society; Norton Museum of Art, West Palm Beach, FL; David C. Driskell Center for the Study of the Visual Arts and Culture of African Americans and the African Diaspora at the University of Maryland, College Park; Petrucci Family Foundation Collection of African-American Art, Asbury, NJ; and Museum of Contemporary Art, University of São Paulo.

PLATE 44

Adama Delphine Fawundu (born 1971). *Daily Bartlesville Enterprise,* 2018. From the series *In the Face of History.* Archival pigment on 100% cotton fiber paper, 22 × 30 in. (55.9 × 76.2 cm). Edition of 5 + 1 AP. Courtesy of the artist.

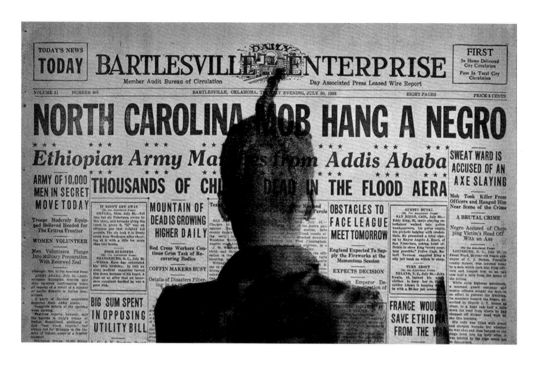

Al Fennar

I take the beauty of the everyday, the mundane, and places often looked at but seldom seen.
—Al Fennar

———————————

Born in New York City and raised in Englewood, New Jersey, Al Fennar joined the Air Force after graduating high school in 1956. During basic training, Fennar worked as a photographic interpretation specialist, where he learned photography. It was during his service at Yokota Air Base in Japan that Fennar absorbed the country's visual culture, especially in film and photography. After seeing an exhibition by Eikoh Hosoe in Tokyo, he decided to pursue photography as an art. Upon his discharge and return to civilian life in 1960, Fennar became a film technician at Slide-O-Chrome, a photo lab in New York City where he met like-minded photographers. His friendship with fourteen other photographers developed into the founding of the Kamoinge Workshop in 1963. With the Civil Rights Movement and Black consciousness in the forefront, they developed their mission to photographically document the Black experience and turn what was perceived as a negative into a positive. Fennar was one of the first Black men hired by NBC, helping to pave the way for women and men who would follow. His career at NBC's global operations in New York City spanned decades. He worked with television anchors, reporters, producers, and documentarians, bringing the latest news and investigative analysis to thousands on the Today Show, Nightly News, and NewsCenter4. Fennar's lifetime of creating fine art photography grew to include a great deal of vibrant color images that were a product of his new environment after relocating to Southern California in the early 2000s.

PLATE 45

Al Fennar (1938–2018). *Straight Street,* 1965 (printed 2009). Archival pigment print, image 12½ × 8½ in. (31.8 × 21.6 cm), sheet 19 × 13 in. (48.3 × 33 cm). Courtesy of Miya Fennar and the Albert R. Fennar Archive.

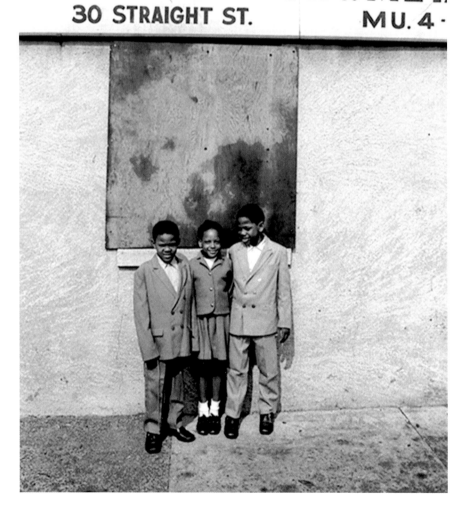

Alanna Fields

Alanna Fields is a photo-based artist creating from a carefully selected archive of Black queer vernacular photography. Working intimately with found photographs, Fields aims to reconstruct the ways in which images of the past are contextualized, pushing them past nostalgia. Fields uses wax to blur legibility and address the historical suppression of Black queer representation. The reconfiguration, cropping, and slicing retrains our eyes to the ways in which we have processed Black queer bodies in the photographic space and the negotiation between queer legibility and masking. By looking closely at gesture, proximity, gaze, and nongaze, and the creation of new images carved out of the old, Fields puts a lens to the long history of Black queer audacity.

Fields's work has been featured in exhibitions at Pt. 2 Gallery, Oakland, CA; Residency Art Gallery, Inglewood, CA; Felix Art Fair, Los Angeles; UNTITLED Art Fair, Miami; Museum of Contemporary African Diasporan Art, Brooklyn; Pratt Institute, Brooklyn; and Prince George's African American Museum and Cultural Center, North Brentwood, MD. Fields is a 2018 Gordon Parks Foundation Scholar, 2020 Light Work Artist-in-Residence, 2020 Baxter St at the Camera Club of New York Workspace Artist-in-Residence, and the recipient of Gallery Aferro's John and Lynn Kearney Fellowship for Equity. Fields received her M.F.A. in photography from Pratt Institute in 2019, and currently lives and works in New York City.

PLATE 46

Alanna Fields (born 1990). *Untitled (II)*, 2019. From the series *As We Were*. Archival inkjet print, wax, and Japanese kozo on panel, 8 × 6 in. (20.3 × 15.2 cm). Collection of Michael Chuapoco.

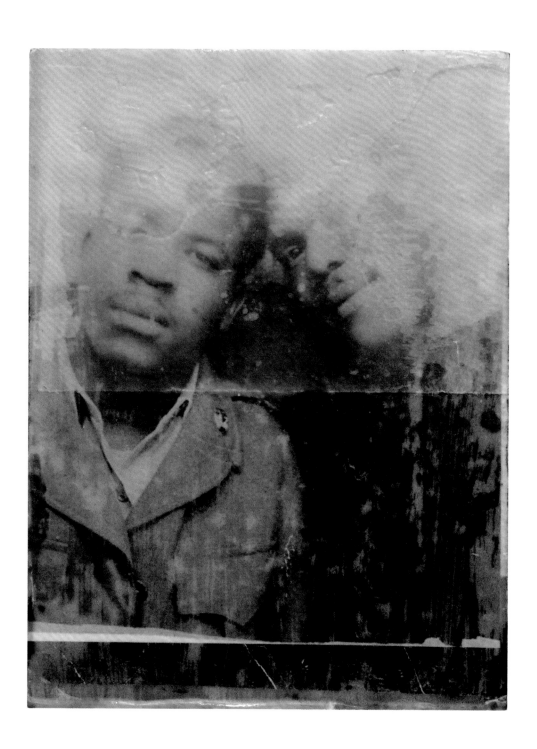

Lola Flash

The portraits in the "[sur]passing" series probe the impact skin pigmentation plays on Black identity and consciousness. Primarily due to the melanin count of their skin, light and dark-skinned Black people experience the world differently, ranging from overt favoritism to extreme alienation. In "[sur]passing," the models are photographed with a large format camera from towering urban vantage points, highlighting the regeneration of a new inner-city culture. They become divine and assertively return the gaze. The "[sur]passing" portraits represent a new generation that is above and beyond "passing." We represent a fresh pride and strength, and where ambiguity and blurred borders create individuality that elevates consciousness and advances positive imagery of Black people all over the world.—*Lola Flash*

Lola Flash's work challenges stereotypes and gender, sexual, and racial preconceptions. An active member of ACT UP during the AIDS epidemic in New York City, Flash was notably featured in the 1989 "Kissing Doesn't Kill" poster. Flash's work is included in important collections, such as the Victoria and Albert Museum in London and the Brooklyn Museum. She is a proud member of Kamoinge, Inc. Flash received her bachelor's degree from Maryland Institute College of Art and her master's degree from London College of Printing. Flash works primarily in portraiture with a 4x5 film camera, engaging those who are often deemed invisible. Flash's practice is firmly rooted in social justice advocacy around sexual, racial, and cultural difference. Flash is a board member at Queer|Art.

PLATE 47

Lola Flash (born 1959). *DJ Kinky, London,* 2003. From the [*sur*]*passing* series. Pigmented inkjet print from 4 × 5 film transparency, 60 × 48 in. (152.4 × 121.9 cm). Courtesy of the artist.

Krista Franklin

My work emerges at the intersection of poetics, popular culture, and the dynamic histories of the African Diaspora. The fantastic, the surreal, mythmaking, Black portraiture, and the collective conscious are conceptual preoccupations of my work. The forms take shape in collage, hand papermaking, installation, poetry, letterpress, altered bookmaking, and performance. I appropriate image and text as political gesture, to chisel away at narratives historically inscribed on women and people of color, and forge imaginative spaces for radical possibilities and visions. Black ritual, the metaphysical, and the Black nostalgic are core concerns in my practice. I orchestrate the collision of past, present, and future, and mine historical and fictional memory for artistic content.
—*Krista Franklin*

Krista Franklin is a writer and visual artist, the author of *Too Much Midnight* (2020), the artist book *Under the Knife* (2018), and the chapbook *Study of Love & Black Body* (2012). She is a recipient of the Meier Achievement Award from the Helen Coburn Meier and Tim Meier Foundation for the Arts and a Painters & Sculptors Grant from the Joan Mitchell Foundation. Her visual art has been exhibited in Chicago at the Chicago Cultural Center, Museum of Contemporary Photography, National Museum of Mexican Art, Poetry Foundation, and Rootwork Gallery, as well as at Konsthall C in Stockholm, The Studio Museum in Harlem, and on the set of Twentieth Century Fox Television's *Empire*. She has been published in *Poetry, Black Camera, The Offing, Vinyl*, and a number of anthologies and artist books.

PLATE 48

Krista Franklin (born 1970). *In Hea'bin,* 2008. Digital copy of ink, watercolor, and collage on magazine page, 13 × 10 in. (33 × 25.4 cm). Courtesy of the artist.

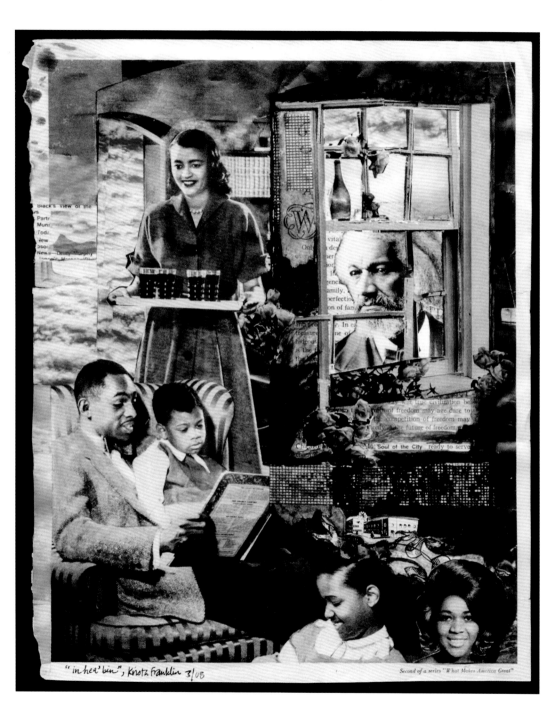

"in hea'bin", Krista Franklin 3/08

LaToya Ruby Frazier

By the end of my life's work, I hope to have created an archive that shows just how diverse the working class is and who the workers are. I want to show the fullness of the working class, because it's not just synonymous with whiteness. —LaToya Ruby Frazier

LaToya Ruby Frazier was born in Braddock, Pennsylvania. Frazier's work has been the subject of numerous solo exhibitions at institutions in the United States and Europe, including the Brooklyn Museum; The Institute of Contemporary Art, Boston; Contemporary Arts Museum Houston; Musée des Arts Contemporains, Grand-Hornu, Belgium; CAPC Musée d'Art Contemporain de Bordeaux, France; and Musée d'art Moderne Grand-Duc Jean, Luxembourg. In 2015, her first book *The Notion of Family* (2014) received the International Center for Photography Infinity Award. In 2020, Frazier was named the inaugural recipient of the Gordon Parks Foundation/Steidl Book Prize. Her work is held in numerous public collections, including the Museum of Modern Art, The Studio Museum in Harlem, Brooklyn Museum, Bronx Museum of the Arts, Whitney Museum of American Art, and Solomon R. Guggenheim Museum, all in New York, as well as the Museum of Contemporary Art Chicago.

PLATE 49

LaToya Ruby Frazier (born 1982). *On The Making Of Steel Genesis: Sandra Gould Ford (2017). Sandra Gould Ford looking back at the view from her former Talbot Towers Apartment in Braddock PA,* 2017. Gelatin silver print, 48 × 60 in. (121.9 × 152.4 cm). Edition of 3 + 2 AP. Copyright LaToya Ruby Frazier. Courtesy the artist and Gladstone Gallery, New York and Brussels.

Russell Frederick

I saw this man riding a bike down Franklin Avenue in the street then jump on to the sidewalk to attempt to go to Popeyes. The police stopped him. He said, "I'm going to Popeyes." They told him, "riding your bike on the sidewalk is illegal. We need to see some ID." His reply was, "my wife and daughter are waiting for me to bring them some food." The police said, "you can call them at the precinct." —*Russell Frederick*

————————

Russell Frederick is a Brooklyn-born photographer of Panamanian heritage. He is best known for his photographs of the Black communities of Bedford-Stuyvesant, a project he began in 1999. As a young photographer he was mentored by Eli Reed. His work has been exhibited in photo festivals (Visa pour l'image, Photoville), museums, and arts institutions worldwide. His photojournalism has appeared on every major U.S. television network; in newspapers from the *New York Times* and *Wall Street Journal* to the *Amsterdam News*; digital sites, including *NBC News*, *Slate*, and *Daily Beast*; and magazines from *New York* and *Ebony* to *Der Spiegel* and *VICE*. His personal work, shot largely in medium-format black-and-white, has been exhibited and collected by the Brooklyn Museum; Gordon Parks Museum, Fort Scott, KS; International Center of Photography; Aperture Foundation; Schomburg Center for Research in Black Culture; Library of Congress; and Goethe Institute in Accra, Ghana. UNESCO commissioned him to conduct a series of workshops for young photographers in Ethiopia and South Sudan. Frederick is a proud member of Kamoinge, Inc.

PLATE 50

Russell Frederick (born 1970). *Bedford-Stuyvesant, Brooklyn,* 2009. Pigmented inkjet print, 16 × 16 in. (40.6 × 40.6 cm). Courtesy of the artist.

Tia-Simone Gardner

Through an intentionally failed mimesis, the work from this series attempted a conversation with ghosts, what Saidiya Hartman calls a critical fabulation. There is a desire to go back in time, to speak with the dead, with the writer Mayotte Capécia, with the fictional Diouana, with my grandmother, even. The mask, images, and text in this piece were produced by me and thieved from film sequences in Senegalese filmmaker Ousmane Sembène's *La Noire de . . .* (1966). The work uses incoherence, misplaced ideas of madness, neurosis, and anger that are so often located onto the Black female body, as a productive space to reimagine life and its relation to the nonliving, between the animate and the inanimate. —*Tia-Simone Gardner*

Tia-Simone Gardner is an interdisciplinary artist, educator, and Black feminist scholar whose practice draws on ideas of geography, mobility, and stasis, particularly in relation to creating a Black sense of place. Gardner grew up in Fairfield, Alabama, and received her B.A. in art and art history from the University of Alabama in Birmingham and her M.F.A. in interdisciplinary practices and time-based media from the University of Pennsylvania. Gardner participated as a Studio Fellow in the Whitney Independent Study Program, and has held residencies at IASPIS in Stockholm, Sweden, and the Center for Photography at Woodstock. Gardner was awarded a McKnight Visual Artist Fellowship and Smithsonian Artist Research Fellowship. She lives in Saint Paul, Minnesota.

PLATE 51

Tia-Simone Gardner (born 1983). From the series *Neither One or Somewhere in Between,* 2008–18. Foam, metal, and archival inkjet prints, 18⅞ × 10 × 12 in. (48 × 25.4 × 30.5 cm). Courtesy of the artist. Photo by Rik Sferra.

Courtney Garvin

"In These Clasped Hands" started as a set of documentary portraits of my family that originally accompanied a written capstone that looked at racism, slavery, and the ability to create an accurate family tree. While working on the project, the Mother Emanuel AME shooting happened in Charleston, and I couldn't continue the project without acknowledging the current acts of racism that were going on around me. The project became about my family, intergenerational traumas, community, and some of the multifaceted aspects of Black life. —*Courtney Garvin*

Courtney Garvin is a visual artist who was born in South Carolina and raised in New York. She received her B.S. from Syracuse University with a minor in art photography in 2016 and was a 2018 Magnum Foundation Photography and Social Justice Fellow. Her work primarily uses photography, video, and sound and is centered on the way Blackness can be presented. Her work stems from a deep interest in family histories, memory, sexuality, storytelling, and exploring the boundaries between relationships.

PLATE 52

Courtney Garvin (born 1994). *Bre and Josh,* 2015. From the *In These Clasped Hands* series. Pigmented inkjet print, image 16 × 24 in. (40.6 × 61 cm), sheet 16 × 24 in. (40.6 × 61 cm). Courtesy of the artist.

Bill Gaskins

This series of photographs explore questions I'm posing about race, photographic representation, and the possibilities of the photographic portrait in the twenty-first century. An entry point for this work is the storied relationship between the Cadillac and African American men, and a period when the Cadillac and American automotive manufacturing was marketed and regarded as the "Standard of the World." —*Bill Gaskins*

Bill Gaskins explores questions about visual and media culture through photography and media from an interdisciplinary professional and academic foundation that includes his body of arts and culture writing framed through photography, the history of photography, visual and material culture, and American and African American studies scholarship. He is the author of the groundbreaking monograph *Good and Bad Hair: Photographs by Bill Gaskins* (1997), and has published essays and reviews in numerous journals, including *The Society of Contemporary Craft, Artsy, Exposure: The Journal of The Society of Photographic Education,* and *The New Art Examiner,* among others. Gaskins has exhibited his work at the Crocker Art Museum in Sacramento, CA; Brooklyn Museum; Detroit Institute of Arts; and the Smithsonian Anacostia Community Museum. He is the director of the photographic and electronic media M.F.A. program at the Maryland Institute College of Art. Gaskins received his B.F.A. from the Tyler School of Art, his M.A. from The Ohio State University, and his M.F.A. from the Maryland Institute College of Art.

PLATE 53

Bill Gaskins (born 1953). *Michael Baldwin, Branch Brook Park, Newark, NJ,* 2007. From *The Cadillac Chronicles* series. Archival pigment print, 48 × 64 1/2 in. (121.9 × 163.8 cm). Courtesy of the artist.

John F. Glanton

At the time that my father, John F. Glanton Sr., was photographing the people and places of the Twin Cities, in the mid-1940s and early 1950s, African Americans enjoyed a thriving community here. Minneapolis was no Chicago or Detroit, but African American social clubs, political organizations, and churches abounded during this time. —*Joan Glanton Howard*

John F. Glanton was born in Minneapolis, about twenty years after his parents Herbert and Rosalind Glanton migrated there from Hogansville, Georgia. At a young age Glanton showed talent for the piano, and he studied at the MacPhail School of Music. In high school he joined the photography club and discovered his love of the medium. While serving in the military during World War II he learned drafting and later in life became a civil engineer. Back in Minneapolis after the war, he began a career as a photographer and established his own photography studio. His primary client was the *Minneapolis Spokesman*, a local African American newspaper. He continued his practice of photography after changing careers to engineering. A treasure trove of more than eight hundred negatives was discovered in his home after his death. This became the John F. Glanton Collection, now housed in the Hennepin County Library.

PLATE 54

John F. Glanton (1923–2004). *Untitled,* 1940s. Digital print from 4 × 5 film negative, image 10 × 7½ in. (25.4 × 19 cm), sheet 12 × 10 in. (30.5 × 25.4 cm). Hennepin County Library, John F. Glanton Collection. Copyright 2018 by the Children of John F. Glanton. Courtesy of the Hennepin County Library and the Children of John F. Glanton. GLAN0806.

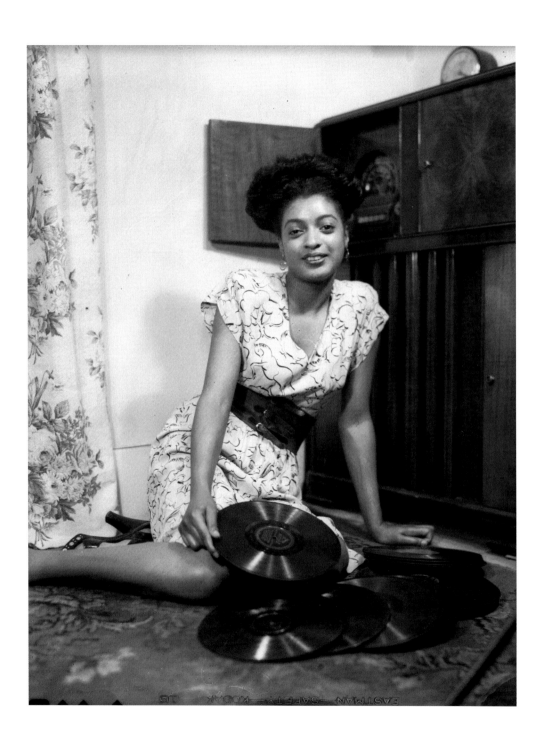

Tony Gleaton

The images I produce most often are ones in which people look directly and openly into the camera, yet the most important aspect of these portraits is the giving of a narrative voice by visual means to people deemed invisible by the greater part of society. And in doing so deliberately crafting an "alternative iconography" of what beauty and family and love and goodness might stand for. One that is inclusive not exclusive. —*Tony Gleaton*

Tony Gleaton was born in Detroit. In the late 1950s his family moved to Los Angeles, where he attended high school. After military service he attended the University of California, Los Angeles, and became interested in photography. Gleaton moved to New York and worked for several years as a photographer in the fashion industry. In his early thirties he began a series of extended travels, eventually reaching sixteen countries, which resulted in his distinctive body of work. His photographs of Black cowboys were seen in the traveling exhibition *Cowboys: Reconstructing an American Myth*. The Smithsonian Institution extensively toured his exhibition *Africa's Legacy in Mexico*. Works by Gleaton are included in the permanent collections of the Brooklyn Museum, Field Museum in Chicago, and the Smithsonian American Art Museum.

PLATE 55

Tony Gleaton (1948–2015). *Hija Negra/Flor Blanca/Black Girl/White Flower* (*Mango Creek, Belize*), 1992. Digital gelatin silver print, image 16 × 16 in. (40.6 × 40.6 cm), sheet 24 × 20 in. (61 × 50.8 cm). Copyright 2021 Tony Gleaton. All Rights Reserved. Courtesy of the Tony Gleaton Photographic Trust.

Goodridge Brothers Studio

During the decade or so between William's second marriage and his untimely death, he and Gertrude assembled an album of family portraits that is a rare glimpse into the private lives of the Goodridges. It reveals that although the Goodridges were at the pinnacle of professional achievement, they could also use their cameras to create a series of family "snaps."
—*John Vincent Jezierski*

In 1847 Glenalvin Goodridge began making daguerreotypes in York, Pennsylvania, in his studio known as Goodridge's Daguerrian Rooms. In the late 1850s his brothers Wallace and William O. Goodridge joined the business, creating one of the earliest and most enduring photographic enterprises in the United States. The Goodridge Studio relocated to East Saginaw, Michigan, in 1863. The studio specialized in the latest photographic technology, and the Goodridges documented nearly everything imaginable, from the fire department to the police department, from factories to logging camps, from churches to residences. After Glenalvin died in Minneapolis in 1867, his brothers continued the business. Their work appeared in the Forestry Division portion of the U.S. Department of Agriculture's exhibit at the 1889 Exposition Universelle in Paris. The Goodridge Brothers Studio continued operations until 1922—an astounding photographic legacy that lasted seventy-five years.

PLATE 56

Goodridge Brothers Studio (1947–22). *Gertrude Watson Goodridge and William O. Goodridge, Jr.,* 1883. Inscribed in plate: "Age 3 months/Taken June 18, 1883/W.O. Goodridge Jr." Tintype, 3⁷⁄₁₆ × 2½ in. (8.7 × 6.4 cm). University of Minnesota Libraries, Department of Archives and Special Collections.

Age 3 months
Taken June 18, 1883
W. O. Gravendyke Jr.

Kris Graves

"A Bleak Reality" is a series of eight photographs made at the exact locations where eight unarmed Black men were murdered by police officers. Over the course of eight days, I traveled across the country in search of eight Black, male subjects who will never sit in my studio—I set out to document the physical spaces where, one by one, their lives ended. We know their names well by now, even if we will never know the men (and the children) who wore them. They've already been replaced by a crop of new ones that will themselves—either today or tomorrow—also be supplanted. —*Kris Graves*

———————————

Kris Graves is an artist and publisher based in New York and London. He works to elevate the representation of people of color in the fine art canon and to create opportunities for conversation about race, representation, and urban life. Graves creates photographs of landscapes and people to preserve memory. He received his B.F.A. in visual arts from S.U.N.Y. Purchase. He has been published and exhibited globally, including at the National Portrait Gallery in London, England; Aperture Gallery, New York; and University of Arizona, Tucson. His work is included in the permanent collections of the Museum of Fine Arts, Houston; Brooklyn Museum; and The Wedge Collection, Toronto. Graves also sits on the board of Blue Sky Gallery, the Oregon Center for the Photographic Arts, Portland; and The Architectural League of New York as vice president of photography.

PLATE 57

Kris Graves (born 1982). *The Murder of Philando Castile, Falcon Heights, Minnesota,* 2016. From the series *A Bleak Reality*. Pigmented inkjet print, 16 × 20 in. (40.6 × 50.8 cm). Courtesy of the artist and ParisTexasLA.

Walter Griffin

I developed a curiosity about photography in a third-grade science class. It was magical to see an image appear on a white piece of paper immersed in liquid. That magic has driven my life.

I first studied photography at South Side Community Art Center in Chicago and worked in a darkroom built by Gordon Parks. South Side Community Art Center was the creative hub for the Black community in Chicago, providing dance, painting, textile design, printmaking, rehearsal space for musicians, and a gallery for art exhibitions. I loved being able to exhibit my photographs so others could see what I had seen. I've photographed civil rights, jazz musicians, cityscapes, cultural events, dancers, and the seasons of life worldwide. My work has been exhibited in more than 150 single-person and group exhibitions, including in the Twin Cities at the Minneapolis Institute of Art, Guthrie Theatre, Target Corporation, Macalester College, and Hennepin Theatre Trust, as well as venues across the county. —*Walter Griffin*

PLATE 58

Walter Griffin (born 1947). *Civil Rights March,* March 8, 1990. Gelatin silver print, 9 × 13¼ in. (22.9 × 33.7 cm). Courtesy of the artist.

This photograph was made in Selma, Alabama, on the 25th anniversary of the crossing of the Edmund Pettus Bridge, in which peaceful voting rights activists were beaten by state troopers. The day was remembered as "Bloody Sunday."

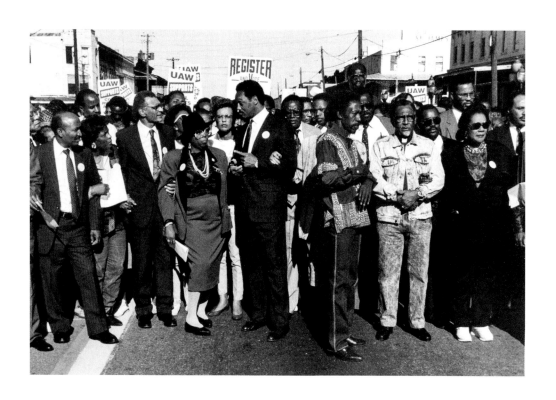

Allison Janae Hamilton

My artwork features uncanny subjects and surreal scenes that blend the epic with the everyday and the disturbing with the delicate within the expanse of the rural American south. The chief concern of my practice is land: I am curious about the ways that the physical environment of the American South contributes to the region's own social construction. I am likewise interested in the role of landscape in the conception and figuring of "Americana." Each work contains narratives that are pieced together from folktales, family lore, and overheard gossip; hunting and farming rituals; African American nature writing; and Baptist hymns. —*Allison Janae Hamilton*

———————————————

Allison Janae Hamilton has exhibited widely across the United States and abroad. Her work has been the subject of institutional solo exhibitions at Massachusetts Museum of Contemporary Art (MASS MoCA) and Atlanta Contemporary. Select recent group exhibitions include *there is this We,* Sculpture Milwaukee; *The Dirty South: Contemporary Art, Material Culture, and the Sonic Impulse,* Virginia Museum of Fine Arts (traveling); *Shifting Horizons,* Nevada Museum of Art; *Enunciated Life,* California African Art Museum; *More, More, More,* TANK Shanghai; *Indicators: Artists on Climate Change,* Storm King Art Center. Work by the artist is held in public collections, including Hood Museum of Art, the Menil Collection, Nasher Museum of Art, Nevada Museum of Art, and Speed Museum of Art, among others. Hamilton has participated in a range of fellowships and residencies, including the Whitney Independent Study Program; The Studio Museum in Harlem; and Fundación Botín, Santander, Spain. She is the recipient of the Creative Capital Award and the Rema Hort Mann Foundation Grant. Hamilton holds a Ph.D. in American studies from New York University and an M.F.A. in visual arts from Columbia University. She lives and works in New York.

PLATE 59

Allison Janae Hamilton (born 1984). *Sisters, Wakulla County FL,* 2019. Archival pigment print, 24 × 36 in. (63.5 × 94 cm). Copyright Allison Janae Hamilton. Courtesy of the artist and Marianne Boesky Gallery, New York and Aspen.

Lucius W. Harper

Lucius W. Harper was born in Texas. He was an accomplished painter and photographer. In 1886 he was listed as an artist in the Galveston directory. In 1894 his painting was shown in the Colored Department of the Texas State Fair in Dallas. He operated a photography studio in Galveston at 1303 29th Street. A devastating hurricane struck Galveston in 1900, killing thousands of people and destroying a third of the city's property, including much of the Black business district. Harper survived the storm and continued to operate in Galveston. He later relocated twice, first to Houston and then to Dallas, finally returning to Galveston permanently by 1914. He made two photographs inscribed "Off for School" depicting his sons Amos and Lucius Jr., in which they are dressed in similar double-breasted suits and posed with their hats and schoolbooks. Harper was wounded in World War I. After he died in 1920, Lucius Jr. continued to operate the Harper Studio through 1928.

PLATE 60

Lucius W. Harper (1867–1920). *Lucius Harper Jr., Off for School,* ca. 1910. Digital copy of silver and photographic gelatin on photographic paper, image 4⅞ × 3⅜ in. (12.4 × 8.6 cm), card 7⅞ × 5⅞ in. (20 × 15 cm). Collection of the Smithsonian National Museum of African American History and Culture. 2014.37.30.3.

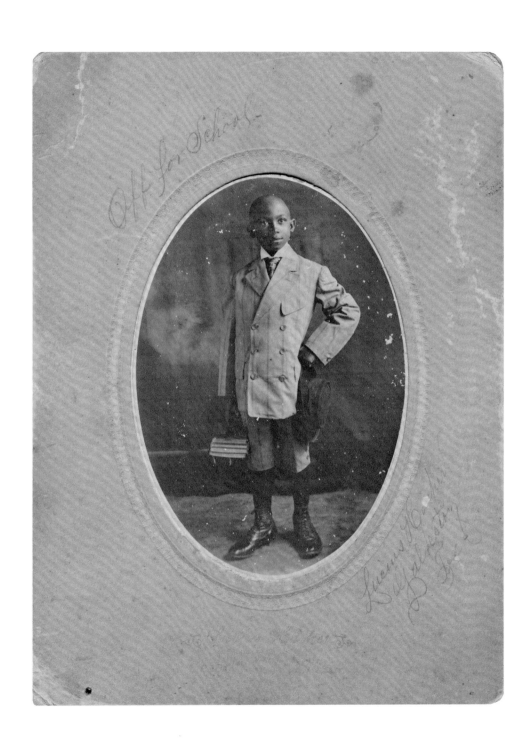

Charles "Teenie" Harris

Charles "Teenie" Harris was born in Pittsburgh's legendary Hill District neighborhood on July 2, 1908, the youngest son of William Franklin Harris and Ella Mae "Olga" Taliaferro Harris, owners of the Masio Hotel. He was nicknamed "Teenie" when he was three years old. During the mid-to-late 1920s, Harris worked at the hotel and for his brother, William "Woogie" Harris, a numbers baron and co-owner of the Crystal Barbershop. Harris bought his first camera in the early 1930s and began photographing celebrities for *Flash Weekly*. He opened a photo studio in the Hill District in 1936, naming it Harris Studio, and maintained it for several years while freelancing with the *Pittsburgh Courier,* a Black newspaper with one of the largest circulations in the country. Harris chronicled the vibrant Black community of Pittsburgh from Jim Crow through the civil rights era. Teenie was the preeminent photographer for the *Courier* but retained the negatives and image rights to his work. Teenie captured everyday experiences as well as the extraordinary people who shaped the twentieth century, including entertainers, civil rights leaders, musicians, politicians, athletes, and educators. As a result of his busy schedule, Harris closed his studio in 1953 and moved his darkroom to his home. Harris retired from the *Courier* in 1975 and continued shooting for friends and family until the mid-1980s. In 1996, Harris entrusted his vast archive of nearly eighty thousand negatives to the Carnegie Museum of Art. He died in 1998, before the first official exhibition of his life's work.

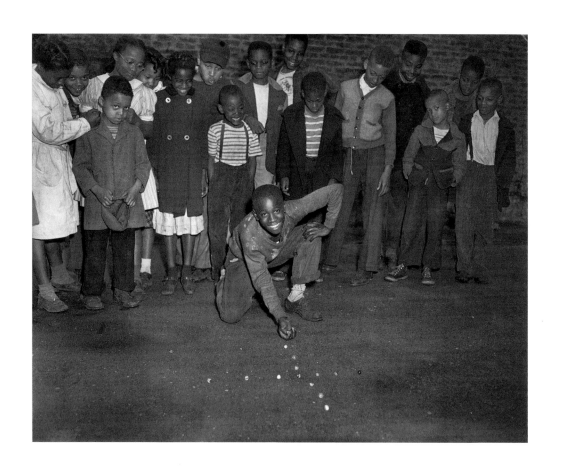

Daesha Devón Harris

"Just Beyond the River" weaves historical imagery and text with found objects and natural elements in the landscape that together elicit incarnations, acknowledgment, and resistance. This work is inspired by stories of the African diaspora, those with both local origins and that of the greater community, including Negro folklore, slave narratives, and Harlem Renaissance poetry, particularly stories that involve the crossing of water. This work highlights America's enduring legacies of colonialism and systemic racism, while reiterating the central narrative that emerges from the referenced memoirs—the ongoing struggle for freedom.—*Daesha Devón Harris*

Daesha Devón Harris is a Saratoga Springs, New York, artist and photographer. Both her multicultural family and the unexpected death of her young father have greatly shaped her life. She holds a B.F.A. in studio art from the College of Saint Rose in Albany and an M.F.A. in visual art from the University at Buffalo. Most recently Harris has been an En Foco Fellowship winner; MDOCS Storyteller's Institute Fellow; Artist-in-Residence at the Center for Photography at Woodstock, Sitka Center for Art and Ecology, Studios of Key West, and Yaddo; Aaron Siskind Foundation Individual Photographer's Fellowship awardee; NYSCA/NYFA Artist Fellow in Photography; Pollock–Krasner Foundation grantee; and named one of the Royal Photographic Society's Hundred Heroines. She is also an avid fisherwoman and hobbyist gardener.

PLATE 62

Daesha Devón Harris (born 1979). *I do not need Freedom when I'm dead. I cannot live on tomorrow's bread,* 2017. From the series *Just Beyond the River: A Folk Tale*. Chromira print and letter opener in hardwood box with etched glass, 31 × 21 in. (78.7 × 53.3 cm). Courtesy of the artist.

... not need Freedom when I'm dead.
I cannot live on tomorrow's bread.

L. Kasimu Harris

As a child, I thought some things would never happen. I never thought that we would have a Black president. I was far more hopeful that my hometown team, the New Orleans Saints, would win the Super Bowl. But then, in the span of just two years, both of my childhood dreams did come true. Taken in New Orleans, my photographs illustrate dreams in various forms. Sometimes, we dream best with our eyes wide open. —*L. Kasimu Harris*

L. Kasimu Harris has shown in numerous solo and group exhibitions across the United States and internationally. In 2018 his *War on the Benighted* series was part of *Changing Course: Reflections on New Orleans Histories* at the New Orleans Museum of Art. His writing and photographs were featured in "A Shot Before Last Call: Capturing New Orleans's Vanishing Black Bars" published in the *New York Times*. Harris has images in several publications, including *Dandy Lion: The Black Dandy and Street Style* (2017) He was among sixty artists selected nationwide for *State of the Art 2020* at Crystal Bridges Museum of American Art and had a solo exhibition, *Vanishing Black Bars & Lounges: Photographs by L. Kasimu Harris,* at the August Wilson African American Cultural Center in Pittsburgh. Harris was a 2018 Artist-in-Residence at the Center for Photography at Woodstock and was a 2020 Joan Mitchell Center Artist-in-Residence.

PLATE 63

L. Kasimu Harris (born 1978). *Obama,* 2009. From the series *Dreams Do Come True.* Pigmented inkjet print, 8⅜ × 12½ in. (21.3 × 31.8 cm). Courtesy of the artist.

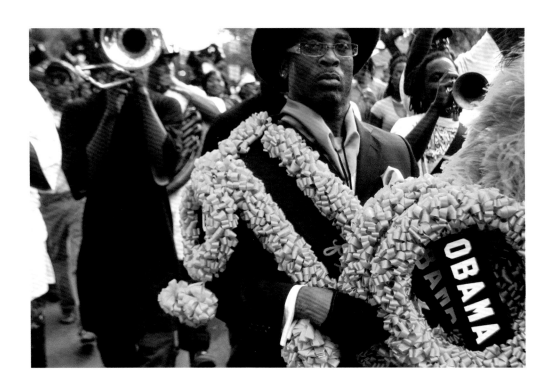

LeRoy Henderson

I just wanted to be out there where things were going on, so I just went out in the street and started shooting. I was looking for visual drama, something in the midst of the ordinary to catch my eye … a part of the American landscape. It's just capturing the things you see in the street that could be very easily overlooked by most people. —LeRoy Henderson

————————————

LeRoy Henderson was born in Richmond, Virginia. At the age of twelve he bought himself a Kodak Brownie Hawkeye camera for his twelfth birthday. He holds a bachelor's degree from Virginia State University and a master's degree from Pratt Institute, with additional study at the School of Visual Arts. His professional career spans more than fifty years and includes fine art photography, photojournalism, corporate events, public relations, aerial and theatrical photography, and advertising. Works by Henderson are included in the permanent collections of the Brooklyn Museum, Virginia Museum of Fine Arts, Schomburg Center for Research in Black Culture, and the Smithsonian National Museum of African American History and Culture. He has participated in exhibitions at the Bronx Museum of the Arts, Brooklyn Museum, BRIC Rotunda Gallery, High Museum of Art, June Kelly Gallery, Smithsonian National Museum of African American History and Culture, The Studio Museum in Harlem, among many others. His work was included in the first edition of *The Black Photographers Annual,* published in 1973. Henderson lives and works in Brooklyn, New York.

PLATE 64

LeRoy Henderson (born 1936). *Tribute to Jimi,* 2017. Pigmented inkjet print, image 14 × 21 in. (35.6 × 53.3 cm), sheet 17 × 22 in. (43.2 × 55.9 cm). Courtesy of the artist.

Jon Henry

"Stranger Fruit" was created in response to the senseless murders of Black men across the nation by police violence. Even with smart phones and dash cams recording the actions, more lives get cut short due to unnecessary and excessive violence. Who is next? Me? My brother? My friends? How do we protect these men? Lost in the furor of media coverage, lawsuits, and protests is the plight of the mother. Who, regardless of the legal outcome, must carry on without her child. The mothers in the photographs have not lost their sons but understand the reality that this could happen to their family. The mother is also photographed in isolation, reflecting on the absence. When the trials are over, the protesters have gone home, and the news cameras are gone, it is the mother left. Left to mourn, to survive. —*Jon Henry*

———————————

Jon Henry is a visual artist working with photography and text. His work reflects on family, sociopolitical issues, grief, trauma, and healing within the African American community. His work has been published both nationally and internationally, and exhibited in numerous galleries, including Aperture Foundation, Smack Mellon, and BRIC Rotunda Gallery. He was recently awarded the Arnold Newman Prize for New Directions in Photographic Portraiture and an En Foco Photography Fellowship for 2020. He was one of LensCulture's Emerging Talents for 2019 and received a Continuing Project Award from the Film Photo Award sponsored by Kodak.

PLATE 65

Jon Henry (born 1982). *Untitled #35, North Minneapolis, MN,* 2019. From the series *Stranger Fruit.* Archival inkjet print, 30 × 24 in. (76.2 × 61 cm). Courtesy of the artist.

Chester Higgins

During my childhood, she made the best blackberry pies in her wooden oven. She would listen to me. I loved her more than my Mom. —*Chester Higgins*

––––––––––––––––––––

Chester Higgins is the author of the photo collections *Black Woman*, *Drums of Life*, *Some Time Ago*, *Feeling the Spirit: Searching the World for the People of Africa*, and *Elder Grace: The Nobility of Aging*. His memoir is entitled *Echo of the Spirit: A Photographer's Journey* (Doubleday), and his work illustrated *Ancient Nubia: African Kingdoms on the Nile* (The American University in Cairo Press). Photographs by Higgins have appeared in *ARTnews*, *New York Times Sunday Magazine*, *Look*, *Life*, *Newsweek*, *The New Yorker*, and other publications. His work is the topic of two films, *An American Photographer: Chester Higgins Jr.*, and *Brotherman*, and has been featured on ABC, CBS, and PBS. His solo exhibitions have appeared at the International Center of Photography; Smithsonian Anacostia Community Museum, National Museum of African Art, and National Portrait Gallery; Museum of Photographic Arts in San Diego; Schomburg Center for Research in Black Culture; and Newark Museum of Art; among others. Higgins is the recipient of grants from the Ford Foundation, Rockefeller Foundation, International Center of Photography, Open Society Institute, National Endowment for the Arts, and The Andy Warhol Foundation for the Visual Arts.

In 2015 he retired from the *New York Times* after thirty-eight years as a staff photographer. His current project, *Sacred Nile*, examines how the ancient cultures of that river have been central to the development of Western religions.

PLATE 66

Chester Higgins (born 1946). *My Great-Aunt and Midwife Shugg McGowan Lampley's Night-Time Prayer, New Brockton, Alabama,* 1968 (printed 2021). Pigmented inkjet print, image 42½ × 28¾ in. (108 × 73 cm), sheet 44 × 32¼ in. (111.8 × 81.9 cm). Courtesy of the artist.

Bobby Holland

From the moment I took my first photograph, I knew what I was meant to do.
—Bobby Holland

———————————

Bobby Holland, a native of Providence, Rhode Island, has spent the last thirty years photographing Hollywood's top entertainers. His destiny as a photographer and filmmaker was sealed when he was a young man, after a neighbor introduced him to the art of photography with a gift of a used 35mm camera. Later, he moved to Los Angeles and began photographing celebrities like Michael Jackson, Quincy Jones, and Stevie Wonder. Photographs by Holland were published as cover images of *Soul Magazine*, *Essence*, *Black Enterprise*, *Jet*, and *Ebony*. After hundreds of portraits and album covers, Holland received a Grammy nomination for Stevie Wonder's 1985 *In Square Circle*. In 2020 the Hollywood Beauty Awards recognized Holland with the award for Outstanding Achievement in Photography.

PLATE 67

Bobby Holland (born 1954). *Earth, Wind & Fire*, 1981. C-print, 16 × 20 in. (40.6 × 50.8 cm). Copyright 2009 Bobby Holland. Courtesy Motion Picture and Television Photo Archive. All rights reserved.

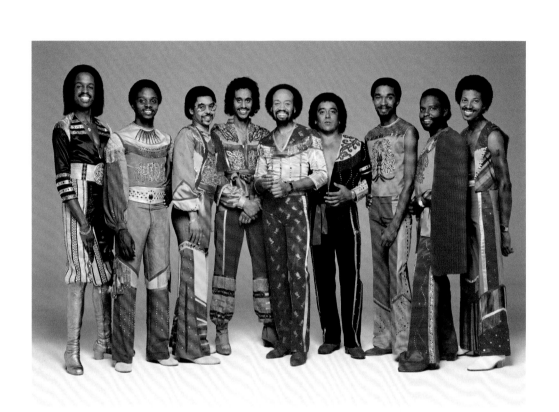

Mildred Howard

Mildred Howard's conceptually driven assemblages depict the human experience and the anthropological quest for knowledge. In the late 1970s, Howard began experimenting with color Xerox machines—then an exciting, new technology—creating collages and self-portraits by positioning images and objects together on the scanner bed. Memory is central to Howard's work: she responds to personal experiences and expands outward, paying homage to past lives. By positioning each individual experience as one element of a larger, collective history, Howard redefines and contextualizes this shared identity.

Howard's work has been widely exhibited, including large-scale installations at Creative Time, New York; INSITE, San Diego; Museum of Glass, Tacoma; National Museum of Women in the Arts, Washington, DC; and New Museum, New York. Her work is included in the permanent collections of numerous institutions, including the San Francisco Museum of Modern Art; de Young Museum, San Francisco; Berkeley Art Museum and Pacific Film Archive; Museum of Contemporary Art San Diego; and San José Museum of Art. Howard has received numerous awards and fellowships, including the Lee Krasner Award in recognition of a lifetime of artistic achievement, Nancy Graves Grant for Visual Artists, Joan Mitchell Foundation Award, and California Arts Council fellowship. Born in San Francisco, Howard received her A.A. in fashion art at the College of Alameda and her M.F.A. from the Fiberworks Center for the Textile Arts at John F. Kennedy University in Berkeley, CA.

PLATE 68

Mildred Howard (born 1945). *Untitled,* 1979. Color Xerox photo collage, 11⅞ × 8⅜ in. (30.2 × 21.3 cm). Courtesy of the artist and Parrasch Heijnen, Los Angeles.

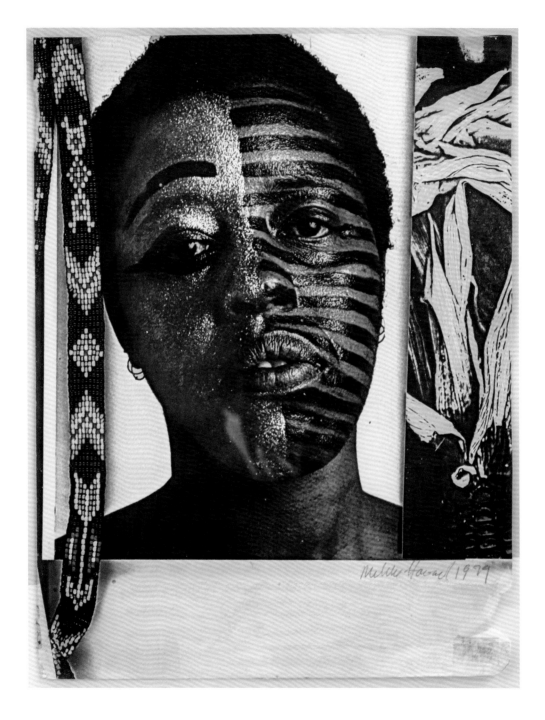

Earlie Hudnall

I want my photos to remind people of something or someone familiar and identify with it in some way. There is no greater gift. Each day that I wake up, I'm just trying to photograph life as I see it. You have to walk around and respect what is about to happen in front of the camera. It's a sacred moment. —*Earlie Hudnall*

Earlie Hudnall was born and raised in Hattiesburg, Mississippi. In 1968, he relocated to Houston to attend Texas Southern University and received his B.A. in art education. Hudnall's photographs have been exhibited widely in museums and art galleries throughout the country and abroad, including the landmark exhibition *Soul of a Nation: Art in the Age of Black Power* at the Museum of Fine Arts, Houston, in 2020, and *Street Dreams: How Hip-Hop Took over Fashion* at the Kunsthal Rotterdam in 2019. His photographs are included in major museum collections, including the Amon Carter Museum of American Art in Fort Worth; Museum of Fine Arts, Houston; Harry Ransom Center at the University of Texas at Austin; Art Institute of Chicago; Schomburg Center for Research in Black Culture; Smithsonian American Art Museum; and Smithsonian National Museum of African American History and Culture.

PLATE 69

Earlie Hudnall (born 1946). *The Guardian,* 1991. Gelatin silver print, 20 × 16 in. (50.8 × 40.6 cm). Courtesy PDNB Gallery, Dallas.

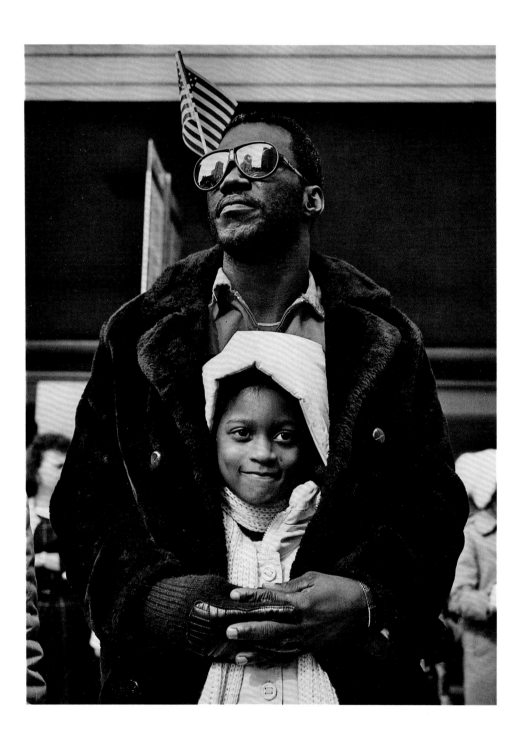

Ayana V. Jackson

Ayana Jackson has used the archival impulse to assess the impact of the colonial gaze on the history of photography and its relationship to ideas about the body. In the series *Take Me to the Water* she has chosen to embrace the magical worlds of speculative fiction. Her new characters inhabit an aquatopia populated by aquahumanoids whose attributes are inspired by African and African diasporic water spirits. Jackson is interested in "the mythic worlds we have studied," yet emphasizes that she is "more concerned with those we have been taught to forget."

By using her lens to deconstruct nineteenth- and early twentieth-century portraiture, Jackson questions photography's authenticity and role in perpetuating socially relevant and stratified identities. Her practice maps the ethical considerations and relationships among the photographer, subject, and viewer, in turn exploring themes around race, gender, and reproduction. Her work examines myths of the Black diaspora and restages colonial archival images as a means to liberate the Black body. Her work is collected by major local and international institutions, including The Studio Museum in Harlem; Newark Museum of Art; JPMorgan Chase Art Collection; Princeton University Art Museum; National Gallery of Victoria, Melbourne; Museum of Contemporary Photography, Chicago; and Bill and Melinda Gates Foundation. Jackson was a 2014 New York Foundation for the Arts Fellow in Photography and the recipient of the 2018 Smithsonian Fellowship.

PLATE 70

Ayana V. Jackson (born 1977). *Consider the Sky and the Sea,* 2019. From the series *Take Me to the Water.* Archival pigment print on German etching paper, 46⅞ × 42⅞ in. (119 × 109.04 cm). Courtesy of Mariane Ibrahim.

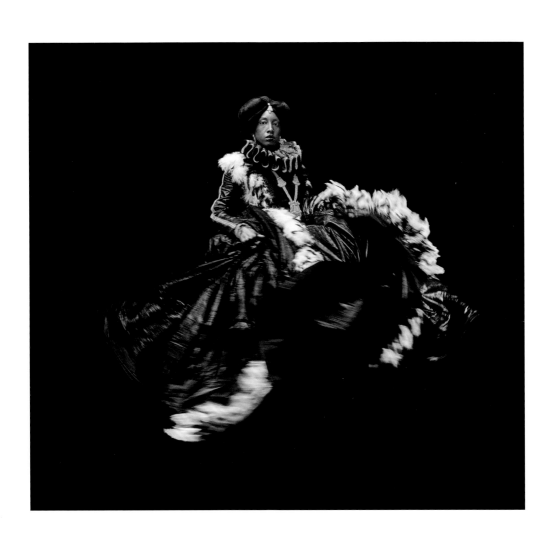

Frank Jackson

I don't have a favorite subject, because what fuels my passion visually is the power that light can give any subject. I discovered that my talent was the ability to see and understand light. Every new photographer has to learn to work with available light. This means you better learn to respect the sun. —*Frank Jackson*

Frank Jackson was born in Jacksonville, Florida. The city got its name from the unusually high number of Jacksons living in the area. Complicating matters was the fact that his father had intended to name him Jack, Jr. Had this happened, Jackson would have been Jack's son Jack Jackson, Jr., from Jacksonville. His mother, however, saw little point in naming him Jack, Jr., as his father's name is Frank. During the confusion, Jackson left for Northern California, settling in the vicinity of Sacramento. He eventually developed an interest in photography after discovering that no matter how skilled he became at drawing, art supplies looked less attractive hanging from his neck than a camera. Jackson's interests and appetites are diverse. He enjoys fresh air, strawberry milkshakes, and black and white film. "I prefer shooting in black and white," says Jackson, "because it forces the viewer to look at the essence of an image . . . its form, tone, light, and shadow . . . instead of being distracted by the decorative effects of color." Jackson is self-trained, leaving others blameless for his level of accomplishment.

PLATE 71

Frank Jackson (born 1956). *Jon Hendricks, Central Park, Early Spring,* 1996. Analog film/archival pigment print, 16 × 16 in. (40.6 × 40.6 cm). Courtesy of the artist.

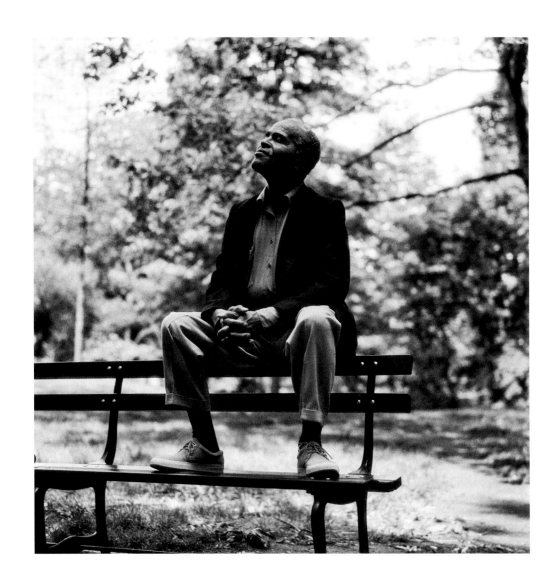

Leslie Jean-Bart

This image is from my Reality & Imagination series, a visual exploration of the interaction between the culture of the host country and the culture of the immigrant who lives permanently abroad. I explore that relationship through photographing the movement of the tide and sand at the beach. The cultures automatically interact in a motion that is instantly fluid and turbulent, just as the sand and tide. It's a constant movement in unison wherein each always retains its distinctive characteristics. This creates a duality that is always present. I chose to accept the upside-down to being as important, if not more so, than the right-side-up world. Because of this approach, the images created pull the viewer into a world that seems instantaneously familiar and unfamiliar.
—Leslie Jean-Bart

———————————

Leslie Jean-Bart has exhibited his work in the United States and abroad. He was born in Haiti, where he acquired his love for the ocean. The call to combine the ocean and the camera was never far from his mind. His mother has suffered from dementia for more than a decade, and Jean-Bart's role as her caretaker has been one of the two major factors powering his creativity and overall view of life these last few years. The second is the magic of the ocean, and its ability to transport him to a place of calmness and beauty. Combining the ocean and the camera came about in *Reality & Imagination* while he was taking care of his mother.

PLATE 72

Leslie Jean-Bart (born 1954). *Parting,* 2015. From the series *Reality & Imagination.* Archival pigment print, image 20 × 30 in. (50.8 × 76.2 cm), sheet 24 × 36 in. (61 × 91.4 cm). Courtesy of the artist.

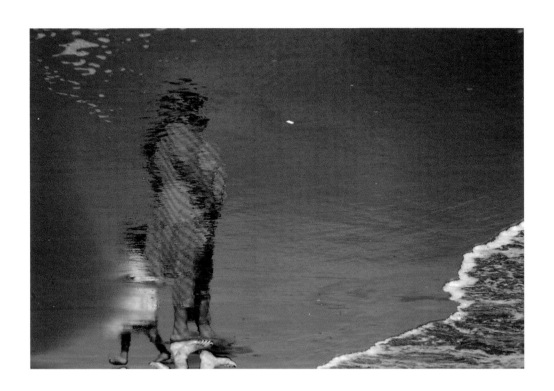

Rashid Johnson

Early on, I had a specific investment in exploring and understanding how Blackness would be defined for me—and by me. I wanted to emphasize the history of Black intellectuals, such as Frederick Douglass, Harold Cruise, W.E.B. Du Bois, so that my shorthand and my form were not just tragic histories.—Rashid Johnson

Born in Chicago, Rashid Johnson is among an influential cadre of contemporary American artists whose work employs a wide range of media to explore themes of art history, individual and shared cultural identities, personal narratives, literature, philosophy, materiality, and critical history. After studying in the photography department of the Art Institute of Chicago, Johnson expanded his practice to embrace sculpture, painting, drawing, filmmaking, and installation. The result is a complex multidisciplinary practice that incorporates diverse materials rich with symbolism and personal history.

Johnson's work has been the subject of numerous one-person exhibitions, including at the Power Plant, Toronto (2019); Museo Tamayo, Mexico City (2019); Institute for Contemporary Art at Virginia Commonwealth University, Richmond (2018); Milwaukee Art Museum (2017); and Grand Palais, Paris (2015). Recent group exhibitions include *Tense Conditions: A Presentation of the Contemporary Art Collection* at the Staatsgalerie Stuttgart and *Grief and Grievance: Art and Mourning in America,* at the New Museum, New York.

PLATE 73

Rashid Johnson (born 1977). *Self-Portrait with My Hair Parted Like Frederick Douglass,* 2003. Lambda print, image 54½ × 42⅛ in. (138.5 × 107 cm), sheet 59⅞ × 46⅞ in. (152 × 119 cm). Edition of 3 + 2 AP. Copyright Rashid Johnson. Courtesy the artist and Hauser & Wirth.

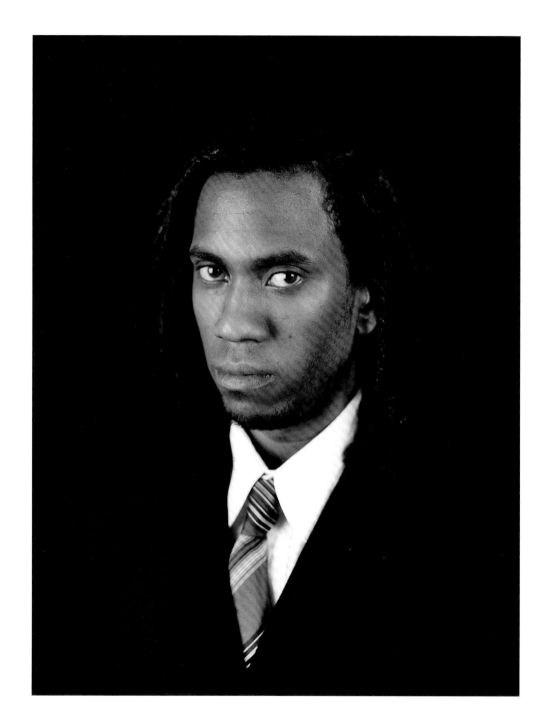

Caroline Kent

Wilma's era was one where W.E.B. Du Bois's conception of "double consciousness" weighed heavy, where in spite of her achievements she could not be emancipated from being named and defined by the gaze of the white other. Kent points to this fractured identity through doubling, reversing, and repeating the image of Wilma's body stretching across the finish line—rendering her identity unstable, multifaceted, and contingent on external factors.... Kent's work ultimately explores the unwavering promise of being an exception beyond all social prejudice and qualifiers. Of course, this is in itself a fiction that has yet to be made a reality—it is the fourth dimension of the contemporary American experience. —*Yesomi Umolu*

Caroline Kent received her M.F.A. from the University of Minnesota, Minneapolis, and a B.S. in art at Illinois State University, Normal. She is a recipient of a Joan Mitchell Foundation Grant and the Artadia Award, as well as the McKnight Fellowship for Visual Arts, Pollock-Krasner Foundation grant, and a Jerome Hill Artist Fellowship in Visual Arts. Kent is an assistant professor of painting at the Weinberg College of Arts and Sciences at Northwestern University, Evanston, IL. Her work is included in the permanent collections of the Art Institute of Chicago, Walker Art Center, Dallas Museum of Art, and New Orleans Museum of Art, among others. Recent exhibitions include *Chicago Works: Caroline Kent,* Museum of Contemporary Art Chicago; *LatinXAmerican,* DePaul Art Museum, Chicago; and *Recent Acquisitions,* Art Institute of Chicago.

PLATE 74

Caroline Kent (born 1975). *Two Wilmas,* 2010. Collage and inkjet print on archival paper, 22 × 17 in. (55.9 × 43.2 cm). Courtesy of the artist.

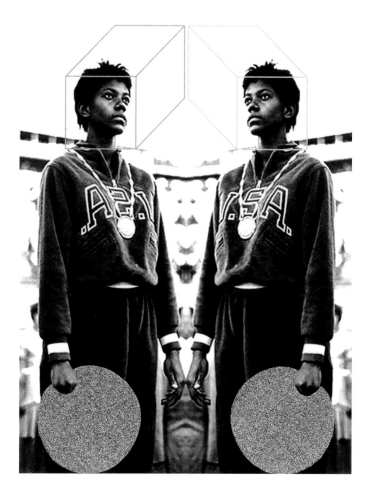

Dionne Lee

Part of my interest in collage is in challenging the history of landscape photography and wanting to disrupt the colonial gaze. By altering these idyllic images of nature, I am also exploring questions around the impression of natural space serving as refuge or site of potential danger. In A Plot That Also Grounds, the gesture presented can be read as opposing acts: one of repair or removal. By opening, or closing, a portal at the center I am thinking about the resiliency of land, the damage done to it by humans, and our own will to repair that damage. —Dionne Lee

Dionne Lee works in photography, collage, and video to explore power, survival, and personal history in relation to the American landscape. Lee received her M.F.A. from California College of the Arts in 2017. She has exhibited work in New York City at the Museum of Modern Art, Aperture Foundation, and the school of the International Center of Photography, and throughout the San Francisco Bay Area at Aggregate Space, Interface Gallery, and the San Francisco Arts Commission. Lee was a 2019 Artist-in-Residence at the Center for Photography at Woodstock and a finalist for the 2019 San Francisco Museum of Modern Art SECA and San Francisco Artadia Awards. Lee lives and works on the unceded territories of the Ohlone and Chochenyo peoples.

PLATE 75

Dionne Lee (born 1988). *A Plot That Also Grounds,* 2016. Archival inkjet print, 35 × 26 in. (88.9 × 66 cm). Courtesy of the artist.

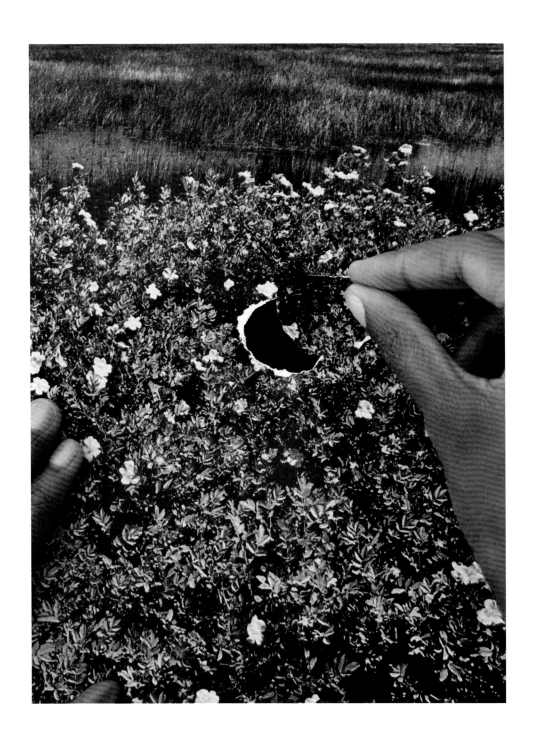

Fern Logan

I don't take images. They are given to me. —*Fern Logan*

————————————

Fern Logan's work has been shown widely since the early 1970s when she emerged as a promising photographer from Paul Caponigro's Apeiron Workshop. Her work was included in exhibitions at The Studio Museum in Harlem and Kenkeleba House, New York, as well as *Committed to the Image: Contemporary Black Photographers* at the Brooklyn Museum and two exhibitions curated by Deborah Willis at the Smithsonian Anacostia Community Museum, *Reflections in Black: A History of Black Photographers, 1840 to the Present* and *Imagining Families: Images and Voices.*

Logan's artworks are included in the permanent collections of the Harlem State Office Building; Schomburg Center for Research in Black Culture; Bellevue Hospital Center, New York; and Michigan Technological University, Houghton. Logan is professor emerita of cinema and photography at Southern Illinois University. She also taught photography and graphic design at Elmhurst College and Michigan Technological University. Her book *The Artist Portrait Series,* which included portraits of prominent Black artists such as Romare Bearden, Elizabeth Catlett, and Jacob Lawrence, was published by Southern Illinois University Press. Logan was recognized for this work with a grant from the New York State Council on the Arts. Her work with digitally manipulated imagery was honored with two Illinois Arts Council Fellowships.

PLATE 76

Fern Logan (born 1945). *Mom in the Clouds,* 1986. Gum bichromate, 10 × 13 in. (25.4 × 33 cm). Courtesy of the artist.

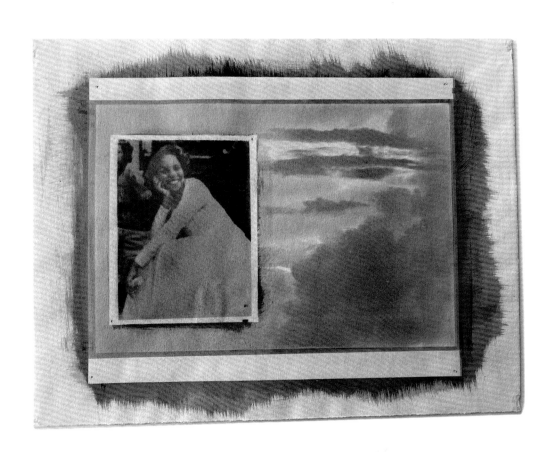

Stephen Marc

As a documentary/street photographer and digital montage artist, I've been engaged in projects that explore the diversity of American identity, sense of place, and history, often with an emphasis on the African American community. Currently, my focus is on documenting public space gatherings from the everyday rituals of contemporary life to the celebrations, protests, and other special events that are socially and culturally relevant. I am looking for the ways we define ourselves and recognize each other. —*Stephen Marc*

Stephen Marc is a professor of art in the Herberger Institute for Design and the Arts at Arizona State University. Raised between Chicago and Champaign, IL, he began teaching at ASU in 1998, following twenty years at Columbia College Chicago. Marc's most recent book, *American/True Colors* (2020), addresses who we are as Americans in a polarized country with changing demographics, from an African American perspective. Marc's three earlier books include *Urban Notions* (1983), addressing the three Illinois communities where he had family ties; *The Black Trans-Atlantic Experience: Street Life and Culture in Ghana, Jamaica, England, and the United States* (1992); and *Passage on the Underground Railroad* (2009), digital composites that provide insight into the historic sites and the institution of slavery. Marc was awarded a Guggenheim Foundation Fellowship in Photography in 2021.

PLATE 77

Stephen Marc (born 1954). *Untitled (Columbia, South Carolina)*, 2015. Digital photograph/inkjet print, 16 × 24 in. (40.6 × 61 cm). Courtesy of the artist.

A State Trooper is on guard at a Ku Klux Klan rally on the south side of the South Carolina State House. The KKK banner identifies them as "The Original Boys N The Hood." The event was held one week after the Confederate battle flag was retired from the South Carolina State Capitol Grounds, Columbia, S.C.

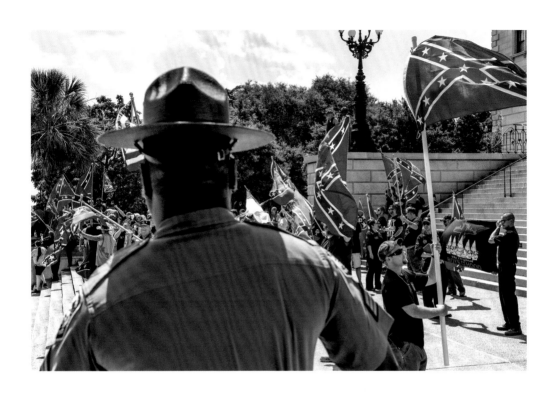

Robert H. McNeill

One time I took a picture of Mrs. Roosevelt and Mrs. Bethune together. My flashbulb exploded and, oh boy, did everybody freeze! Her Secret Service agent asked, "What happened?" I said there's just too much personality for one poor flashbulb to tolerate between Mrs. Roosevelt and Mrs. Bethune. That relaxed everybody and I went and got another flashbulb. After that, they required that we put a shield over our flashbulbs when we took pictures of dignitaries. —*Robert H. McNeill*

Robert H. McNeill began taking photographs as a student at Dunbar High School in Washington, DC, and continued during his studies at Howard University. After photographs McNeill made of Jesse Owens in 1936 were published widely in the Washington press, he enrolled in the New York Institute of Photography. His subsequent photographs of Black women domestic workers in New York were published in *Flash* magazine. At the age of twenty he was invited by Sterling Brown to join the Federal Writers' Project. The iconic images he produced were published two years later in *Virginia: A Guide to the Old Dominion* and *The Negro in Virginia*. Following military service McNeill became a staff photographer for the Army and the Department of State. His works have been included in numerous exhibitions, including presentations at the Museum of Modern Art, the Smithsonian Anacostia Community Museum, and Virginia Museum of Fine Arts. The Smithsonian American Art Museum and National Museum of African American History and Culture have works by McNeill in their permanent collections.

PLATE 78

Robert H. McNeill (1917–2005). *Self-Portrait,* ca. 1940s (printed 2021). Fiber print from 4 × 5 negative, image 20¾ × 15¾ in. (52.7 × 40 cm), sheet 24 × 20 in. (61 × 50.8 cm). Courtesy of Susan McNeill and the Estate of Robert H. McNeill.

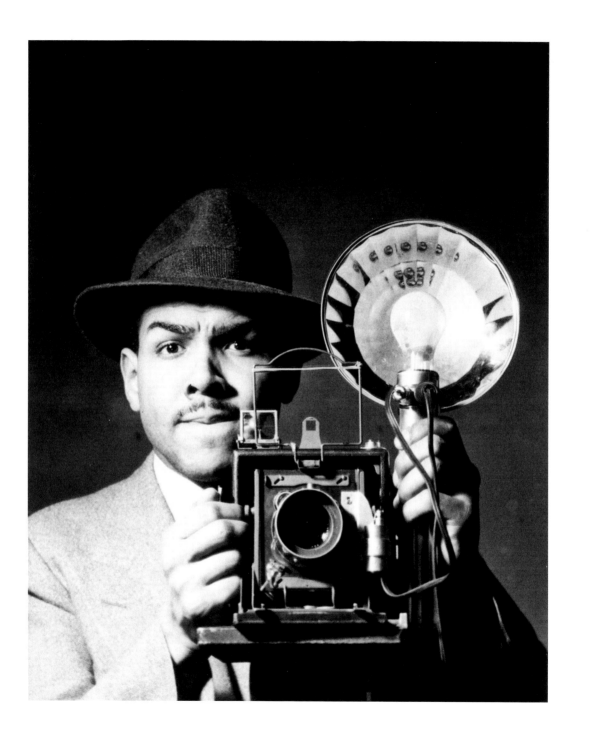

Ozier Muhammad

Ozier Muhammad graduated with a B.A. in photography from Columbia College Chicago. He has been a photojournalist for more than three decades. His first job was as a staff photographer at *Ebony*. Muhammad joined the *Charlotte Observer* in 1978, went to *Newsday* in 1980, and joined the *New York Times* in 1992. He has covered Africa since 1974, first for *Ebony*, going to Dar es Salaam for the Sixth Pan-African Congress, and in 1977 to Lagos, Nigeria, for the Second World Black and African Festival of Arts and Culture (FESTAC). While at *Newsday* he also traveled to Ivory Coast, Mali, Burkina Faso, Ethiopia, Eritrea, Zimbabwe, and Kenya. For the *New York Times* he covered the first nonracial election in South Africa, in which Nelson Mandela became president, as well as stories in Cuba, Haiti, Jamaica, Congo, and Morocco. Muhammad has also worked in Guinea for Amadou Diallo's funeral, the presidential election in Nigeria in 1999, and an alleged Al-Qaeda training camp in central Somalia in 2001. He was in Afghanistan just after the fall of the Taliban and a year later was embedded with the Marines when the war in Iraq began. Muhammad went to New Orleans immediately after the Hurricane Katrina evacuation effort began. More recently, he spent several months traveling with then U.S. Senator Barack Obama during his presidential campaign and the aftermath of the earthquake in Haiti. Muhammad was born in Chicago and lives in Harlem. He is married and has two children.

Nancy Musinguzi

I've dedicated my storytelling practice to investigate, highlight, and amplify underrepresented narratives of those furthest at the margins. Chronicling both the everyday American experience and cultural-shifting moments through a first-generation Black queer lens, I believe documenting one's own community is complex To be seen in this moment means more than hypervisibility, maintaining truth, or shifting narrative. It means being fully engaged in the practice of recentering, listening, and trusting the voices of those most impacted by these moments to bring the rest of us closer in proximity to the reality of things. —*Nancy Musinguzi*

Nancy Musinguzi (they/them/theirs) is a Ugandan/Liberian, first-generation trans/nonbinary American immigrant documentary photographer, visual artist, and storyteller based in Minneapolis. Their current body of work focuses on emerging movements, radical traditions, and imaginations from their own community: Black, immigrant, LGBTQ+ Americans and their lived experiences. Since 2014 they have installed exhibitions and guest curated gallery shows in collaboration with early career and emerging artists, community organizations, foundations, universities, high schools, and youth-led collectives. They have self-published eight photography books, most recently, *The Letter Formally Known As Q,* a multimedia oral history and archival project documenting the intergenerational narratives of queer/trans American immigrants of color and their personal experiences of migrating.

PLATE 80

Nancy Musinguzi (born 1991). *Son of Sons,* 2020. Pigmented inkjet print, image 63½ × 42 in. (161.3 × 106.7 cm), sheet 63½ × 42 in. (161.3 × 106.7 cm). Courtesy of the artist.

On May 26, 2020, Southside residents and community members gathered together to mourn, organize, and march to Chicago Avenue and 38th Street, the site where George Floyd was murdered by Minneapolis police officers the previous day.

Bruce Palaggi

My photographic journey began in the mid-1970s with a Nikkormat FT2 camera. For many years my Nikons and I were inseparable! Circumstances in my life changed and, for too long a period, I rarely touched my cameras. In the fall of 2005, with the purchase of my first "real" digital camera, the love affair began again. There have been many photographers whose work I have admired, but my favorites have been Gordon Parks, Pete Turner, Jay Maisel, and Ernst Haas. All shared a passion for capturing life as they viewed it. None were limited by what the standards of the time may have dictated. Whatever I photograph, I want to capture it the way I see it in my mind's eye. This could either be the stark reality of what is in front of me, or it could be the way I imagine it to be. I have many interests in life and, hopefully, these are reflected in my work. I may be attracted to a subject by its color, shape, or texture. What is most important to me, however, is my initial reaction to the subject—that is what I want to capture.—*Bruce Palaggi*

PLATE 81

Bruce Palaggi (born 1953). *Fishin'*, 2007. Pigmented inkjet print, 14 × 11 in. (35.6 × 27.9 cm). Courtesy of the artist.

Gordon Parks

I had experienced a kind of bigotry and discrimination here that I never expected to experience. At first, I asked [Ella Watson] about her life, what it was like, and [it was] so disastrous that I felt I must photograph this woman in a way that would make me feel or make the public feel about what Washington, D.C., was in 1942. So, I put her before the American flag with a broom in one hand and a mop in another. And I said, "American Gothic"—that's how I felt at the moment.
—*Gordon Parks*

Gordon Parks was born in Fort Scott, Kansas. Following his mother's death, he was sent to live with his sister in St. Paul, Minnesota, at the age of fifteen. From this young age he worked at a variety of jobs. He purchased his first camera at a pawnshop and began his photography career in the Twin Cities. A turning point came with an internship at the Farm Security Administration, for which he created a series of photographs of Ella Watson, including the iconic *American Gothic*. Parks had a monumental career that included work as a photographer, photojournalist, writer, musician, composer, and Hollywood film director. His work continues to be exhibited widely and is included in the permanent collections of the International Center of Photography, Metropolitan Museum of Art, and Museum of Modern Art, among other institutions.

PLATE 82

Gordon Parks (1912–2006). *American Gothic, Washington, D.C.*, 1942. Gelatin silver print, image 11¹³⁄₁₆ × 8⁷⁄₁₆ in. (30 × 21.43 cm), sheet 14 × 10¹⁵⁄₁₆ in. (35.56 × 27.78 cm). Lent by the Minneapolis Institute of Art. Gift of Frederick B. Scheel. 2007.35.169. Courtesy of and copyright The Gordon Parks Foundation.

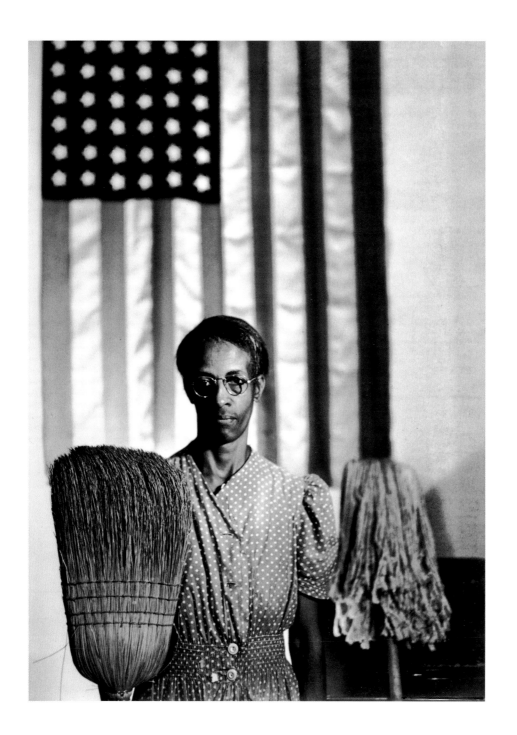

Howardena Pindell

In 1973 I started using television in my work. As a child I had an Etch-A-Sketch toy. You drew on it and lifted the plastic or acetate to erase the image. That led me to layering acetate over the television screen. The action on the screen would redefine the drawing. Sports were the best images as they were in motion, which created a dynamic relationship between the numbers, arrows, and image. Later I started adding text for my *War* series. —*Howardena Pindell*

Born in Philadelphia, Howardena Pindell studied painting at Boston University and Yale University. After graduating, she worked at the Museum of Modern Art for twelve years, finishing her tenure there as associate curator and acting director in the Department of Prints and Illustrated Books. In 1979, she began teaching at the State University of New York, Stony Brook, where she is a full professor. Throughout her career, Pindell has exhibited extensively. In 2017 her work appeared in *We Wanted a Revolution: Black Radical Women, 1965–1985* at the Brooklyn Museum. Her 2018 retrospective at the Museum of Contemporary Art Chicago, *Howardena Pindell: What Remains to Be Seen,* traveled to the Virginia Museum of Fine Arts and the Rose Art Museum at Brandeis University. Pindell's work is in the permanent collections of major museums, including the Metropolitan Museum of Art; Museum of Modern Art; Whitney Museum of American Art; National Gallery of Art; and Louisiana Museum of Modern Art, Copenhagen.

PLATE 83

Howardena Pindell (born 1943). *Video Drawings: Track,* 2007. Cibachrome print, 8 × 10 in. (20.3 × 25.4 cm). Courtesy of Garth Greenan Gallery, New York.

John Pinderhughes

I fell in love with the camera and photography in the mountains of Ethiopia in 1966, working with Operation Crossroads Africa. That summer was all about discovery. Discovering and learning about who I was, just what my place in the world was going to be, and who I was going to become. Some of my first photographs with my new camera, which took me almost a year to save for and buy, were of myself. I was an easy subject since I was readily available and always on call. But more than that, it was a period in my life of deep reflection and contemplation. I was searching for me. I came to be unafraid to show myself; when you look in the mirror you need to be able to see the whole you, not just what your mind wants to see. Be real and explore yourself. Face the truth—both hurtful and joyful! I have tried to use these "Autobiographical" Images to explore me; all that I am, all that I aspire to be, and all that I have become. Over the years I have continued to explore and photograph myself, examining my feelings, emotions, life changes, growth, failings … Autobiographical! —*John Pinderhughes*

John Pinderhughes has been a working photographer for over fifty years. His advertising and editorial client list includes Con Edison, Verizon, Chase Bank, *Black Enterprise* magazine, *Family Circle*, and Odyssey Couleur, among many others. His decades-long career in fine art photography has included exhibitions at the Brooklyn Museum, the Museum of Modern Art, and The Studio Museum in Harlem. He is a member of Kamoinge, Inc., the historic collective of African American photographers established in 1963.

PLATE 84

John Pinderhughes (born 1946). *Coming to Terms with Reality,* 2015. Pigmented inkjet print, image 11 × 11 in. (27.9 × 27.9 cm), sheet 19 × 13 in. (48.3 × 33 cm). Courtesy of the artist.

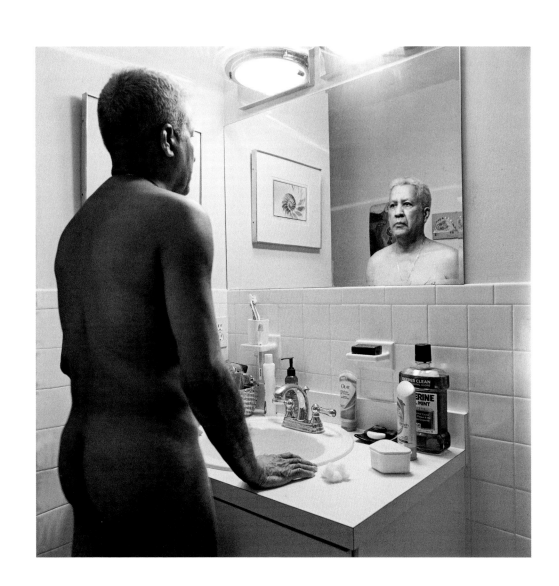

Carl Robert Pope, Jr.

I was interested in environmental portraiture, the mix between the environment and the person. I didn't know any of these people, but they knew my face and felt comfortable with me. I used a toy camera because I thought it was less threatening than a 35mm camera. When I started to print the pictures, I really liked the edge because it looked homemade, the whole look of the image was informal. We understand photography through advertising and through photojournalism, but the most immediate and the most emotionally enriching way is the way that people take pictures of the people they love.—*Carl Robert Pope, Jr.*

—————————

Works by Carl Robert Pope, Jr., are included in the permanent collections of the Museum of Modern Art and Whitney Museum of American Art. In 2018 the Cleveland Museum of Art acquired Pope's epic *The Bad Air Smelled of Roses* (2004-ongoing), consisting of 108 letterpress posters at the time of its acquisition. In 2017 Pope produced a limited-edition print book in association with Nicholas Mirzoeff's *The Appearance of Black Lives Matter,* published by [NAME] and produced a commissioned installation for *Mari Evans: Carl Pope* at the Tube Factory art space in Indianapolis. In 2015 he participated in an artist residency at the Montalvo Arts Center in Saratoga, California.

PLATE 85

Carl Robert Pope, Jr. (born 1961). *Carbondale, Illinois,* 1982. From the series *Toy Camera.* Hand-colored gelatin silver print, image 9 1/4 × 9 7/16 in. (23.5 × 23.97 cm), sheet 19 7/8 × 15 7/8 in. (50.48 × 40.32 cm). Lent by the Minneapolis Institute of Art. The Ethel Morrison Van Derlip Fund. 89.23.1. Copyright Carl Robert Pope, Jr.

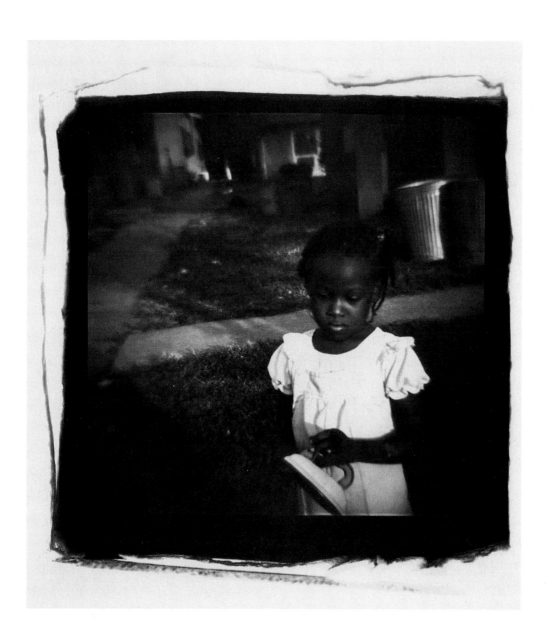

Deborah Roberts

Whether I was aware of it or not, otherness has been at the center of my consciousness since the beginning of my artistic career. My early ideals of race and beauty were shaped by and linked through paintings of Renaissance artists and photographs in fashion magazines. Those images were mythical, heroic, beautiful, and powerful, and embodied a particular status that was not afforded equally to anyone I knew. Those images influenced the way I viewed myself and other African Americans, which led me to investigate the way our identities have been imagined and shaped by societal interpretations of beauty, to critically engage image-making in art history and pop culture, and ultimately to grapple with whatever power and authority these images have over the female figure.—*Deborah Roberts*

Deborah Roberts's work has been exhibited widely and is included in the permanent collections of the Whitney Museum of American Art; San Francisco Museum of Modern Art; Dallas Museum of Art; Scottish National Galleries/American Patrons of the National Library and Galleries of Scotland; ICA Boston; Brooklyn Museum; The Studio Museum in Harlem; Virginia Museum of Fine Arts; Los Angeles County Museum of Art; and Blanton Museum of Art, Austin. She was selected to participate in the Robert Rauschenberg Residency and was a finalist for the 2019 Outwin Boochever Portrait Competition, as well as the recipient of the Anonymous Was A Woman Grant and the Pollock-Krasner Foundation grant. Roberts received her M.F.A. from Syracuse University. She lives and works in Austin, Texas. Roberts is represented by Stephen Friedman Gallery, London, and Vielmetter Los Angeles.

PLATE 86

Deborah Roberts (born 1962). *What else can I do,* 2020. Mixed-media collage on paper, 52 × 38 in. (132 × 96.5 cm). Copyright Deborah Roberts. Courtesy the artist and Stephen Friedman Gallery, London. Private Collection. Photo by Paul Bardagjy.

Herb Robinson

The photographs included in this exhibition are some of my most deeply personal work, as it represents the intersection of my art, my history, and my political activism. "The Three Gentlemen" captures the dignity and beauty of men of African descent, so often under-represented in art and mainstream media. In stark contrast, other photographs in the exhibition are my response to some of the most devastating periods in recent American history, including the aftermath of Hurricane Katrina and the epidemic of murder of young Black men by law enforcement. It is a deliberate act to display images of injustice and tragedy alongside other photographs that capture the elegance of the human form. —*Herb Robinson*

Herb Robinson has been documenting the human experience as a photographer for more than fifty years. Born in Jamaica, West Indies, he immigrated with his family to New York City when he was five. Robinson was one of the original members of the Kamoinge Workshop, the legendary Black photography collective founded in 1963. Robinson's work has been exhibited extensively and was included in two recent landmark traveling exhibitions: *Soul of a Nation: Art in the Age of Black Power,* which opened at Tate Modern in 2017, and *Working Together: Louis Draper and the Kamoinge Workshop,* which opened at the Virginia Museum of Fine Arts in 2020. Works by Robinson are in the permanent collections of the Museum of Modern Art, Whitney Museum of American Art, Virginia Museum of Fine Arts, and the J. Paul Getty Museum.

PLATE 87

Herb Robinson (born 1942). *The Three Gentlemen,* 2013. Archival pigment print, image 12 ¼ × 17 in. (31.1 × 43.2 cm), sheet 17 × 22 in. (43.2 × 55.9 cm). Courtesy of the artist.

Bobby Rogers

Bobby Rogers is a visual historian, photographer, and art director from Minneapolis. His work has broken barriers across various industries and has garnered the attention of publications across the globe. Rogers was named one of the Top Visual Artists to Watch in 2016 by *Minnesota Monthly*, and *City Pages* named Rogers an Artist of the Year in 2017. His work seamlessly blends his passion for design and futurism with his long-standing commitment to intellectual rigor and cultural exploration. His photography incorporates themes of identity, history, and philosophy to tell subtle stories of beauty amid precarity.

After graduating from the Minneapolis College of Art and Design in 2014, Rogers was named the staff photographer for Walker Art Center, and subsequently became the first senior art director of African American style at Target Corporation. His first solo exhibition, *The Blacker the Berry,* premiered at Public Functionary in 2017 to wide acclaim, with *Juxtapoz* magazine writing, "The show is delicately complex and under-stated, yet unapologetically bold and confident in its humility." Rogers has premiered work at various institutions, from the Minnesota Museum of American Art to the International Center of Photography. He has lectured at the Minneapolis Institute of Art, and his writing on the plight of Black Muslimhood was read aloud at the Oxford University Islamic Society.

Rogers's clientele includes Apple, *PAPER* magazine, Timberland, Red Bull, Vox Media, and *City Pages*. He is the co-founder and executive director of The Bureau, an interdisciplinary art studio that produces critical dialogue and intellectual ingenuity through robust artistic production.

Keris Salmon

I've spent years documenting antebellum Southern plantation and slave dwellings through text and image. As a journalist, I am drawn to storytelling through words, and as a visual artist I respect the way an image can bring a text alive. As a filmmaker I'm refreshing the documentary form, working instead with still imagery. And as an African American, I am in the process to explore the many significant links between my people's past and present. I have consulted letters, slave auction records, transcribed WPA-era interviews, and countless books to compile a continuous, though patchwork, narrative of the history of the American slave economy. By coupling the words with impressionistic images, I aim to give voice to life in the crude, quotidian realities behind the grand, sweeping staircases and Spanish Moss of sugar-coated tourist lore.—*Keris Salmon*

Keris Salmon graduated from Stanford University and completed her graduate studies in journalism at the University of California, Berkeley. After a career in documentary filmmaking, she turned to storytelling through the combination of words and still imagery. As an African American woman married to a white man—a descendant of a family that owned the largest American tobacco plantation in the antebellum South— her most recent work explores the foundations of white supremacy and its tragic lasting impact on America. Salmon has had solo exhibitions at the Chrysler Museum of Art, Norfolk, VA; Josée Bienvenu Gallery, New York; and Galerie Frank Elbaz, Paris. Recent group exhibitions include showings at Jack Fischer Gallery, San Francisco, and International Print Center New York.

PLATE 89

Keris Salmon (born 1959). *Tampa,* 2016. From the series *We Have Made These Lands What They Are: The Architecture of Slavery.* Digital print and letterpress text on Hahnemuhle paper, 19 × 13 in. (48.3 × 33 cm). Courtesy of the artist and Arnika Dawkins Gallery, Atlanta.

AARON,
AMERICAN NEGRO, 40, PLOUGHMAN, LABORER...$600

ALEXIS,
CREOLE NEGRO, 36, PLOUGHMAN...$350

PHILIP,
CONGO NEGRO OF THE FIELD, 50...$450

SALLY,
AMERICAN NEGRESS, 50, DOMESTIC...$150

TAMPA,
AMERICAN NEGRESS OF THE FIELD, 30, &
2 CHILDREN JONASSE, 3, DANIEL, 1...$500

Keisha Scarville

The image *Untitled* from the *Surrogate Skin* series explores the body and materiality as a threshold. I engage my late mother's garments as a vehicle for transformation and visualizing absence. I draw inspiration from the aesthetic desires of late nineteenth-century spirit photographers. I aim to transform the fabric into an ectoplasmic, secondary skin. In the series, I am looking at ways I can facilitate and construct a visual place where I can conjure my mother's presence while using my body as a medium. —*Keisha Scarville*

Keisha Scarville was born in Brooklyn, where she lives and works today. Her art weaves together themes dealing with transformation, place, and the unknown. Her work has been widely exhibited, including at The Studio Museum in Harlem; ICA Philadelphia; Contact Photography Festival, Toronto; Aljira, a Center for Contemporary Art, Newark; Caribbean Cultural Center African Diaspora Institute, New York; Museum of Contemporary Diasporan Arts, Brooklyn; Light Work, Syracuse; Brooklyn Museum; Higher Pictures Generation, Brooklyn; and Baxter St at Camera Club of New York. She has participated in artist residencies at Vermont Studio Center, Light Work, Lower Manhattan Cultural Council Workspace Program, Stoneleaf, BRICworkspace, and Skowhegan School of Painting and Sculpture. In addition, her work has appeared in *Vice, Transition, Nueva Luz, Small Axe, Oxford American, The Village Voice, Hyperallergic,* and the *New York Times,* where her work has also received critical review. She is currently an adjunct faculty member at the International Center of Photography and Parsons School of Design in New York.

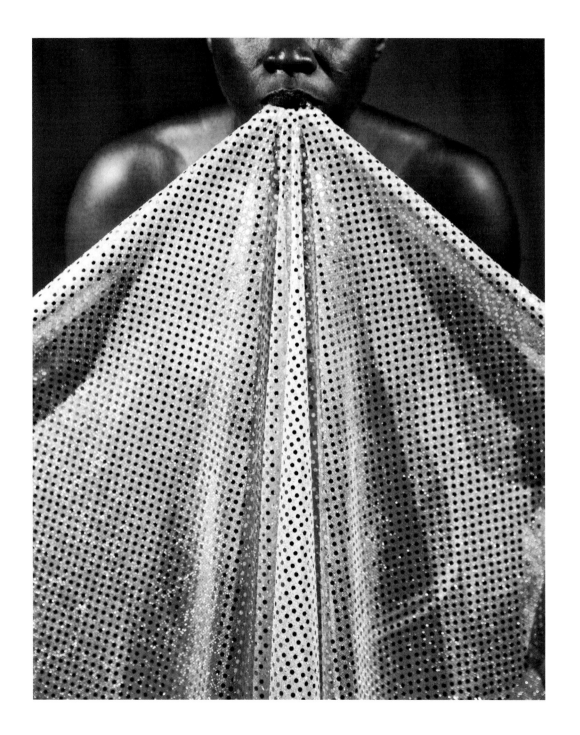

Addison N. Scurlock

Our father would put photographs of famous people and not-so-famous people out there, and people saw this nice display and just walked in and asked if you could make them look as beautiful as the people in the case. —*George Scurlock*

———————————

Addison N. Scurlock was born in Fayetteville, North Carolina, and moved with his family to Washington, DC, in 1900. Scurlock, followed by his sons George and Robert, created a massive photographic archive of African American life and culture in Washington that spanned the twentieth century. In addition to operating their professional photography studios, they also founded the Capitol School of Photography. One of their students, Jacqueline Bouvier, as the inquiring photographer for the *Washington Times Herald,* was introduced to John F. Kennedy while working on assignment. With public funding and private donations, the Archives Center at the National Museum of American History is working in a race against time to preserve and digitally copy the thousands of precious Scurlock Studio negatives before they disintegrate.

PLATE 91

Addison N. Scurlock (1883–1964). *Self-Portrait,* ca. 1920s. Digital copy of photograph, image 10 × 7 in. (25.4 × 17.8 cm), sheet 12 × 9 in. (30.5 × 22.9 cm). Scurlock Studio Records, Archives Center, National Museum of American History, Smithsonian Institution. NMAH-AC0618–001–0000022.

Paul Mpagi Sepuya

There is no ambiguity for me. Everything is very apparent. If you know someone there is no fragment of their body that is ambiguous or unfamiliar, right? —*Paul Mpagi Sepuya*

———————————

Paul Mpagi Sepuya became known for his zine series *SHOOT* (2005–7) and monograph *Beloved Object & Amorous Subject, Revisited* (2008), as well as his contributions to *BUTT* magazine and the reemergence of queer zine culture of the 2000s. He has been Artist-in-Residence at the Lower Manhattan Cultural Council, Center for Photography at Woodstock, The Studio Museum in Harlem, and Fire Island Artist Residency. He has had recent solo exhibitions at the Bemis Center, Omaha (2020–21); DOCUMENT, Chicago (2021); Vielmetter Los Angeles (2020); Modern Art, London (2020); Blaffer Art Museum, Houston; Contemporary Art Museum St. Louis (2019); and Foam, Amsterdam (2018). Sepuya's work is included in the permanent collections of the Museum of Modern Art, Whitney Museum of American Art, Solomon R. Guggenheim Museum, The Studio Museum in Harlem, International Center of Photography, Cleveland Museum of Art, Milwaukee Art Museum, and Carnegie Museum of Art, among others. Sepuya is a recipient of the 2017 Rema Hort Mann Foundation grant. He was born in San Bernardino, California, and received a B.F.A. at the New York University Tisch School of the Arts and an M.F.A. at the University of California, Los Angeles.

PLATE 92

Paul Mpagi Sepuya (born 1982). *Darkroom Mirror (_2010851),* 2017. Archival pigment print, 32 × 24 in. (81.3 × 61 cm). Edition 1 of 5. Courtesy the artist and DOCUMENT, Chicago.

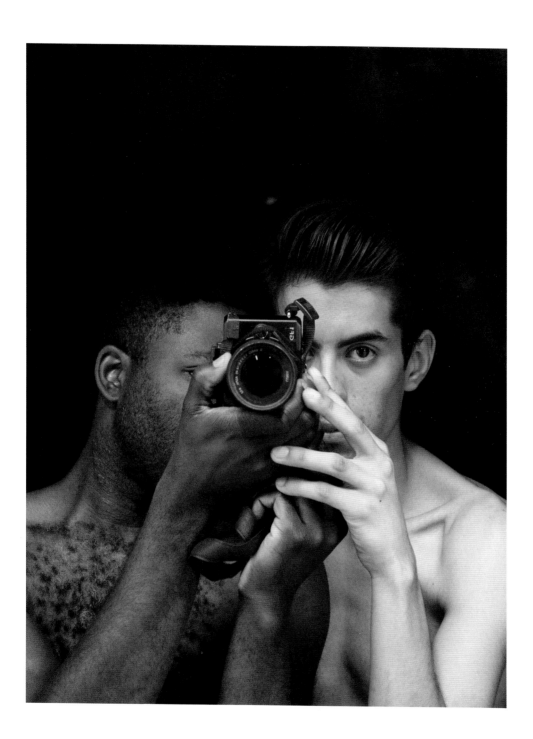

Jamel Shabazz

The cornerstone of my photographic practice is rooted in my desire to contribute to the preservation of African American history and culture, while offering a counter narrative to stereotypical images that always seem present. I started making images as a teenager, inspired by my father who was a professional photographer. It was under his guidance that I learned various aspects of the craft, including light, speed, composition, themes, and print making.

As my interest grew, I began to study the work of photographers James Van Der Zee, Gordon Parks, and Leonard Freed. It was in their images that I found my calling to photograph marginalized communities within the United States. One of the key elements I look for while capturing a decisive moment is love. It is very important to me to have that special ingredient present, in the majority of my work. Having the ability to see is a divine gift, and with it I have a huge responsibility to create images that provoke thought and inspire hope.—*Jamel Shabazz*

Jamel Shabazz is known for his photographs of New York during the 1980s. A documentary, fashion, and street photographer, he has also authored ten books. His photographs have been exhibited worldwide, and his work is housed in the permanent collections of the Whitney Museum of American Art, The Studio Museum in Harlem, and the Smithsonian National Museum of African American History and Culture. Over the years, Shabazz has taught young students at The Studio Museum in Harlem's Expanding the Walls project and the Schomburg Center for Research in Black Culture's Teen Curators program. Jamel Shabazz is the 2018 recipient of the Gordon Parks Foundation Award for documentary photography.

PLATE 93

Jamel Shabazz (born 1960). *Father and Son, New York City,* ca. 2003. Pigmented inkjet print, image 12⅝ × 19 in. (32 × 48.3 cm), sheet 16 × 20 in. (40.6 × 50.8 cm). Courtesy of the artist.

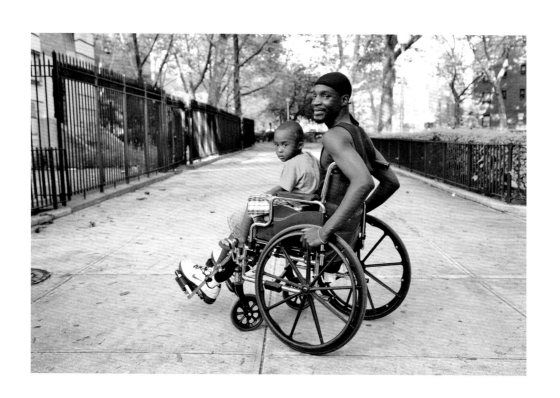

Harry Shepherd

Harry Shepherd was born in Salem, Virginia. In 1888 he established the first photography studio operated by an African American in Minnesota by purchasing the People's Photographic Gallery at 93 East Seventh Street in St. Paul (now the site of a municipal parking garage). By 1889 he owned two studios and employed a staff of eight. In 1898 Shepherd made photographs of the entire Minnesota state legislature. In 1900 he was commissioned by Thomas Calloway to contribute photographs of students at Atlanta University and Tuskegee Institute for the Exposition Universelle in Paris. In 1905 Shepherd moved to Chicago, where he opened a photography studio. In 1909 he relocated to Seattle, and in 1912 he reportedly moved to Los Angeles. The last years of his life are not well-documented.

PLATE 94

Harry Shepherd (1856–?). *Frederick (or Fredrick) L. McGhee (1861–1912)*, ca. 1890. Digital copy of cabinet photograph, 6¼ × 4¼ in. (15.9 × 10.8 cm). Minnesota Historical Society. por 11265 r2.

Frederick Lamar McGhee was born in Aberdeen, Mississippi. He graduated with a degree in law from Knoxville College in Tennessee in 1885. Arriving in St. Paul, Minnesota, in 1889, he was the state's first African American lawyer. Together with W.E.B. Du Bois, he was one of the organizers of the Niagara Movement, the predecessor to the N.A.A.C.P. The three-story home at 663 University Avenue, where he lived with his wife and daughter, has since been demolished and replaced by the American National Bank, which bears a plaque in his honor.

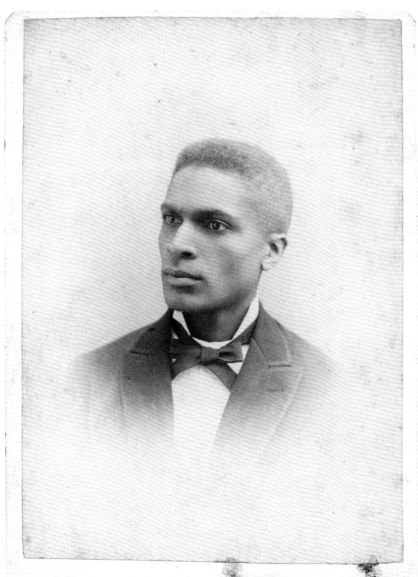

Harry Shepherd

PHOTO. CO.

MINN. STATE AGTL. SOCIETY GOLD MEDAL TO HARRY SHEPHERD 1891

418 & 420
WABASHA STREET,
ST. PAUL.

Coreen Simpson

Sometimes I wish that I'd not been made aware of photo history. This is a double-edged sword. It's good to know history, but then history can suffocate you. A true artist should probably know history but then be able to transcend it or add to it. It's probably valid for an artist to work in the mode of someone who is a great master. I think that if you want to make a statement, then you must somehow transcend. Every artist wants to go a little farther down the road.
—*Coreen Simpson*

———————————

Coreen Simpson's portraits and performative documentary photography include a wide variety of subjects. Her work reveals a depth of character and dignity for her subjects, and have garnered comparisons to the complex photographs of Diane Arbus and Weegee. Today, her work is represented in private collections and numerous institutions, including the Museum of Modern Art; Brooklyn Museum; International Center of Photography; Bronx Museum of the Arts; Musée de la Photographie in Belgium; Peter Norton Family Foundation, Santa Monica, CA; Rush Philanthropic Arts Foundation, Philadelphia; Library of Congress; Smithsonian National Museum of African American History and Culture; and Schomburg Center for Research in Black Culture. Her *Power Images* were featured in the Tony Award-winning Broadway musical *Bring in 'da Noise, Bring in 'da Funk*. Simpson is a Light Work, New York Foundation for the Arts, and New York State Council for the Arts fellow.

PLATE 95

Coreen Simpson (born 1942). *Self-Portrait, West End Ave, NYC,* ca. 1990s (printed 2021). Digital copy of gelatin silver print, image 10 × 7 in. (25.4 × 17.8 cm), sheet 12 × 9 in. (30.5 × 22.9 cm). Courtesy of the artist.

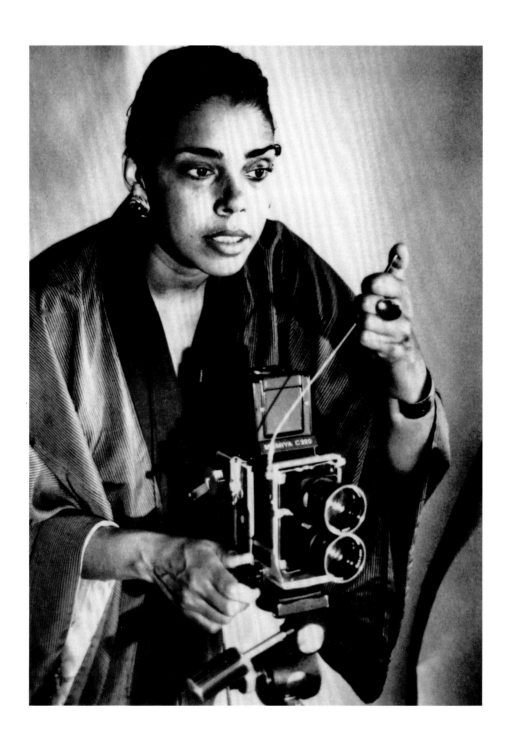

Lorna Simpson

In works such as *1978–1988* (1990) and *Counting* (1991), the lexicon of hair—twists, locks, weaves, braids, tangle, knot—almost imperceptibly signifies African-American culture … a large coil of braided hair repeats the pattern of bricks in the image of a circular slave quarters above it, at once marking the distance and proximity of the past. —*Kellie Jones*

Lorna Simpson was born in Brooklyn, New York. She became well-known in the mid-1980s for her large-scale photograph-and-text works that confront and challenge narrow, conventional views of gender, identity, culture, history, and memory. Her work has been exhibited extensively in one-person exhibitions, including at the Contemporary Art Museum St. Louis (2021); The Fabric Workshop and Museum, Philadelphia (2020); Museum of Contemporary Art Chicago (2017); Jeu de Paume, Paris (2013); Walker Art Center, Minneapolis (2010); and the Whitney Museum of American Art (2007). Recent group exhibitions include *The Doubling* at the National Gallery of Art (2022); *A Site of Struggle* at The Block Museum of Art, Evanston, IL (2022); *Grief and Grievance: Art and Mourning in America* at the New Museum, New York (2021); and *Pictures, Revisited* at the Metropolitan Museum of Art (2020). Her work is included in numerous permanent collections, including the Museum of Contemporary Art Chicago; Museum of Contemporary Art, Los Angeles; Museum of Modern Art; and Whitney Museum of American Art. She has a B.F.A. from the School of Visual Arts and an M.F.A. from the University of California, San Diego.

PLATE 96

Lorna Simpson (born 1960). *Counting*, 1991. Photogravure and screenprint on paper, sheet 73⁷⁄₁₆ × 37¹³⁄₁₆ in. (186.6 × 86 cm). Collection Walker Art Center, Minneapolis. T.B. Walker Acquisition Fund, 1992.

9am-1pm
2am-6pm
11pm-4am
8pm-10pm
9am-11am

310 years
ago

1575
bricks

25 twists 70 braids 50 locks

Marvin and Morgan Smith

During the 1930s, '40s, and '50s, Harlem spread itself before the cameras of Morgan and Marvin Smith like a great tablecloth, and eagerly they went about devouring what it had to offer.
—*Gordon Parks*

———————————

Twin brothers Marvin and Morgan Smith were born in Nicholasville, Kentucky. While growing up they acquired a camera and taught themselves how to use it. The brothers moved to New York City in 1933. In 1937 Morgan became the staff photographer at the *New York Amsterdam News.* Two years later the brothers opened M. Smith Studio near the Apollo Theater in Harlem. They became the official photographers for the Apollo and were acquainted with many artists, performers, and politicians, including W.E.B Du Bois, Eartha Kitt, and Billie Holiday. They also photographed the street life of Harlem, including anti-lynching demonstrations. During the war Marvin was the first Black student to attend the Naval Air Station School of Photography and Motion Pictures. In the 1950s the brothers began work in film and television production. In 1968 they closed their studio, and in 1975 they retired from television work.

PLATE 97

Marvin Smith (1910–2003) and Morgan Smith (1910–1993). *Pearl Bailey,* ca. 1944. Digital copy of silver and photographic gelatin on photographic paper, image $9\,^{11}/_{16} \times 7\,^{11}/_{16}$ in. (24.6 × 19.5 cm), sheet $9\,^{15}/_{16} \times 7\,^{15}/_{16}$ in. (25.2 × 20.2 cm). Collection of the Smithsonian National Museum of African American History and Culture. 2013.118.182.3

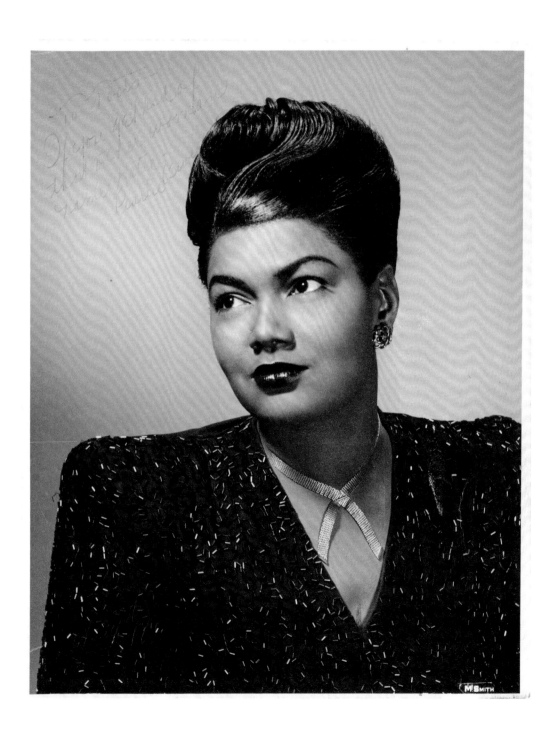

Ming Smith

Street photography is walking around and making something out of nothing, making art from something that you see every day. That sense of discovery—shooting and walking—it's almost a form of meditation because most of the time you're not interacting with anyone else. It's just you and the world.—*Ming Smith*

––––––––––––––––

Ming Smith was born in Detroit and raised in Columbus, Ohio. After graduating from Howard University, she moved to New York. Early in her career Smith joined the historic Kamoinge Workshop as its first female member, the Museum of Modern Art acquired her work for its permanent collection—its first acquisition by a Black female photographer, and her work was included in the inaugural volume of the *Black Photographers Annual*. Smith was included in the landmark exhibitions *Working Together: Louis Draper and the Kamoinge Workshop*, Virginia Museum of Fine Arts (2020); *Soul of a Nation: Art in the Age of Black Power*, Tate Modern (2017); *Pictures by Women: A History of Modern Photography*, Museum of Modern Art (2010); and *Reflections in Black: A History of Black Photographers 1840 to the Present*, Smithsonian Anacostia Community Museum (2000). Her work is included in the permanent collections of the Brooklyn Museum, National Gallery of Art, Philadelphia Museum of Art, Whitney Museum of American Art, and other institutions.

PLATE 98

Ming Smith. *Lady and Child, Pittsburgh, PA*, ca. 1993 (printed ca. 1993). From the series *August Wilson*. Vintage gelatin silver print, 20 × 16 in. (50.8 × 40.6 cm). Copyright Ming Smith. Courtesy of the artist and Mackin Projects, New York.

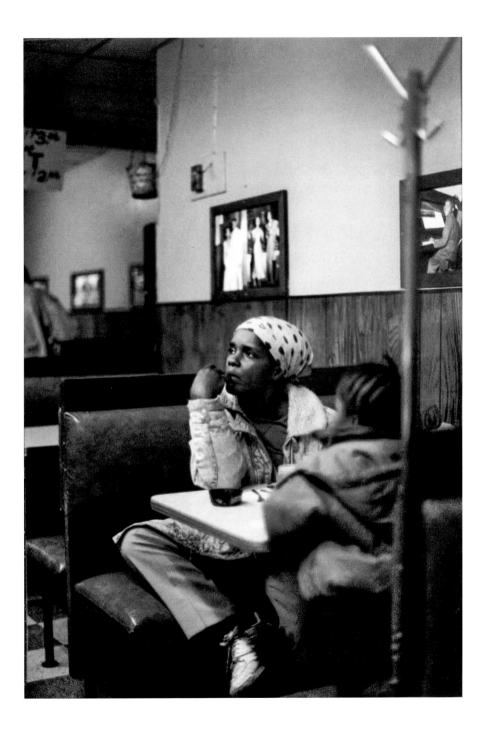

Jovan C. Speller

This work is from the multidisciplinary series *Relics of Home*. This series was largely research based and centered around what I call the Speller Plantation in Windsor, North Carolina (not its real name, but an accurate description of its history). I looked back to this land to examine land ownership, Black labor, and trace origin stories through the depiction of specific sites significant to my family history. The Roanoke River where enslaved people disembarked and were brought to auction, the last house my family owned, the ever-present cotton fields, and the house my grandfather grew up in. These works are representations of a place and time remembered, by the land, and through stories told by those who still inhabit this history. —*Jovan C. Speller*

Jovan C. Speller holds a B.F.A. in fine art photography from Columbia College Chicago. Speller's work has been exhibited at Plains Art Museum, Fargo ND; Bockley Gallery, Minneapolis; and Minneapolis College of Art and Design, and she has upcoming one-person exhibitions at Aspect/Ratio Projects in Chicago and Minneapolis Institute of Art. She is a recipient of the McKnight Visual Artist Fellowship, Next Step Fund grant, Jerome Hill Artist Fellowship, and Minnesota State Arts Board grant. She completed a residency at Second Shift Studio Space in St. Paul and was awarded the Carolyn Glasoe Bailey Foundation Minnesota Art Prize in 2021. Speller is represented by Aspect/Ratio Projects. Her artwork *I Just Came Across the River* (2017) was acquired by the Minneapolis Institute of Art in 2020.

PLATE 99

Jovan C. Speller (born 1983). *Housed in the Body of the River,* 2020. From the series *Relics of Home.* Cut and layered archival digital photographs, 20 × 20 in. (50.8 × 50.8 cm). Copyright Jovan C. Speller. Collection of Gary Metzner. Courtesy of the artist and Aspect/Ratio Projects.

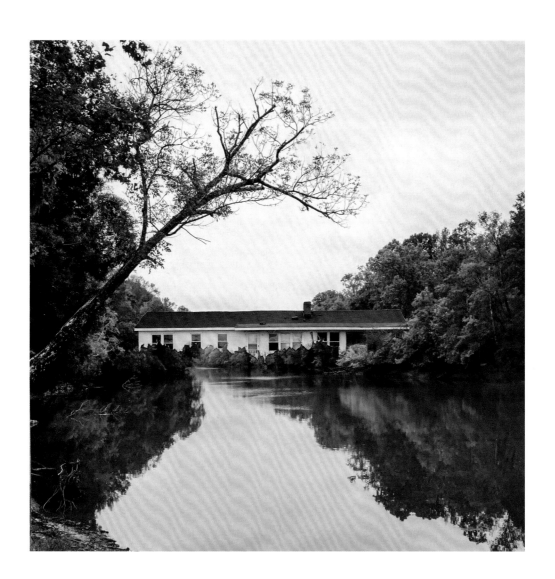

Bruce W. Talamon

These are photographs of David Hammons as seen through the lens of a young African American photographer at the start of his career. I've known David for more than forty-five years. To this day, I don't know why he gave me such intimate access to his process, but I recognize the responsibility I had. I would like to think that we developed a certain level of trust.

—*Bruce W. Talamon*

Bruce W. Talamon was born in Los Angeles. At the age of twenty-one, he purchased his first camera during a foreign study trip to Germany. He photographed Miles Davis and began a prodigious career in photography that has continued for fifty years, working as an editorial photographer for clients such as *Time* magazine and as a movie stills photographer for such studios as Paramount, Warner Brothers, and Universal. His images of musicians are the subject of two books, *Bob Marley: Spirit Dancer* (1994) and *Bruce W. Talamon: SOUL R&B FUNK Photographs 1972–1982* (2018). Talamon's work is in the collections of the Library of Congress, Brooklyn Museum, and Smithsonian National Portrait Gallery. In 2020 he produced advertising campaign photographs for the Tom Hanks movie *News of the World*. His unique photographic record of the artist David Hammons started in 1974 and continues today.

PLATE 100

Bruce W. Talamon (born 1949). *David Hammons Slauson Avenue Studio, Los Angeles,* 1974. From the *Body Print Series*. Digital gelatin silver print, image 20 × 16 in. (50.8 × 40.6 cm), sheet 24 × 20 in. (61 × 50.8 cm). Copyright 2021 Bruce W. Talamon. All Rights Reserved. Courtesy of the artist.

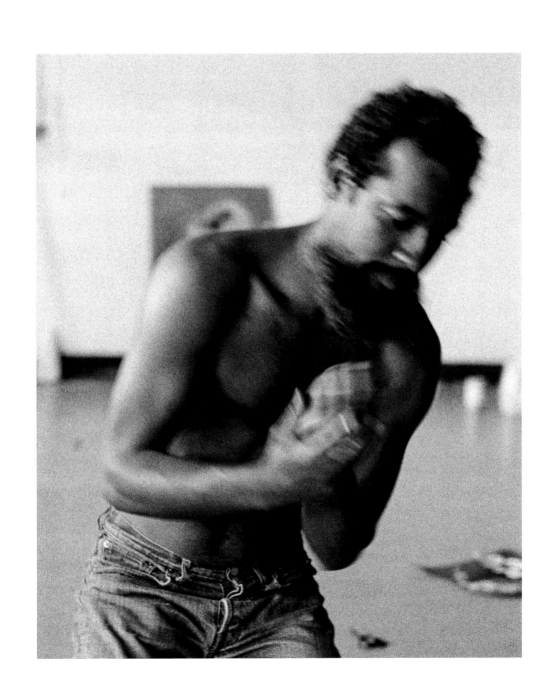

Elnora and Arthur Chester Teal Studio

The Teal Portrait Studio, operated by the husband-and-wife team of Elnora and Arthur, was established in downtown Houston in 1919. The studio, known for the quality of its work, was so successful they opened a second studio in the Fourth Ward. Arthur operated the Fourth Ward studio and Elnora operated the downtown studio. They served an active Black clientele at both locations. The Teal studios prospered through the Great Depression. During the 1940s the Teals sponsored Teal's School of Photography, which was affiliated with the Houston Junior College for Negroes (later Texas Southern University). Elnora continued the studio after Arthur died in 1956. In 1965 other family members continued the business. Photographs by the Teal Studio are in the collections of Prairie View A&M University and the Houston Metropolitan Research Center.

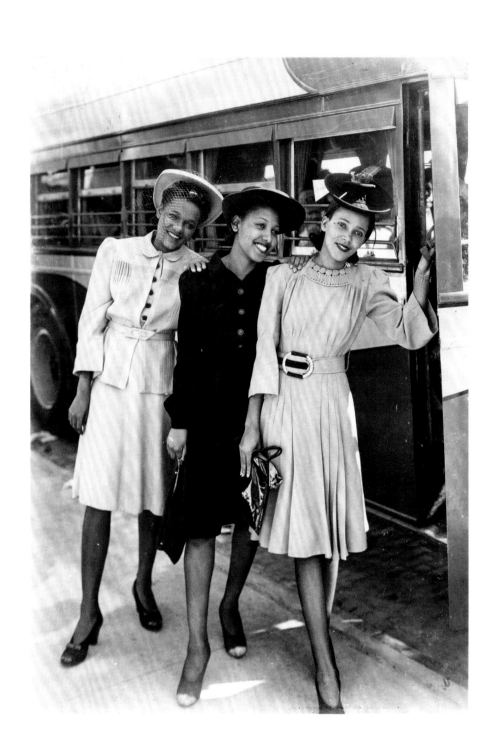

Hank Willis Thomas

Hank Willis Thomas's practice is concerned with revelation and concealment in relation to historical moments. Through mirroring, Thomas asks us to look at ourselves in relation to these transformative events. In this work, Thomas assembled images upon mirrored surfaces that reproduce reporter James "Spider" Martin's photographs of the Selma to Montgomery civil rights marches. By incorporating mirrors into Martin's images, Thomas pulls viewers into the work, implicating them in the events they see.

Hank Willis Thomas is a conceptual artist focusing on themes relating to perspective, identity, commodity, media, and popular culture. His work often incorporates widely recognizable icons—many from well-known advertising or branding campaigns—to explore their ability to reinforce generalizations developed around race, gender, and ethnicity. Work by Thomas has been exhibited throughout the United States and abroad, including at the Guggenheim Museum Bilbao; Musée du quai Branly, Paris; and Witte de With Center for Contemporary Art, Rotterdam. Solo exhibitions of his work have been featured at Crystal Bridges Museum of American Art, Cleveland Museum of Art, Corcoran Gallery of Art, and the Brooklyn Museum. Thomas's work is included in numerous public collections, including the Museum of Modern Art, Solomon R. Guggenheim Museum, and the Whitney Museum of American Art. Thomas is a recipient of the Gordon Parks Foundation Fellowship, the Guggenheim Fellowship, and the New York Foundation for the Arts Fellowship Award. He holds a B.F.A. from New York University and an M.A./M.F.A. from the California College of the Arts.

PLATE 102

Hank Willis Thomas (born 1976). *Bury Me Standing*, 2016. Glass, silver, and digital print, framed 14½ × 11½ × 1½ in. (36.8 × 29.2 × 3.8 cm). Copyright Hank Willis Thomas. Courtesy of the artist and Jack Shainman Gallery, New York.

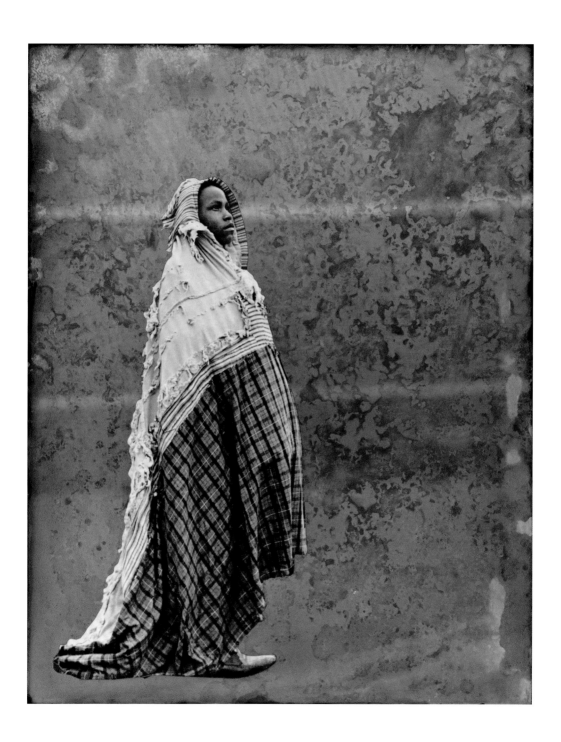

Richard Aloysius Twine

Richard Aloysius Twine was born in St. Augustine, Florida. Twine and his siblings attended St. Benedict the Moor School. In 1916, at the age of twenty, Twine moved to New York, where he is believed to have learned photography. In the early 1920s he returned to St. Augustine and established a photography studio. Twine produced many beautiful studio portraits, and recorded weddings and other community and social events. He also made films and screened them at the Odd Fellows Lodge. After about five years Twine closed his studio and joined three of his brothers in their restaurant venture in the rapidly expanding city of Miami. The family business suffered during the Depression. Twine gave up his photography practice and managed a hotel. After the hotel burned down in the 1960s, he ran a boarding house. Twine died on September 27, 1974. The St. Augustine Historical Society acquired the Twine Collection in 1988, when boxes of glass-plate negatives were found in the attic of the house where the photographer had lived, just before the house was demolished.

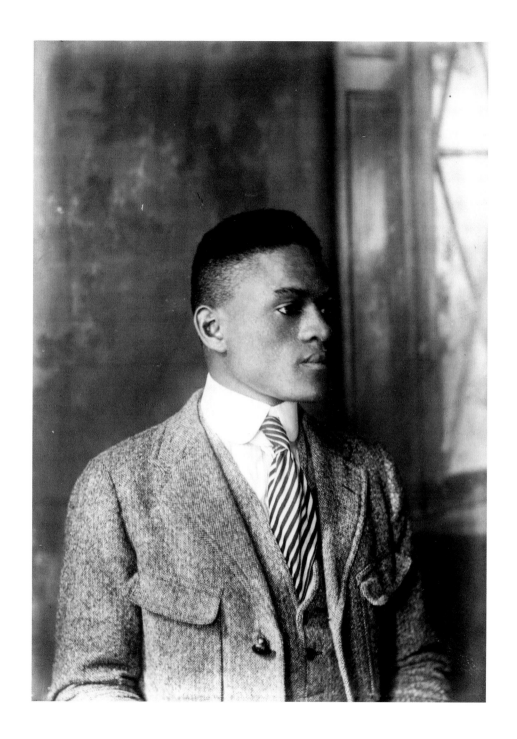

James Van Der Zee

Well, it seems as though I had a personal interest in the pictures … sometimes they seemed to be more valuable to me than they did to the people I was photographing because I put my heart and soul into them. —*James Van Der Zee*

————————

James Van Der Zee was born in Lennox, Massachusetts. He received his first camera at the age of fourteen. At twenty, he moved to New York. In 1915 Van Der Zee was hired as a darkroom technician in Newark, New Jersey. Eighteen months later he returned to New York and opened his first studio in Harlem. Van Der Zee was sought after for portraits of individuals, church groups, and social organizations. During the 1920s and 1930s he photographed many important events and famous personalities in Harlem. His business suffered during the 1940s, and a period of decline followed. His inclusion in the 1969 exhibition *Harlem on My Mind* at the Metropolitan Museum of Art introduced his work to new audiences, and he later began making photographs again. In 1993 the National Portrait Gallery organized an exhibition of his work in recognition of his immense and enduring legacy. In 2021 the Metropolitan Museum of Art and The Studio Museum in Harlem announced that they would share ownership of the James Van Der Zee Archive, comprised of approximately twenty thousand prints and thirty thousand negatives.

PLATE 104

James Van Der Zee (1886–1983). *Miss Suzie Porter, Harlem*. From *Eighteen Photographs* portfolio, 1915 (printed 1974). Gelatin silver print, image 7⁷⁄₁₆ × 6⅛ in. (18.89 × 15.56 cm, mount 14¹⁵⁄₁₆ × 12½ in. (37.94 × 31.75 cm). Lent by the Minneapolis Institute of Art. The Stanley Hawks Memorial Fund. 74.36.5. Courtesy of Donna Mussenden Van Der Zee, New York, New York. © 1998, all rights reserved.

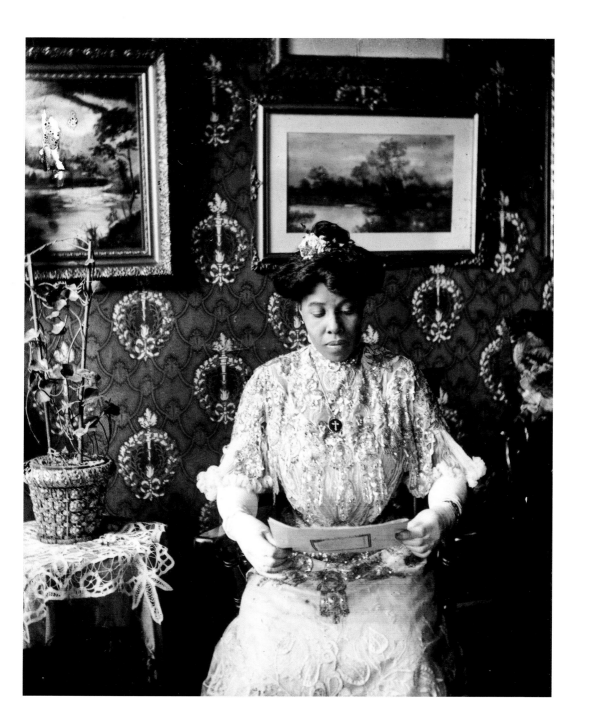

Shawn Walker

The Neutron Bomb is my story. Jazz is my vehicle to sing my song. In this series, I am dealing with reflective surfaces. I am interested in the multilayering and how the interplay of the layers influences the interpretation of their individual meaning and the viewer's understanding of the whole image. Within this, mannequins become the representatives of the absent people; shadows are reminiscent of the "remains" of those vaporized by the Neutron Bomb. These are all analog images that have been "found"—neither computer-generated or enhanced, nor superimpositions done in the darkroom. I am attempting to emulate musicians: taking basic, common themes and reworking them—improvising on them. —*Shawn Walker*

Born and raised in Harlem, New York, Shawn Walker has a B.F.A. from Empire State College and is a founding member of Kamoinge, the longest existing Black photographers' collective. A professional photographer for more than fifty years and a photographic educator for more than forty, he has traveled extensively and exhibited, lectured and been published throughout the world, including at the Smithsonian Anacostia Community Museum, Brooklyn Museum, Whitney Museum of American Art, MoMA PS 1, and San Francisco Museum of Modern Art. His work is included in the permanent collections of the Museum of Modern Art, National Gallery of Art, Carnegie Museum of Art, Whitney Museum of American Art, Virginia Museum of Fine Arts, and other institutions. In 2019 the Library of Congress acquired Walker's archive of nearly 100,000 photographs and his collection of 2,500 items documenting the Kamoinge Workshop.

PLATE 105

Shawn Walker (born 1940). *From Be-Bop to Illusion #1,* 2010. Pigmented inkjet print, image 12½ × 19 in. (31.8 × 48.3 cm), sheet 16 × 24 in. (40.6 × 61 cm). Courtesy of the artist.

Augustus Washington

Augustus Washington was one of the first African American photographers. At the age of twenty-five he established a successful business in Hartford, Connecticut, making daguerreotypes, a skill he learned while a student at Dartmouth College. In addition to producing hundreds of portraits of Hartford's citizenry, he created three daguerreotypes of John Brown while the radical abolitionist was living in nearby Springfield, Massachusetts. Two of these plates are known to have survived: one is now in the collection of the Smithsonian National Portrait Gallery and the other is owned by the Nelson-Atkins Museum of Art. In 1853 Washington, with his wife Cordelia and their two young children, immigrated to Liberia under the partial patronage of the American Colonization Society. In West Africa, Washington prospered as a daguerreotypist, merchant, and farmer. In 1865 he was chosen as Speaker of the House of Representatives of the Republic of Liberia and in 1871 was elected a senator. He died in Monrovia, Liberia, on June 7, 1875.

PLATE 106

Augustus Washington (1820/21–1875). *John Hanson* (ca. 1791–1860), ca. 1857. Digital copy of sixth-plate daguerreotype. Daguerreotype Collection. American Colonization Society Records. Image courtesy Prints and Photographs Division, Library of Congress. LC-USZC4–6824.

Having purchased his freedom from slavery, John Hanson was thirty-six years old when he left Baltimore and immigrated to Liberia. In 1840 he won election to the newly created Colonial Council, Liberia's first popularly elected legislative body. Seven years later, when the independent Republic of Liberia held its first elections, Hanson was one of two senators elected from Grand Bassa County. He served several terms in the Liberian Senate.

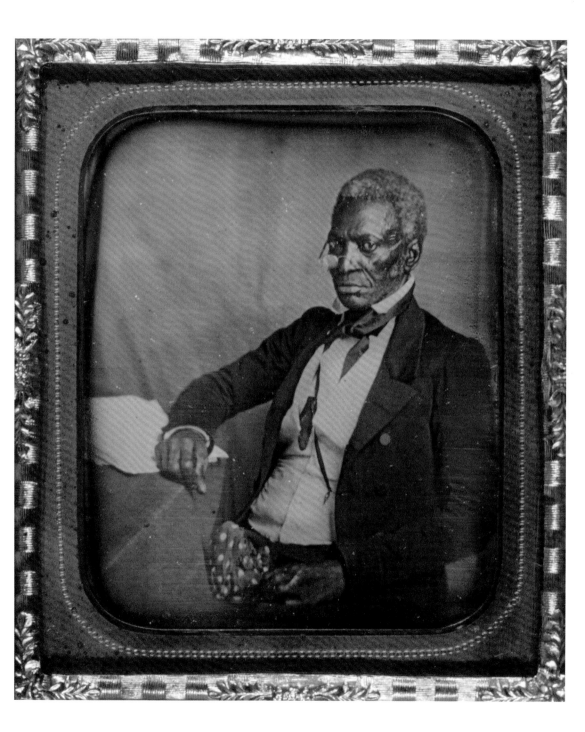

Carrie Mae Weems

The kitchen table series is really a play around notions of family. It's really about how one comes into their own. It's a mock biography of one woman's journey as she contemplates and negotiates what it means to be a contemporary woman who wants something different for herself.
—Carrie Mae Weems

Carrie Mae Weems was born in Portland, Oregon. She has had numerous one-person exhibitions, including at the Württembergischer Kunstverein Stuttgart (2021); *Carrie Mae Weems: II Over Time,* Goodman Gallery, Cape Town (2020); and *Push,* Galerie Barbara Thumm, Berlin (2019). Her work has been included in many group exhibitions, including *Grief and Grievance: Art and Mourning in America,* New Museum (2021); the 13th Havana Biennial (2019); and *We Wanted a Revolution: Black Radical Women, 1965–85,* Brooklyn Museum (2017). Her work is included in the permanent collections of the Metropolitan Museum of Art; Museum of Fine Arts, Houston; Museum of Modern Art; Museum of Contemporary Art, Los Angeles; and Tate Modern. Weems has received the Prix de Rome, an N.E.A. grant, and a MacArthur Fellowship. She has a B.F.A. from California Institute of the Arts and an M.F.A. from the University of California, San Diego.

PLATE 107

Carrie Mae Weems (born 1953). *Untitled,* 1990. Gelatin silver prints, paint on wood; 28 ⅛ × 131 ⁹⁄₁₆ × 1¾ in. (71.4 × 334.2 × 4.5 cm), overall installed (with text panels). Collection Walker Art Center, Minneapolis. Rollwagen/Cray Research Photography Fund, 1991.

Carla Williams

There is the image you present to the camera, but it is never the one the camera records. The relationship is rather like telling one's deepest secrets to a friend. —*Carla Williams*

────────────────

Carla Williams was born and raised in Los Angeles. She received a B.A. at Princeton University, and M.A. and M.F.A. degrees in photography at the University of New Mexico, Albuquerque. In 2020 she presented *Digital Gallery—Femmes Féroces: Material Life X Femmes Noires,* a collaboration with Mickalene Thomas and Lee Laa Ray Guillory, at the Contemporary Arts Center, New Orleans. Williams founded Material Life in 2015 as a retail concept shop inside the Contemporary Arts Center. The space was dedicated to gathering, promoting, archiving, and making accessible the complexity of Black life and history through photography, fashion, books, fine art, and vintage collectibles, with a particular emphasis on African American history. In 2002 she co-authored with Deborah Willis *The Black Female Body: A Photographic History* (Temple University Press). Her published works have also appeared in *Black Women in America: An Historical Encyclopedia* (Oxford University Press), *Encyclopedia of African American Art and Architecture* (Grolier Academic Reference), *Skin Deep, Spirit Strong: The Black Female Body in American Culture* (University of Michigan Press), *Our Grandmothers* (Stewart, Tabori & Chang), and *Picturing Us: African American Identity in Photography* (New Press). Williams participated in Light Work's Artist-in-Residence Program in 1997. Her work is included in the permanent collection of the Princeton University Art Museum.

PLATE 108

Carla Williams (born 1965). *Self-Portrait,* 1987 90 (printed 2021). Pigmented inkjet print, image 18 × 12 in. (45.7 × 30.5 cm), sheet 20 × 14 in. (50.8 × 35.6 cm). Courtesy of the artist.

Deborah Willis

The Right to Vote: Women's Work Never Praised/Never Done! A reimagining. My series of five images focus on women's labor, dress, domestic work, and photography of black women suffragists of the early twentieth century. This work includes my own photographs and images from the archives of women suffragists who carried banners, wore dresses, comfy and fancy shoes in marches and at meetings to discuss their right to vote in America. The metaphor of the clothesline signifies the domestic and club work that women endured to maintain their rights. Included are images of black women who voted for the first time with text and names of the early women in the movement. The sheets, pillows, and banners contextualize and reimagine the comfort they shared in their activism. —*Deborah Willis*

———————————

Deborah Willis is university professor and chair of the Department of Photography and Imaging at the Tisch School of the Arts and director of the Center for Black Visual Culture/Institute for African American Affairs at New York University. She is a recipient of a MacArthur Fellowship and a Guggenheim Fellowship. She is the author of *The Black Civil War Soldier: A Visual History of Conflict and Citizenship* and *Posing Beauty: African American Images from the 1890s to the Present,* among other publications. Willis's curated exhibitions include *Women Creating Nouns, Not Adjectives: Votes for Women* in conjunction with the exhibition *100 Years/100 Women* at the Park Avenue Armory, New York City; *Let Your Motto Be Resistance: African American Portraits* at the International Center of Photography, New York City; *Out [o] Fashion Photography: Embracing Beauty* at the Henry Art Gallery, University of Washington; and *Framing Beauty: Intimate Visions* at the Grunwald Gallery, Indiana University Bloomington. Her recent photographic work is focused on women and the vote.

PLATE 109

Deborah Willis (born 1948). *Women's work never praised, never done,* 2020. Digital C Print, 30 × 40 in. (76.2 × 101.6 cm). Courtesy of the artist.

NOTES TO PLATES

Unattributed quotations were provided by the artists or their representatives. Sources for previously published materials or caption texts provided for this volume are listed below.

ALI, PLATE 1

Salimah Ali quoted in Anthony Barboza and Herb Robinson, eds., *Timeless: Photographs by Kamoinge* (Atglen, PA: Schiffer Publishing, Ltd., 2015), 374.

ALLEN, PLATE 2

Devin Allen quoted in Lakin Starling, "Devin Allen's Photographs are Vivid Love Letters to Baltimore," October 4, 2017, thefader.com.

ANDERSON, PLATE 3

Quotation and text provided by the National Museum of African American History and Culture, Smithsonian Institution, Washington, DC.

ASKEW, PLATE 5

Title and photographer attribution based on research by Deborah Willis. "About This Item," Library of Congress, loc.gov/item/98518743/. Floyd Hall, *Correcting the Canon: The Underexposed Thomas Askew,* October 13, 2016, ArtsATL.org, including citation of Herman Mason, *Hidden Treasures: African-American Photographers in Atlanta, 1870–1970* (Atlanta, GA: African-American Family History Association, 1991).

BAILEY, PLATE 6

Radcliffe Bailey quoted in conversation with Tyler Green, November 5, 2020. Presented by the Sheldon Museum of Art, accessed on University of Nebraska-Lincoln Media hub.

BANKS, PLATE 8

John L. Banks quoted in audio interview with David Vassar Taylor, June 19, 1974, Minnesota Black History Project, Minnesota Historical Society, transcript p. 16, collections.mnhs.org.

BARNES, PLATE 11

Miranda Barnes quoted in *New York Times,* June 21, 2020.

BATTEY, PLATE 12

John Stauffer, Zoe Trodd, and Celeste-Marie Bernier, *Picturing Frederick Douglass: An Illustrated Biography of the Nineteenth Century's Most Photographed American* (New York: Liveright Publishing Corporation, 2015), xviii.

BAYNES, PLATE 13

Andrew Garn quoted in press release for *Polaroid: Instant Joy,* curated by Andrew Garn at A.M. Richard Fine Art, Brooklyn, New York, June 19–July 31, 2010.

BEDOU, PLATE 15

Text provided by the University Library, Xavier University of Louisiana.

BELL, PLATE 16

Hugh Bell quoted in John Durniak, "Hugh Bell," *Popular Photography* (March 1956).

BEY, PLATE 17

Dawoud Bey quoted in "From the Streets into the Studio," in *Dawoud Bey: Seeing Deeply* (Austin: University of Texas Press, 2018), 136–37.

BLACKSHEAR, PLATE 18
Quotation and text provided by Larry Grossberg, edited by Claudia Menza.

BRATHWAITE, PLATE 19
Kwame Brathwaite quoted in preface to Tanisha C. Ford, *Kwame Brathwaite: Black Is Beautiful* (New York: Aperture, 2019), 7–8.

BROWN, PLATE 21
Rules and Regulations Handbook, 1933, A Guide to the Independent Order of St. Luke 1877–1970, Special Collections, Virginia Polytechnic Institute and State University, and Gregg D. Kimball, *The Dictionary of Virginia Biography,* encyclopediavirginia.org.

CARTER, PLATE 26
Quotation and text provided by Sarah Hasted Art Advisory, New York.

CHAMBLIS, PLATE 27
Charles Chamblis quoted in Ben Petry, "Sights, Sounds, and Soul: Twin Cities Through the Lens of Charles Chamblis," *Minnesota Historical Society Magazine* (Spring 2014): 20.

CLENNON, PLATE 30
Mark Clennon quoted in "The Story Behind the Photograph of Protestors Outside of Trump Tower That Resonated around the World," June 2, 2020, time.com.

COLE, PLATE 31
Tameca Cole quoted in Nicole R. Fleetwood, markingtimeart.com.

COLLINS, PLATE 32
Arthé A. Anthony quoted in Kirk Silsbee, "Book Tracks the Work of Creole Photographer," December 3, 2012, *Glendale News-Press.*

DRAPER, PLATE 36
Louis Draper quoted in press release for the exhibition *Louis Draper: True Grace* at Bruce Silverstein Gallery, New York, January 9–February 22, 2020.

EDMONDSON, PLATE 40
Dudley Edmondson quoted in *Artists to Know,* honoringthefuture.org.

ERIZKU, PLATE 42

Awol Erizku quoted in Antwuan Sargent, "Awol Erizku is Creating a New Language," October 1, 2020, gq.com.

FAUSTINE, PLATE 43

Nona Faustine quoted in baxterst.org. Baxter St at the Camera Club of New York.

FENNAR, PLATE 45

Quotation and text provided by The Albert R. Fennar Archive.

FRAZIER, PLATE 49

LaToya Ruby Frazier quoted in Edward Siddons, "LaToya Ruby Frazier's Best Photograph: Me and My Guardian Angel," August 23, 2018, theguardian.com.

GLANTON, PLATE 54

Joan Glanton Howard quoted in preface to *Double Exposure: Images of Black Minnesota in the 1940s; The Photography of John Glanton* (St. Paul: Minnesota Historical Society, 2018), xi.

GLEATON, PLATE 55

Tony Gleaton quoted in press release for the exhibition *The African Legacy in Central America: Tony Gleaton's Photographs from CAAM's Collection*, California African American Museum, January 7–March 20, 2016.

GOODRIDGE, PLATE 56

John Vincent Jezierski quoted in *Enterprising Images: The Goodridge Brothers, African American Photographers, 1847–1922* (Detroit: Wayne State University Press), 2000, 202–3.

PLATE 61, HARRIS

Text provided by Charlene Foggie-Barnett, Teenie Harris community archivist, Carnegie Museum of Art.

HENDERSON, PLATE 64

LeRoy Henderson quoted in Antwaun Sargent, "Photographing Ordinary Life in Passing," *New York Times*, June 19, 2018.

HOLLAND, PLATE 67

Bobby Holland quoted in mptvimages.com.

HUDNALL, PLATE 69

Earlie Hudnall quoted in Paul Moakley, "'I'm Just Trying to Photograph Life as I See It': Earlie Hudnall Jr. Has Spent More than 40 Years Documenting Historically Black Neighborhoods in Houston," August 6, 2020, time.com.

JACKSON, PLATE 71

Biographical text provided by Gordon Lewis, 1998.

JOHNSON, PLATE 73

Rashid Johnson quoted in Jennifer Sauer, "Rashid Johnson Gets Candid About the Greater Meaning of Art," March 6, 2020, crfashionbook.com.

KENT, PLATE 74

Yesomi Umolu, "States of Exception," in *Caroline Kent: Saint Wilma and the 4th Dimension*, Juxtaposition Arts Gallery, Minneapolis, 2013, n.p.

MCNEILL, PLATE 78

Quotation provided by The Estate of Robert H. McNeill.

PARKS, PLATE 82

Gordon Parks quoted in Minneapolis Institute of Art, collections.artsmia.org.

POPE, PLATE 85

Carl Robert Pope, Jr. quoted in Minneapolis institute of Art, collections.artsmia.org.

SCURLOCK, PLATE 91

George Scurlock, quoted in *The Scurlock Studio and Black Washington: Picturing the Promise* (Washington, DC: National Museum of African American History and Culture, 2009), 30.

SEPUYA, PLATE 92

Paul Mpagi Sepuya quoted in Lanre Bakare, "A New Mapplethorpe? The Queer Zine Legend Reinventing the Nude," April 28, 2020, theguardian.com.

SHEPHERD, PLATE 94

Jane McClure, *Frederick L. McGhee*, Saint Paul Historical, saintpaulhistorical.com/items/show/65, and Bonnie G. Wilson, "Working the Light: Nineteenth-Century Professional Photographers in Minnesota," *Minnesota Historical Society Magazine* (Summer 1990): 42–60.

SIMPSON, PLATE 95

Coreen Simpson quoted in interview with Robert Birt, 1987, cited in Lisa Zeiger, "It Takes One to Know One: Coreen Simpson's Divas," May 26, 2019, bookandroom.com.

SIMPSON, PLATE 96

Kellie Jones, "(Un)Seen and Overheard: Pictures by Lorna Simpson," in Kellie Jones, Thelma Golden, Chrissie Iles, *Lorna Simpson* (New York: Phaidon Press), 44–47.

SMITH, PLATE 97

Gordon Parks, foreword to *Harlem: The Vision of Morgan and Marvin Smith* (Lexington: The University Press of Kentucky, 1998), ix.

SMITH, PLATE 98

Ming Smith quoted in Zoe Whitley, "Interview with Ming Smith," March 2021, thewhitereview.com.

TALAMON, PLATE 100

Bruce W. Talamon quoted in "David Hammons, Photographs 1974–1980," in *David Hammons—Body Prints, 1968–1979* (New York: The Drawing Center, 2021), 100.

TEAL, PLATE 101

Jeanne Moutoussamy-Ashe, *Viewfinders: Black Women Photographers* (New York: Dodd, Mead & Company), 44–45.

TWINE, PLATE 103

Dr. Patricia Griffin and Diana Selsor Edwards, "Richard A. Twine: A Brief Biography," *El Escribano: The St. Augustine Journal of History* 53 (2016): 5–11.

VAN DER ZEE, PLATE 104

James Van Der Zee quoted in Deborah Willis-Thomas, "James Van Der Zee: A Community Visionary," in *Harlem Heyday: The Photography of James VanDerZee* (New York: The Studio Museum in Harlem, 1982), n.p.

Text researched and written by Ann M. Shumard, senior curator of photographs, Smithsonian National Portrait Gallery, Washington, DC.

Carrie Mae Weems quoted in James Estrin, "The 'Genius' of Carrie Mae Weems," *New York Times: Lens,* September 25, 2013.

CONTRIBUTOR BIOGRAPHIES

On leave from Cornell University, CHERYL FINLEY is director of the Atlanta University Center Art History + Curatorial Studies Collective and distinguished visiting professor in the Department of Art & Visual Culture at Spelman College. Finley is associate professor of art history at Cornell University. She holds a Ph.D. in African American studies and history of art from Yale University. Her seminal study *Committed to Memory: The Art of the Slave Ship Icon* is the first in-depth study of the most famous image associated with the memory of slavery. Her prolific critical attention to photography produced the co-authored publications *Teenie Harris, Photographer: An American Story*; *Harlem: A Century in Images*; *Diaspora, Memory, Place: David Hammons, María Magdalena Campos-Pons, Pamela Z*; and numerous essays and articles on artists such as Berenice Abbott, Walker Evans, Joy Gregory, Roshini Kempadoo, Lorna Simpson, Hank Willis Thomas, Carrie Mae Weems, and Deborah Willis.

HERMAN J. MILLIGAN, JR., is a managing partner with the Fulton Group, LLC, an independent consulting firm specializing in marketing research, competitive intelligence, nonprofit organizational development, and culturally specific initiatives. Milligan received his Ph.D. in sociology from the University of Minnesota-Twin Cities and his B.A. in sociology from the

University of Wisconsin-Madison. Milligan began the practice of photography in Cambridge, MA, in 1971 and studied photography at the University of Minnesota-Twin Cities Department of Art when he started graduate school in 1972. His curatorial career spans more than forty-seven years. As student director for the Midwest Sociological Society, he organized its first two visual sociology exhibitions (1979, 1981) and has curated exhibitions at various higher education and community organizations.

CRYSTAL AM NELSON is a scholar, curator, and artist who holds a Ph.D. in visual studies from UC Santa Cruz as well as an M.F.A. in photography from San Francisco Art Institute. Her work examines African American art and black visual culture through an interdisciplinary lens. nelson's current project explores the visual culture of black pleasure and engages new modes of black visuality as articulated by painters working in the black romantic figurative tradition. Her writing has appeared in *Feminist Media Histories, Contact Sheet, Brooklyn Rail,* and other publications.

HOWARD ORANSKY is director of the Katherine E. Nash Gallery, operated by the Department of Art at the University of Minnesota. With Lynn Lukkas he co-curated *Covered in Time and History: The Films of Ana Mendieta,* the first full-scale gallery exhibition and publication devoted to the artist's film works. The exhibition traveled to the NSU Art Museum, Berkeley Art Museum and Pacific Film Archive, Bildmuseet (Umeå), Martin Gropius Bau (Berlin), and Jeu de Paume (Paris), and was chosen twice as among the Best Exhibitions of 2016 by *Artforum.* The American Alliance of Museums awarded the catalogue, co-published with University of California Press, First Place for Art Museum Catalogue Design. He has a B.A. in painting from CSU, Northridge, and an M.F.A. in painting from CalArts.

SEPH RODNEY was born in Jamaica and came of age in the Bronx, New York. He has an English degree from Long Island University, Brooklyn; a studio art M.F.A. from the University of California, Irvine; and a Ph.D. in museum studies from Birkbeck College, University of London. He is the opinions editor and managing editor for the Sunday edition of *Hyperallergic.* He has also written for the *New York Times,* CNN, NBC Universal, and *American Craft* magazine, and penned catalogue essays for Joyce J. Scott, Teresita Fernández, and Meleko Mokgosi, among others. He has appeared on the *AM Joy* show with Joy Reid and on the *Jim Jefferies Show* on Comedy Central. He can be heard weekly on the podcast *The American Age.* His book *The Personalization of the Museum Visit* was published by Routledge in 2019. In 2020 he won a Rabkin Award in Visual Arts Journalism.

DEBORAH WILLIS is university professor and chair of the Department of Photography and Imaging at the Tisch School of the Arts and director of the Center for Black Visual Culture/Institute for African American Affairs at New York University. She is a recipient of a MacArthur Fellowship and a Guggenheim Fellowship. She is the author of *The Black Civil War Soldier: A Visual History of Conflict and Citizenship* and *Posing Beauty: African American Images from the 1890s to the Present,* among other publications. Willis's curated exhibitions include *Women Creating Nouns, Not Adjectives: Votes for Women* in conjunction with the exhibition *100 Years/ 100 Women* at the Park

Avenue Armory, New York City; *Let Your Motto Be Resistance: African American Portraits* at the International Center of Photography, New York City; *Out [o] Fashion Photography: Embracing Beauty* at the Henry Art Gallery, University of Washington; and *Framing Beauty: Intimate Visions* at the Grunwald Gallery, Indiana University Bloomington. Her recent photographic work is focused on women and the vote.

INDEX